WOMEN: PORTRAITS

Edited by

James Hall, Nancy J. Jones, and Janet R. Sutherland

McGraw-Hill Book Company

New York St. Louis Dallas San Francisco Atlanta

ACKNOWLEDGMENTS

We are indebted to the following for permission to reprint copyrighted material:

Margaret Walker Alexander for permission to reprint "Lineage" from *For My People* by Margaret Walker.

Minerva C. Allen for permission to reprint her poem "She Is Alone."

T. D. Allen and Ramona Garden for permission to reprint "Tumbleweed" by Ramona Garden from *The Whispering Wind*, T. D. Allen, editor, Doubleday & Company, Inc., 1972. Used by permission of the author, a former student at the Institute of American Indian Arts, a Bureau of Indian Affairs School, Santa Fe, New Mexico.

Aphra for permission to reprint "The Sink" by Susan Griffin, which first appeared in *Aphra*, Volume One, Winter 1970.

Authors, as follows, for permission to reprint selections which appeared in *Male and Female Under 18* (edited by Nancy Larrick and Eve Merriam, Avon Books, 1973): Steve Arbuss for "The Easier Half of the Population"; Ronald Hense for "What I Like to Do"; Dina Kersh for "At the Age of 10"; Pamela Kolstad for "A Girl Is Someone"; Coleen Quilliam for "Girls and Boys Are Alike"; Roni Straussberg for "Self-Surviving Woman"; and Audrey Wright for "Adolescence—Girl Style."

Madeline T. Bass for permission to reprint "To the Mother from Scarsdale Who Asked About Publishing Her Daughter's Poems" by Madeline Bass; copyright © 1975 by Madeline Bass. Originally appeared in *We Become New*, edited by Lucille Iverson and Kathryn Ruby, published by Bantam Books, Inc., 1975.

Laura Chester and The Tribal Press for permission to reprint "Eyes of the Garden" by Laura Chester, from *The All Night Salt Lick*, copyright © 1972 by Laura Chester and Geoffrey Young.

The Dial Press and Delacorte Press for permission to reprint "My Mother" excerpted from *Daybreak* by Joan Baez. Copyright © 1966 by Joan Baez. Reprinted with the permission of The Dial Press. And for "I Stand Here Ironing" from *Tell Me A Riddle* by Tillie Olsen. Copyright © 1956 by Tillie Olsen. Reprinted with permission of Delacorte Press/Seymour Lawrence.

Doubleday & Company, Inc. for permission to reprint from *Looking Back: A Chronicle of Growing Up Old in the Sixties* by Joyce Maynard. Copyright © 1972, 1973 by Joyce Maynard. Reprinted by permission of Doubleday & Company, Inc.

Shirley Faessler for permission to reprint "A Basket of Apples" by Shirley Faessler. Copyright by Shirley Faessler. First appeared in *The Atlantic Monthly*, January 1969.

Library of Congress Cataloging in Publication Data
Main entry under title:

Women: portraits.

 (Patterns in literary art; 16)
 SUMMARY: An anthology of literature realistically portraying women from varying times and cultures.
Includes questions and activities.
 1. American literature—Women authors. 2. English literature—Women authors. 3. Women—Literary collections. [1. American literature—Women authors—Collections. 2. English literature—Women authors—Collections. 3. Women—Literary collections] I. Hall, James, date– II. Jones, Nancy J., date– III. Sutherland, Janet R., date–

PS508.W7W6 820'.8'09287 76-10305
ISBN 0-07-025575-X

Editorial Development, Susan Gelles and Laura Mongello; Editing and Styling, Linda Richmond; Design, Cathy Gallagher; Production, Renee Guilmette; Permissions, Laura Mongello.

The Feminist Press (Box 334, Old Westbury, N. Y. 11568), reprinters of "A Mistaken Charity" from *The Revolt of Mother and Other Stories* by Mary Wilkins Freeman, 1974; and of "The Story of an Hour" by Kate Chopin from *The Storm and Other Stories,* edited by Per Seyersted, 1974.

Harcourt Brace Jovanovich, Inc. for permission to reprint "Everyday Use" by Alice Walker. Copyright © 1973 by Alice Walker. Reprinted from her volume, *In Love and Trouble,* by permission of Harcourt Brace Jovanovich, Inc.

Harper & Row, Publishers, Inc. for permission to reprint "Who Cares?" from *Gifts of Passage* by Santha Rama Rau. Copyright © 1958 by Vasanthi Rama Rau Bowers. By permission of Harper & Row, Publishers.

Harper & Row, Publishers, Inc. and Random House, Inc. for permission to reprint an abridgment from pp. 9–13, 26–30 (under Random House title "The Only Thing I Liked") from *I Always Wanted to Be Somebody* by Althea Gibson, edited by Ed Fitzgerald. Copyright © 1958 by Althea Gibson and Edward E. Fitzgerald. By permission of Harper & Row, Publishers.

Dorothy Pitman Hughes for permission to reprint her selection from "Daughters and Mothers," compiled by Ingeborg Day, which appeared in *Ms.* magazine, June 1975.

International Publishers for permission to reprint "What My Child Learns of the Sea" by Audre Lorde from *The New Black Poetry,* edited by Clarence Major.

Robert Lantz Literary Agency, executor, and Floria Lassky, executrix, for permission to reprint "Like That" by Carson McCullers. First appeared in *Redbook* magazine, October 1971. Copyright © 1971 by The Redbook Publishing Company. Used with permission.

Macmillan Publishing Company, Inc. for permission to reprint Chapter 1 from *The Dollmaker* by Harriette Simpson Arnow. Copyright 1954 by Harriette Simpson Arnow.

William Morrow & Co., Inc. for permission to reprint "Mothers" from *My House* by Nikki Giovanni. Copyright © 1972 by Nikki Giovanni. And for "Home and Travel" from *Blackberry Winter* by Margaret Mead. Copyright © 1972 by Margaret Mead.

Ms. Magazine for permission to reprint "Canada: Stranger in My Own Land" by Jeela Alilkatuktuk; "Life and Birth in New Guinea" by Joyce S. Mitchell; and the Wendy Weil piece from "Daughters and Mothers," compiled by Ingeborg Day. All copyrighted by *Ms.* Magazine. Reprinted with permission.

W. W. Norton and Company, Inc. for permission to reprint "Now I Become Myself" from *Collected Poems 1930–1973* by May Sarton. Copyright © 1974 by May Sarton.

Karl J. Pelzer, Director of Southeast Asia Studies, Yale University, for permission to reprint "Inem" by Pramoedya Ananta Toer, from *Six Indonesian Short Stories,* edited by Rufus S. Hendon.

Random House, Inc. for permission to reprint "Sixth Grade" by Margarita Caudrado; "Really" by Gloria Peters; and "To My Friends" by Carmine Vinciforo. All from *Wishes, Lies and Dreams,* by Kenneth Koch and The Students of P.S. 61. Copyright © 1970 by Kenneth Koch. Reprinted by permission of Random House, Inc.

Adrienne Rich for permission to reprint "Jane Eyre: The Temptations of a Motherless Woman" by Adrienne Rich, which appeared in *Ms.* magazine, October 1973.

Rocky Mountain National Park Music Co., Inc. for permission to reprint "Albatross" by Judy Collins. Copyright © 1967 by Rocky Mountain National Park Music Co., Inc. Used by permission. All Rights Reserved.

Saturday Review for permission to reprint "Sexual Stereotypes Start Early" by Florence Howe. Copyright © 1971 by *Saturday Review.*

South Dakota Review for permission to reprint "Navajo Sighs" by Winifred Fields Walters. First published in *South Dakota Review,* Winter 1972–73.

May Swenson for permission to reprint "The Centaur" from *To Mix With Time* by May Swenson, copyright © 1963.

Kitty Tsui for permission to reprint "To My Grandmother: All Your Time" by Kitty Tsui. Copyright © 1973 by Kitty Tsui.

University of Michigan Press for permission to reprint from *Mountain Wolf Woman: The Autobiography of a Winnebago Indian,* edited by Nancy Oestrich Lurie. Copyright © 1961 by the University of Michigan. Reprinted by permission of the University of Michigan Press.

Acknowledgments iii

CONTENTS

iv

INTRODUCTION

In most of the literature that has been available to you as students, women are unfairly portrayed or totally neglected. The literature in this text should therefore be a welcome change. It presents *realistic* portraits of both young and mature women from differing cultures. As you read, your knowledge of the language of stereotypes should increase. You should also be better able to examine critically the unrealistic images of women found in the popular media. Hopefully, these portraits will increase your awareness of the great potential of women in many areas of work and self-expression.

The first chapter, "Women Becoming," begins by examining parents' expectations for their daughters. You will see young women working through the conflicts that occur as they learn to choose whether they must please everyone else or themselves first. And, finally, you will see young women who have successfully settled these conflicts and developed a strong sense of who they are and what they want to do in life.

The second chapter, "Women Being," presents portraits of women who have reached maturity. In this chapter you will see, first, women who have discovered a heritage in the lives of their mothers and grandmothers. Second, you will find women who draw on wide ranges of skills and personal qualities to live complete and worthwhile lives in a condition society usually suggests is dreadfully unsatisfying—being alone. Third, you will encounter women who, with a great deal of determination and courage, wrestle with the role expectations laid down by the culture in which they live. You will have a chance to see how a culture can support and enhance the role of women if their role is defined with respect. Finally, you will meet a few women who somehow live beyond the conventions of their time and place, having discovered in themselves all the resources necessary for a full, active, and creative life.

The chapter "Women Stereotyped" comes last in the book, simply because you will be better able to understand it after you have read about women who challenge the stereotyped views of themselves as fragile, vain, and homebound creatures. The opening article discusses how sex role stereotyping is an integral part of a child's culture and early schooling. The selections in this chapter show that there are two ways to view female stereotypes. If they are considered to be rigid role definitions, they will be very limiting and possibly even destructive. But if they are properly understood to be symbols, they can be reacted to and used to give force and direction to a woman's life.

Women
Becoming

CHAPTER ONE

The concept of "becoming" is a difficult one to get hold of. A way to begin is to ask, "Become what?" Women are becoming. They are becoming what they want to become, as perhaps never before.

What all of us become, in a physical sense at least, is adults. But becoming an adult is difficult. Going from girlhood to adolescence to young womanhood is difficult. Certain "rites of passage" are associated with the journey to adulthood, and these are seen in several of the selections in Women Becoming. The way girls learn about the physical changes women undergo is one of the main themes of Carson McCullers's short story "Like That."

But there are factors beyond these complex physical and emotional concerns which girls must deal with during adolescence. We all form views of ourselves very early in life. These views persist, even though we are often unaware of how and why they were arrived at. It is during adolescence that they must be sorted out. In most of the following selections we see how young girls deal with these views—with the way they see themselves and how they respond to the way others see them, especially their parents. Most especially, it seems, their mothers. Adolescents are forming patterns of thought and feeling, value and belief, work and play. A basic part of the struggle is the effort to become conscious of what their own deep selves want and need to be, sometimes in conflict with the values of their parents, society, and peers.

Traditionally, women have had a more or less passive future predicted for them. Most cultures have permitted a very limited set of opportunities for a young woman. Her major task has been to acquire, by any means necessary, the appearance that her culture considers beautiful. But while trying to become outwardly what will please others, she may be struggling inwardly with a great many confusions and doubts. For, while on the one hand her options seem so limited, on the other hand

she sees a world outside with exciting and demanding opportunities. There will be situations in which every ounce of her courage, strength, and intelligence are needed. She is thus faced with a dilemma. In order to please others, she may have to deny pleasing herself. Or, she may have to acquire her skills secretly, hiding them beneath an "acceptable" exterior.

How a young woman will learn to deal with this dilemma may be determined for her almost from birth, in the attitude of her parents. They may coach her to learn early the lesson to please at all costs, as the mother in "To the Mother from Scarsdale" wants to do. Or, if she is lucky, they will let her experience for herself some sense of meeting the world and shaping it.

In the selections in this chapter we begin to see the dimensions of the struggle that young women from various cultural backgrounds face as they grow into adults and discover what their options are. We see some of the problems they face as they consider those options—options which need be limited only if they are accepted without question. In this section we see mothers hoping for an atmosphere where young women can grow into what they need to be. We see a young girl finding in fantasy a world that contradicts the world of traditional roles. Further, we see young women who adopt traditional roles with enthusiasm only to look back with dismay, as Joyce Maynard does, upon the rigid demands of those roles. Finally, we see women in rebellion against what the culture demands, working through their confusion toward a view of the world that works for them.

From such different portraits you should see that the world does not have to be a limiting place for women. With awareness they can find within themselves those qualities of good sense, inventiveness, and strength that have traditionally been reserved for men. Hopefully they will balance their logic with the care and concern for people that women are supposed to be specially gifted with. With this new awareness women may discover a world much more accepting of them as reasonable, feeling, mature adults.

INTRODUCTION

Sometimes parents try to live through their children. An important part of growing up, therefore, is learning to deal with a changing relationship with your parents. You must pass from being almost a part of them to becoming a separate person who sees them as people who care for you, but cannot *be* you.

The mother in "What My Child Learns of the Sea" realizes that her daughter will seek her own identity and, in so doing, might well become a stranger.

What My Child Learns of the Sea

Audre Lorde

What my child learns of the sea
Of the summer thunder
Of the bewildering riddle that hides at the vortex of spring
She will learn in my twilight
And childlike 5
Revise every autumn.

What my child learns
As her winters fall out of time
Ripened in my own body
To enter her eyes with first light. 10

This is why
More than blood,
Or the milk I have given
One day a strange girl will step
To the back of a mirror 15
Cutting my ropes

Of sea and thunder and sun.
Of the way she will taste her autumns
Toast-brittle, or warmer than sleep
And the words she will use for winter 20
I stand already condemned.

FOR DISCUSSION

1. Why does the poet speak of the sea and thunder as things
her daughter will learn from? What is the mother ac-
cepting as the young girl steps *behind* the "mirror/cutting
[her] ropes"? Why does the mother say she is con-
demned? What does she lose? What does she gain?

2. How have you observed parents reacting to their children's
growing up? Do children always "grow away" from their
parents? Are there differences in the duties young men
and young women feel toward their parents?

ACTIVITIES

1. Make a list of the questions you have about women, their
identity, the roles they play in society, their conflicts, and
their possible futures.

2. Next, make a topic heading for each question—such as
"marriage," "careers," "education"—and label a file folder
for each topic.

3. Use the card catalog in the library, any bibliographies your
librarian can give you on women, *The Reader's Guide to
Periodical Literature*, and additional texts and magazines
your teacher may have. Search for articles that relate to
each topic and copy them for the folder or record the
source there. Clip articles from your own daily newspa-
pers. You have created a resource file for the class.

4. Take one of the topics from the file and make a prelimi-
nary report to the class. At this point, just try to present to
the class what you feel are the most important questions

about your topic. For example, what is the future of women in sports? Or, what are the physiological differences between the sexes? Later, do more research on your topic and do some writing in which you try to answer some of those questions for yourself.

INTRODUCTION

Young women need room to grow and change. Madeline Bass knows the danger of learning to please and of looking toward the market—whether what is for sale is a poem or a face. You might want to think about why she is bothered by the mother's "pushing" of her daughter's work. Is there an invasion of privacy here? How much privacy is a child entitled to, even from parents? Notice the poet's attitude of love and respect for the young woman's ability. Also, look at the pictures of the active, rough-and-tumble life which the poet thinks is the right of every growing girl.

To the Mother from Scarsdale Who Asked About Publishing Her Daughter's Poems

Madeline Bass

If I had a girl child I would tell her to eat
peaches and hang by her knees
all summer, smile as the sun change came in her skin,
and rub her arms when they became sore
from cartwheels; if 5
a girl came to me in a cage of words
I would give her the key
over and over and never
put a price
on her face, or the paper one. If 10
a girl came
in her season
of hair and fear and the tumbling soul of her fell

at my knees, I would hope
to hang her pictures and poems in the kitchen, 15
her doorway with flowers
and bend over her bed every evening
to cover her loneliness; if
a child of mine
like a shadow of me in the curl of my childhood 20
came in a wish to my mothering,
what I would not do
is sell her
or teach her of markets.
I "had a way" as a child, 25
as you say, "way with words";
the presents I made, as exhibits,
were bridges
to nowhere. I traveled
in armor with cheap polish 30
covering something
I wasn't supposed to reveal.
If I had a girl with "a way"
she would go on it, loving the journey.

FOR DISCUSSION

1. Why would the mother want her daughter's poems pub-
 lished? What might this mean for the daughter? Why
 would the poet rather see the young person's work
 hanging in the kitchen?
2. Why does the poet mention selling the girl's face as well as
 the poem? What happens to people when you teach them
 "of markets"? What might happen to the things they want
 to produce that will not sell?
3. How does a person's need to please others sometimes lead
 to problems? Is this a special problem for women?
4. How do little girls learn to please? Is this any different
 from what little boys learn? When did you learn how to
 please without doing things you felt were untrue to your-
 self? What conflicts have you had along the way?

To the Mother from Scarsdale 7

INTRODUCTION

The following statements are answers to a questionnaire which asked people under the age of eighteen to "tell how it feels to be a girl or a boy." These young writers show the force of a process called "acculturation." Acculturation is the process by which people learn what their culture expects of them in their roles as males or females. The expected and proper behaviors are learned through all one's contacts with others—for example, through language, habits, and attitudes. Different toys, games, clubs, dress, and future expectations for males and females all strengthen the difference between these roles. It is important to realize that because the ideas of masculinity and femininity are learned so early, young people often do not know where the ideas come from. Some of the young people here see masculinity and femininity as unchanging conditions. Others are responding to the concept with critical awareness.

Male and Female Under 18

Eve Merriam and Nancy Larrick

At the Age of Ten

To be a girl is special. At the age of ten it means being teased by your brothers. It means dressing up in my mommy's clothes and wearing her make-up. It means sharing secrets with my mother and girl friends. It is fun learning to bake and cook. (I especially like to bake chocolate chip cookies and marble cake.)

I look forward to growing up into a woman having my own

make-up, being called for dates on the telephone. (My whole family is always using the telephone.)

Someday I will be a wife and have a home and children of my own. I hope I have a little girl. To be a girl is special.

—Dina Kersh, 10, F.
New York, New York

What I Like to Do

I just like to pheasant hunt, play football and baseball. I like to play guns, ride a mini-bike and I like to be a paper boy and climb trees and play in them and jump in them. I like to fish in a lake or stream. I like to swim and slide down our hill in the backyard with my brothers.

—Ronald Curtis Hense, 11, M.
Lincoln, Nebraska

A Girl Is Someone

A girl is someone who likes to have wind in her hair. And likes to pinch and kick boys. A girl likes to look cute and precious. A girl likes to scream and holler when a boy pulls her hair. A girl would like to slap the boys in the face when they won't let you watch a Miss Beauty Pageant. A girl is someone who hates watching a football game. A girl is someone who likes to wear hot pants and dresses. A girl is someone who likes cats and sometimes dogs. A girl is someone who likes cute boys. A girl is someone who likes skating and roller skating. A girl is someone who likes high heels and hates when you get stuck in the crack in the sidewalk. A girl likes maxis but hates when you trip and a boy laughs when you fall. A girl is someone who is shy and likes having the best. A girl is someone who likes to eat and eat. A girl is someone who hates going on a diet. A girl is someone who wants to be wanted and

loved. A girl is someone who wants to help. A girl is someone who loves children. A girl is someone who likes making food and cleaning up. A girl is someone who hates war, and hates to see people dying, and cries when she finds out her husband or son or brother is dead.

A girl is loving.

—*Pamela Kolstad, 10, F.*
St. Paul, Minnesota

Girls and Boys Are Alike

Girls and boys are alike because girls and boys both
 Go to school together
 Live together
 Sit together
 Eat together

When grown up
 Marry each other
 Love each other
 Take care of each other

Boys aren't stronger than girls. Boys with muscles are stronger than girls. Girls with health are stronger than boys.

Boys and girls work together, but not on the same jobs and not on the same pay, because boys think girls are different and they're not!

—*Coleen Quilliam, 9, F.*
Commack, New York

Femininity

Femininity is to have grace and charm,
To be polite and careful, to do no harm,

Fussing with your clothes and hair,
Beautifying yourself with very great care,
Walking in the drugstore for a cola sip, 5
Overhearing the neighborhood girls gossip,
Keeping a happy, lively little household,
With tidiness and coziness to have and to hold.

—Anu Jain, 12, F.
New Delhi, India
(formerly of Lincoln, Nebraska)

The Easier Half of the Population

Whenever my sister nags,
Or my mother yells,
I say to myself:
Calm down, the world's not really Hell.
Actually you're better off, you see, 5
Because you're a he . . . not a she.
When you are off fishing or sailing or rowing,
Females are reading or cooking or sewing.
Women keep house with cleaning and stuff,
For you cleaning your room is hard enough. 10
As you observe this with revelation,
You find you're in the easier half of the population!

—Steve Arbuss, 12, M.
Syosset, New York

Adolescence—Girl-Style

My heart,
Enclosed in the fragile shell
Of my skin—
Beats hesitantly.
Am I still a child— 5

Or a young woman?
What is moral and proper?
Who are the right people to know,
And places to go,
Things to do? 10
People say I'm too old to cry,
But too young to vote . . .
Too young to date,
Or drive
Or live away from home. 15
Yet they say I'm independent
And very responsible!
Why?
That doesn't make sense.
How can I speak out? 20
I have ideas, too.
I feel like a
Caged-in tiger,
Barred by the irons of society.
I'm an adult, 25
I think—
Yet I'm still a child.
My heart ponders
Over my life.
A changed life from 30
The yesterdays of my childhood—
But who am I today?

—Audrey Wright, 14, F.
Chapel Hill, North Carolina

Self-Surviving Woman

I will not pretend
To be stupid and silly,
Squirming and squealing
 at the sight of a snake,
 Probably fake, 5

Although I've been told
this is very appealing.

I am not a toy
To be used by a boy.
Not a slave will I be 10
To be owned temporarily.

I am a woman,
Able to live, breathe, think,
Can't control me with your wink.
For I am free, to be as I am 15
And roam untamed fields,
 Like a wild woolly lamb
Without man!

—*Roni Straussberg, 15, F.*
North Woodmere, New York

FOR DISCUSSION

1. How would you answer the question these writers have answered? How *does* it feel to be a boy or a girl?
2. What do you think the important differences are between the sexes? How many are physical, how many a result of custom or tradition? What might be the results of these differences?
3. How are the answers of the young writers different? What would explain the differences?

ACTIVITIES

1. Look for a definition of "culture" in the dictionary. Do you think that the "masculine" culture and the "feminine" culture can be thought of as two coexisting cultures? If so, try to state the differences between the two cultures in the following areas: early training in being a boy or a girl; toys

and games; education; peer groups, such as clubs; dress; and language, including body language.

2. Do a research project to find out about genetic, as opposed to cultural, differences between men and women. How many differences are inborn? Is there disagreement about this?

3. List some of the qualities you think of as being masculine or feminine. Consider both physical characteristics and personality traits.

INTRODUCTION

The following poems were written by grade school children. Each child seems to be quite busy sorting out how she sees herself in relation to how others see her. Each has discovered that her inner reality is often different from, yet more important than, the reality of other people. Thus, in each poem, the writer's strong sense of self comes through. The poems also suggest, however, that there are very real pressures on little girls to conform, at least outwardly, to what the culture expects of them. It is assumed that they will be weak, delicate, and foolish.

Wishes, Lies and Dreams

Kenneth Koch

Sixth Grade

People think I'm so and so
But I am not so and so
People think I'm this
But I am that.

Margarita Cuadrado

To My Friends

To my friends, when we play football, they think I can't play.
But really I know how to play football.
When I go out with my friends I act tough, but when I am at

home doing nothing, I am not tough because there is
 nobody to be tough with.
When I play with my brother he has to always beat me up.
But when we don't play I always beat him up. 5
When I say I'm sick I don't have to wash the dishes.
But I'm not really sick.

Carmine Vinciforo

Really

I seem to be so dumb to my teacher, it seems.
But he really doesn't know me, really.
To my mother I seem to be a brat, it seems to be.
But I really am kind and good, really.
I seem to be shy to some friends I know, I seem to be. 5
But really, I'm not shy, really.
To my cousins, I seem to be a baby, I seem to be,
But really, they don't know me too well, really.
To the students of the class I seem to be kind of dumb,
 I seem to be
But really, I'm kind of smart, really. 10
To other people I seem to be a stranger
But really, I'm their sister, really.

Gloria Peters

FOR DISCUSSION

1. What makes the "self" of each speaker seem so complete?
 Which poem do you like best? Why?
2. Describe the person who wrote each poem. Is there any
 evidence in the poems that little girls are taught by so-
 ciety—home, school, family—to be outwardly passive?
3. How are you different from the way others see you? What

keeps them from seeing you clearly? What do you think allowed these children to speak so clearly of what they really were? Do you always have this kind of freedom to assert yourself? If not, what stands in the way? Can you explain the difference between self-assertion and aggression?

ACTIVITY

Find out about assertiveness training. (See *Ms.* magazine, January, 1975.) Look for evidence of nonassertive behavior in your own and others' speech. Can you and they always refuse a request? Take part in a discussion, interrupting if necessary? Stand up for yourself? Give and take criticism?

INTRODUCTION

A strong imagination can help you see yourself as different from other people. When you were young, you may have had an active imagination that let you try out many different roles and identities, like the girl in the poem below. Through play, the young girl in the poem finds a kind of power not usually associated with women. At this age, she finds herself free to be and do anything her mind will allow.

The Centaur

May Swenson

The summer that I was ten—
Can it be there was only one
summer that I was ten? It must

have been a long one then—
each day I'd go out to choose 5
a fresh horse from my stable

which was a willow grove
down by the old canal.
I'd go on my two bare feet.

But when, with my brother's jack-knife, 10
I had cut me a long limber horse
with a good thick knob for a head,

and peeled him slick and clean
except a few leaves for the tail,
and cinched my brother's belt 15

around his head for a rein,
I'd straddle and canter him fast
up the grass bank to the path,

trot along in the lovely dust
that talcumed over his hoofs, 20
hiding my toes, and turning

his feet to swift half-moons.
The willow knob with the strap
jouncing between my thighs

was the pommel and yet the poll 25
of my nickering pony's head.
My head and my neck were mine,

yet they were shaped like a horse.
My hair flopped to the side
like the mane of a horse in the wind. 30

My forelock swung in my eyes,
my neck arched and I snorted.
I shied and skittered and reared,

stopped and raised my knees,
pawed at the ground and quivered. 35
My teeth bared as we wheeled

and swished through the dust again.
I was the horse and the rider,
and the leather I slapped to his rump

spanked my own behind. 40
Doubled, my two hoofs beat
a gallop along the bank,

the wind twanged in my mane,
my mouth squared to the bit.
And yet I sat on my steed 45

The Centaur 19

quiet, negligent riding,
my toes standing the stirrups,
my thighs hugging his ribs.

At a walk we drew up to the porch.
I tethered him to a paling. 50
Dismounting, I smoothed my skirt

and entered the dusky hall.
My feet on the clean linoleum
left ghostly toes in the hall.

Where have you been? said my mother. 55
Been riding, I said from the sink,
and filled me a glass of water.

What's that in your pocket? she said.
Just my knife. It weighted my pocket
and stretched my dress awry. 60

Go tie back your hair, said my mother,
and *Why is your mouth all green?*
*Rob Roy, he pulled some clover
as we crossed the field,* I told her.

FOR DISCUSSION

1. Do you think the author gives a real view of what a young
 girl's fantasies are like? What does she seem to be saying
 about them? How would they compare to a boy's?
2. Does the poem remind you of anything in your childhood?
 What imaginary identities or companions did you have?
 What games did you like to play? How did sex roles enter
 in? When do you remember learning that being a boy or
 girl meant you would play differently?

ACTIVITIES

1. Do a study of children's toys. Report on how they are different for boys and girls.
2. Study children's groups or organizations. How are those for boys different from those for girls?
3. Study the rhymes and chants children use in jumping rope and in other games. What do you learn about men and women from them?

INTRODUCTION

The chief problem for the narrator of "Backstage" does not lie in her dealing with her identity as a female. She seems quite secure in stating her own views and in standing her ground against feminine fashions. Instead, cultural conflict is the issue. She is considered nearly invisible because she is a Chinese among Americans. She is expected to be "nice and quiet" and self-effacing. It is as though the human wish for affection and attention cannot exist for her.

Backstage

Veronica Huang

On a little street in a little Californian town stood a bluish-gray house. This was the residence of a Chinese immigrant family. They had quietly occupied the house for two years. Although all their children graduated from the public school, Mr. and Mrs. Wong had never bothered with any of the school functions, such as the PTA. Not that they were unsociable people; they were simply hard-working. Being foreigners in the country, they had to be rather conscientious to keep their jobs secure.

Furthermore, they trusted their children, who had always been well-disciplined and diligent. All they had to do was provide the cash, and the children would automatically reach the top of the ladder and live happily ever after.

They could not be bothered with PTA's. After all, only wealthy, leisured parents, or those who did not really care for their children but had to pretend that they did, joined that organization.

Tonight, however, was one of the rare occasions when Mr. and Mrs. Wong visited the local public school. The neon-lighted words, "Spring Concert" sparkled in front of the school

gate. This was the last concert of the school year, and also a celebration for the graduating senior class. T.Y., one of the Wong daughters, was a graduating student. She was the only Oriental among the hundred performers; her parents were proud of her.

A lot of bustle had enlivened the bluish-gray house just before the concert. Everyone was excited, all except T.Y. herself. Mrs. Wong, with all her patience, could not persuade T.Y. to curl her hair, or wear cosmetics. T.Y. had always been a quiet, submissive girl, but in this matter she was hard and stubborn. She only consented to wear her sister's old formal gown, since this was required of all performers. Mrs. Wong offered a pearl necklace to decorate the rather plain gown, but she was again met by T.Y.'s flat refusal.

Having reached her wit's end, Mrs. Wong at last had to relinquish T.Y. as she was: straight black hair, a plain gown, a clean face and a pair of tennis shoes. T.Y. declared that it was impossible to walk in high heels, and she would only put them on the minute before she appeared on stage.

As Mr. Wong drove her to school, T.Y. sat gloomily in the car. Why should she beautify herself now, when for two years she had been struggling against the fashion shows her schoolmates put on from day to day? To them, school was nothing but an arena to parade their colorful feathers.

When T.Y. first entered the school, her heart longed to befriend this strange new group of people. For the first few days, she sat invisible in the classrooms. Very soon, she had sought out the likes and dislikes of these people. She came to the final conclusion, that in order to emerge from her nonentity, she must first disguise herself in appearance.

The day she wore a pretty dress to school, six people spoke to her.

"Oh, you look cute today. Where did you get that dress?"
"It's from Hong Kong, and it's hand-made by a tailor, too."
"Oh wow! Are you from Hong Kong? How nice! Are there many tailors in Hong Kong? Hey, Sue—look at her dress, isn't it pretty? And it's hand-made by tailors in Hong Kong."

Weeks passed, but the "friendship" never got beyond "Oh wow, how nice!" T.Y. fell back to her natural ways, and the pretty dresses were once again pushed back into the darkest corner of the closet.

As the time of the concert approached, more and more parents filed into the auditorium. Most of them were middle-aged people—on the average, plump and heavy, and fashionably dressed.

Backstage, the youngsters were fluttering all over. The comment "Oh wow! You look so pretty, I couldn't recognize you!" was repeated ten thousand times. At a distance, the room seemed to be alive with the presence of youthful dashing butterflies, but if you looked closer at the young faces, their wrinkles and agedness might frighten you. Their senile, petty cares and shrill garrulity were signs of agedness. Cosmetics had ruined the health of their skin, while the corrupted tradition of a dying society had petrified their hearts.

Their faces were so painted that it was impossible to recognize each other. T.Y. was the only familiar face, but she was invisible. She sat at her usual place, silently, painfully watching. Lately, she had become utterly confused. She had lived in many places—Hong Kong, Taiwan, Thailand—and everywhere she made friends easily. Even the Pacific Ocean could not separate some of these friendships. Her experience in the U.S however, was totally different.

Her life here was a suspension of existence and non-existence, approval and rejection. Although she was neglected most of the time, a sudden lavishness of benevolence once in a while would make her glow all over. There were times when an American, a total stranger, would accost her and say:

"Oh, I love Chinese people, especially Chinese food. They're so cheap in Chinatown."

T.Y. often wondered if the "they" referred to the food or the people, or both. Anyhow, she took it as a compliment. Another applause to the glories of her nation was: "The Chinese are such nice and quiet people. They obey law and order. In this country, we've never heard of any Chinese

delinquents." T.Y. flushed with national pride until the double-meaning of the praise began to sting her.

One day, her father found a better job in another firm. The boss who was normally kind, gentle, friendly, though somewhat stingy, now flared up in anger.

"I thought you Chinese were a loyal people. I didn't know you could be so heartless. You can't hang me up like this. Look here, John. I've always been nice to you and I thought you were nice and quiet. How can you do this to me!"

"Nice and quiet—is this a compliment or not?" thought T.Y. "Is it because Father is so nice and quiet that he never gets a raise?"

Suddenly, a horde of feet stampeded to the robe room. Among the crowd of towering bodies, T.Y. underwent the usual jostling and pushing. People shouted out their robe numbers, while the manager passed them out. Each one got his robe in turn, according to the length of his arm. T.Y. was one of the last again. Suddenly, the impulse to scream out her robe number, to charge through the monstrous horde, made her almost fierce. However, she managed to subdue the impetus. She couldn't disgrace the image of a "nice and quiet" nation. Besides, she knew by heart the lesson that diligence and obedience were the only ways to gain esteem.

"Hi, how are you?" An awkwardly cheerful voice startled T.Y.

"Fine," she answered hesitantly. This boy was in her Physics class, and after sitting in the same room with her for one hundred and forty-nine hours, he had not spoken one word to her.

"Hey, about the Physics lab book, do you have all the data written down? Heh, heh, you see, I wrote mine down on sheets of paper, and I lost them. Can I have a look at yours tomorrow?"

T.Y. nodded understandingly. The boy took her nod as assent and walked away happily. She understood it all now: she was nothing but a convenience. People could not completely

ignore her, just as they could not afford to discard a handy gadget.

As T.Y. brooded over her new discovery, a familiar soft tapping tickled her ear. Ken, with a walking-stick for his eyes, dexterously felt his way to the seat beside T.Y.'s. The second row, fourth seat was accustomed to the touch of his sensitive finger.

"T.Y., this is almost the end of the year, and we won't be able to see . . . I mean talk to each other for long. I'm really grateful for your friendship. You know, we'll be going to different universities next year, so . . . can I write you then?"

"Of course you can." T.Y.'s reply was not so enthusiastic, for she had always wriggled with uneasiness while talking to Ken. She was friends with another blind girl too, but uneasiness had never come between them. She began to recognize her conflict with Ken.

Ken was aggressive, argumentative, satirical, but most of all, bitter. His forced, acrid laughter made T.Y. shiver. Ken also loved to exhibit his sense of humor, which, in T.Y.'s opinion, was not humorous but acidic. T.Y. abhorred his cynical, unnatural humor, but her heart softened as she thought of his loneliness. In his life-time struggle in an unsympathetic society, he had learned to forge powerful weapons of cynicism and aggression.

"Do you ever feel discriminated against?" asked Ken.

After a pause, T.Y. answered thoughtfully, "Yes, I think so." She had seen the word "discrimination" used in describing the blacks in her history book, but had never grasped the true meaning of the word. She never realized until now that "discrimination" applied to her too. "Do you feel this way too, Ken?"

"Of course I do. Otherwise I wouldn't be going around with you."

Another new finding, but a stab this time . . . so, so, he would be away larking with the others too if he weren't crippled. So, so . . . she was, in a way, a crippled misfit too.

It was as though after a cold shower, everything appeared piercingly clear. T.Y. felt rigid all over, as if she were transformed into an icicle. Everything from the external world now

26

seeped through her translucent body with the utmost ease. The colors were lucid to the point of dazzling—they mocked at her colorlessness. T.Y. began to rejoice in her transparency for it made her invisible. Her invisibility was a shield against stinging remarks. The Kens and the boys in Physics would not bother her anymore.

The revelation lasted for a few minutes, and all was in motion in the room. T.Y.'s body flowed along with the crowd and was deposited in the midst of another dilemma—flaring stagelights blasted her invisible cloak, mercilessly exposing her to the focus of hundreds of pairs of eyes. T.Y. was acutely conscious of her peculiarities: she was the only Oriental, the only one without make-up and fashionable hairstyle, the only one with a secondhand gown. Her heart coiled back, then suddenly sprang out to the two people in the audience who were proud of her.

Mr. Wong smiled contentedly, but he had to strain his eyes, for T.Y.'s small stature was blocked by a square-built person twice her size. "I knew T.Y. could distinguish herself," thought he. Mrs. Wong, on the other hand, shook her head—T.Y. looked pale on stage; she should have worn make-up.

The music then began. Another transformation jolted T.Y.'s body. She was now alert, with every nerve taut and ready to vibrate. All eyes were on the conductor, and in a flash, sixty mouths opened simultaneously. A harmony that was the consciousness of the choir rang out. T.Y. was intent on only one thing—to harmonize with the group and surrender her total awareness to the music. On the stage, she appeared to be an integral part of the group.

Yet despite her dedication to the performance, T.Y. secretly realized that her efforts were futile. Her union with the group was only momentary. Backstage, everything would be the same again. For two years, she had faithfully attended every rehearsal and had contributed the most effort. But the conductor, who loved to joke and play with the students, had spoken not more than two sentences to her.

When it was time to sign autographs in the students' yearbooks, the conductor signed everyone else's except T.Y.'s.

Since he had not much to say to her, T.Y.'s yearbook, as a matter-of-course, found its way to the bottom of the stack. In the end, it was left in the rehearsal room unsigned, for the conductor had to "rush home for lunch." T.Y.'s yearbook was inevitably stolen.

The conductor did not deliberately slight T.Y., for it was all done subconsciously. After all, he was just an ordinary, good-natured, average American, who liked everything that was "average." He could not help being indifferent to weird objects like T.Y.

After two hours of turmoil, the concert drew to a close. The hustling continued as parents shuffled backstage to congratulate the youngsters. "A fine show! A good performance!" cried all. The conductor strutted pompously around the room, receiving congratulations and congratulating the graduating seniors. T.Y. saw him shaking hands with the graduates, giving each of them a pat on the back, a little joke or a word of encouragement for the future.

As the conductor approached nearer and nearer, T.Y. began to wipe her wet palms on her skirt. She cleared her throat, preparing to return a compliment when the conductor wished her luck. Her knees shook a little as the conductor advanced toward the person in front of her.

To T.Y., this was a grand occasion. She flushed as she thought of the honor of being distinguished as a "person," worthy to shake hands with the conductor. Her heart thumped wildly as she overheard his last words to the other person: "Be good now, ole pal." Her hands were itching to shake, but the next moment, the conductor's back was abruptly turned against her. Everything became blurry while she stared at the conductor's back slowly diminishing into the center of the crowd.

T.Y. pinched herself, and found a weird delight in the pain. She wished with all her heart that everyone in the room would pounce on her, beat her, throttle her, claw at her. They would then at least recognize her existence in flesh and blood. T.Y. closed her eyes and imagined the relish in feeling pain, the pain which only a "person" could feel.

FOR DISCUSSION

1. What insights do you think the narrator might have gained from her experience with racial discrimination that might have allowed her to ignore some of the expectations placed upon her as a young woman?

2. What do you think about the description "nice and quiet"? Do you see a comparison between what the narrator finds Chinese are supposed to be and what women are supposed to be? What are the disadvantages of being "nice and quiet"? Who benefits when a certain group of people are expected by others to be silent?

ACTIVITY

Find out about the history of Chinese people in America. What are the stereotyped views of their life? What are the realities of their life? Try to find out what special problems as well as advantages young women living in this double culture have.

INTRODUCTION

Usually both the culture you are born into and your family's class in that culture determine your status. For women in a poor and socially powerless class, where there is also great ignorance, the condition of their lives often reflects the oppression the men in their families suffer. Such is the situation of the young Indonesian woman in the story "Inem." As in few of the other selections you have read, the portrait of what is possible for Inem to become seems gloomy indeed.

Inem

Pramoedya Ananta Toer

Inem was one of the girls I knew. She was eight years old—two years older than me. She was no different from the others. And if there was a difference, it was that she was one of the prettier little girls in our neighborhood. People liked to look at her. She was polite, unspoiled, deft, and hardworking—qualities which quickly spread her fame even into other neighborhoods as a girl who would make a good daughter-in-law.

And once when she was heating water in the kitchen, she said to me, "Gus Muk, I'm going to be married."

"You're fooling!" I said.

"No, the proposal came a week ago. Mama and Papa and all the relatives have accepted the proposal."

"What fun to be a bride!" I exclaimed happily.

"Yes, it'll be fun, I know it will! They'll buy me all sorts of nice clothes. I'll be dressed up in a bride's outfit, with flowers in my hair, and they'll make me up with powder and mascara. Oh, I'll like that!"

And it was true. One afternoon her mother called on mine. At that time Inem was living with us as a servant. Her

daily tasks were to help with the cooking and to watch over me and my younger brothers and sisters as we played.

Inem's mother made a living by doing batik work. That was what the women in our neighborhood did when they were not working in the rice fields. Some put batik designs on sarongs, while others worked on head cloths. The poorer ones preferred to do head cloths; since it did not take so long to finish a head cloth, they received payment for it sooner. And Inem's mother supported her family by putting batik designs on head cloths. She got the cloth and the wax from her employer, the Idjo Store. For every two head cloths that she finished, she was paid one and a half cents. On the average, a woman could do eight to eleven head cloths a day.

Inem's father kept gamecocks. All he did, day after day, was to wager his bird in cockfights. If he lost, the victor would take his cock. And in addition he would have to pay two and a half rupiahs, or at the very least seventy-five cents. When he was not gambling on cockfights, he would play cards with his neighbors for a cent a hand.

Sometimes Inem's father would be away from home for a month or half a month, wandering around on foot. His return would signify that he was bringing home some money.

Mother once told me that Inem's father's main occupation had been robbing people in the teak forest between our town, Blora, and the coastal town of Rembang. I was then in the first grade, and heard many stories of robbers, bandits, thieves, and murderers. As a result of those stories and what Mother told me, I came to be terrified of Inem's father.

Everybody knew that Inem's father was a criminal, but no one could prove it and no one dared complain to the police. Consequently he was never arrested by the police. Furthermore, almost all of Inem's mother's relatives were policemen. There was even one with the rank of agent first class. Inem's father himself had once been a policeman but had been discharged for taking bribes.

Mother also told me that in the old days Inem's father had been an important criminal. As a way of countering an outbreak of crime that was getting out of hand, the Netherlands Indies government had appointed him a policeman, so that he

could round up his former associates. He never robbed any more after that, but in our area he continued to be a focus of suspicion.

When Inem's mother called on my mother, Inem was heating water in the kitchen. I tagged along after Inem's mother. The visitor, Mother, and I sat on a low, red couch.

"Ma'am," said Inem's mother, "I've come to ask for Inem to come back home."

"Why do you want Inem back? Isn't it better for her to be here? You don't have any of her expenses, and here she can learn how to cook."

"Yes, ma'am, but I plan for her to get married after the coming harvest."

"What?" exclaimed Mother, startled. "She's going to be married?"

"Yes, ma'am. She's old enough to be married now—she's eight years old," said Inem's mother.

At this my mother laughed. And her visitor was surprised to see Mother laugh.

"Why, a girl of eight is still a child!" said Mother.

"We're not upper-class people, ma'am. I think she's already a year too old. You know Asih? She married her daughter when she was two years younger than mine."

Mother tried to dissuade the woman. But Inem's mother had another argument. Finally the visitor spoke again: "I feel lucky that someone wants her. If we let a proposal go by this time, maybe there will never be another one. And how humiliating it would be to have a daughter turn into an old maid! And it just might be that if she gets married she'll be able to help out with the household expenses."

Mother did not reply. Then she looked at me and said, "Go get the betel set and the spittoon."

So I went to fetch the box of betel-chewing ingredients and the brass spittoon.

"And what does your husband say?"

"Oh, he agrees. What's more, Markaban is the son of a well-to-do man—his only child. Markaban has already begun to help his father trade cattle in Rembang, Tjepu, Medang, Pati, Ngawen, and also here in Blora," said Inem's mother.

32

This information seemed to cheer Mother up, although I could not understand why. Then she called Inem, who was at work in the kitchen. Inem came in. And Mother asked, "Inem, do you want to get married?"

Inem bowed her head. She was very respectful toward Mother. I never once heard her oppose her. Indeed, it is rare to find people who are powerless opposing anything that others say to them.

I saw then that Inem was beaming. She often looked like that; give her something that pleased her even a little and she would beam. But she was not accustomed to saying "thank you." In the society of the simple people of our neighborhood, the words "thank you" were still unfamiliar. It was only through the glow radiating from their faces that gratitude found expression.

"Yes, ma'am," said Inem so softly as to be almost inaudible.

Then Inem's mother and mine chewed some betel. Mother herself did not like to chew betel all the time. She did it only when she had a woman visitor. Every few moments she would spit into the brass spittoon.

When Inem had gone back to the kitchen Mother said, "It's not right to make children marry."

These words surprised Inem's mother. But she did not say anything nor did her eyes show any interest.

"I was eighteen when I got married," said Mother.

Inem's mother's surprise vanished. She was no longer surprised now, but she still did not say anything.

"It's not right to make children marry," repeated Mother.

And Inem's mother was surprised again.

"Their children will be stunted."

Inem's mother's surprise vanished once more.

"Yes, ma'am." Then she said placidly, "My mother was also eight when she got married."

Mother paid no attention and continued, "Not only will they be stunted, but their health will be affected too."

"Yes, ma'am, but ours is a long-lived family. My mother is still alive, though she's over fifty-nine. And my grandmother is still alive too. I think she must be seventy-four. She's still

vigorous and strong enough to pound corn in the mortar."

Still ignoring her, Mother went on, "Especially if the husband is also a child."

"Yes, ma'am, but Markaban is seventeen."

"Seventeen! My husband was thirty when he married me."

Inem's mother was silent. She never stopped shifting the wad of tobacco leaves that was stuck between her lips. One moment she would move the tobacco to the right, a moment later to the left, and the next moment she would roll it up and scrub her coal-black teeth with it.

Now Mother had no more arguments with which to oppose her visitor's intention. She said, "Well, if you've made up your mind to marry Inem off, I only hope that she gets a good husband who can take care of her. And I hope she gets someone who is compatible."

Inem's mother left, still shifting the tobacco about in her mouth.

"I hope nothing bad happens to that child."

"Why would anything bad happen to her?" I asked.

"Never mind, Muk, it's nothing." Then Mother changed the subject. "If the situation of their family improves, we won't lose any more of our chickens."

"Is somebody stealing our chickens, Mama?" I asked.

"No, Muk, never mind," Mother said slowly. "Such a little child! Only eight years old. What a pity it is. But they need money. And the only way to get it is to marry off their daughter."

Then Mother went to the garden behind the house to get some string beans for supper.

Fifteen days after this visit, Inem's mother came again to fetch her daughter. She seemed greatly pleased that Inem made no objection to being taken away. And when Inem was about to leave our house, never to be a member of our family again, she spoke to me in the kitchen doorway, "Well, good bye, Gus Muk. I'm going home, Gus Muk," she said very softly.

She always spoke softly. Speaking softly was one of the customary ways of showing politeness in our small-town society. She went off as joyfully as a child who expects to be given a new blouse.

34

From that moment, Inem no longer lived in our house. I felt very deeply the loss of my constant companion. From that moment also, it was no longer Inem who took me to the bathing cubicle at night to wash my feet before going to bed, but my adoptive older sister.

Sometimes I felt an intense longing to see Inem. Not infrequently, when I had got into bed, I would recall the moment when her mother drew her by the hand and the two of them left our house. Inem's house was in back of ours, separated only by a wooden fence.

She had been gone a month. I often went to her house to play with her, and Mother always got angry when she found out that I had been there. She would always say, "What can you learn at Inem's house that's of any use?"

And I would never reply. Mother always had a good reason for scolding me. Everything she said built a thick wall that was impenetrable to excuses. Therefore my best course was to be silent. And as the clinching argument in her lecture, she was almost certain to repeat the sentences that she uttered so often: "What's the point to your playing with her? Aren't there lots of other children you can ask to play with you? What's more, she's a woman who's going to be married soon."

But I kept on sneaking over to her house anyway. It is really surprising sometimes how a prohibition seems to exist solely in order to be violated. And when I disobeyed I felt that what I did was pleasurable. For children such as I at that time—oh, how many prohibitions and restrictions were heaped on our heads! Yes, it was as though the whole world was watching us, bent on forbidding whatever we did and whatever we wanted. Inevitably we children felt that this world was really intended only for adults.

Then the day of the wedding arrived.

For five days before the ceremony, Inem's family was busy in the kitchen, cooking food and preparing various delicacies. This made me visit her house all the more frequently.

The day before the wedding, Inem was dressed in all her finery. Mother sent me there with five kilos of rice and twenty-five cents as a neighborly contribution. And that afternoon we children crowded around and stared at her in admiration. The

hair over her forehead and temples and her eyebrows had been carefully trimmed with a razor and thickened with mascara. Her little bun of hair had been built up with a switch and adorned with the paper flowers with springs for stalks that we call *sunduk mentul.* Her clothes were made of satin. Her sarong was an expensive one made in Solo. These things had all been rented from a Chinaman in the Chinese quarter near the town square. The gold rings and bracelets were all rented too.

The house was decorated with constructions of banyan leaves and young coconut fronds. On each wall there were crossed tricolor flags encircled by palm leaves. All the house pillars were similarly decorated with tricolor bunting.

Mother herself went and helped with the preparations. But not for long. Mother rarely did this sort of thing except for her closest neighbors. She stayed less than an hour. And it was then too that the things sent by Inem's husband-to-be arrived: a load of cakes and candies, a male goat, a quantity of rice, a packet of salt, a sack of husked coconuts, and half a sack of granulated sugar.

It was just after the harvest. Rice was cheap. And when rice was cheap all other foodstuffs were cheap too. That was why the period after the harvest was a favorite time for celebrations. And for that reason Inem's family had found it impossible to contract for a puppet performance. The puppet masters had already been engaged by other families in various neighborhoods. The puppet theater was the most popular form of entertainment in our area. In our town there were three types of puppet performance: the *wajang purwa* or shadow play, which recounted stories from the *Mahabharata* and the *Ramayana,* as well as other stories similar in theme; the *wajang krutjil,* in which wooden puppets in human shape acted out stories of Arabia, Persia, India, and China, as well as tales of Madjapahit times; and the *wajang golek,* which employed wooden dolls. But this last was not very popular.

Because there were no puppet masters available, Inem's family engaged a troupe of dancing girls. At first this created a dispute. Inem's relatives on her mother's side were religious scholars and teachers. But Inem's father would not back down.

The dance troupe came, with its *gamelan* orchestra, and put on a *tajuban*.

Usually, in our area, a *tajuban* was attended by the men who wanted to dance with the girls and by little children who only wanted to watch—little children whose knowledge of sexual matters did not go beyond kissing. The grown boys did not like to watch; it embarrassed them. This was even more the case with the women—none of them attended at all. And a *tajuban* in our area—in order to inflame sexual passions—was always accompanied by alcoholic beverages: arrack, beer, whisky, or gin.

The *tajuban* lasted for two days and nights. We children took great delight in the spectacle of men and women dancing and kissing one another and every now and then clinking their glasses and drinking liquor as they danced and shouted, *"Huse!"*

And though Mother forbade me to watch, I went anyway on the sly.

"Why do you insist on going where those wicked people are? Look at your religious teacher: he doesn't go to watch, even though he is Inem's father's brother-in-law. You must have noticed that yourself."

Our religious teacher also had a house in back of ours, to the right of Inem's house. Subsequently the teacher's failure to attend became a topic that was sure to enliven a conversation. From it there arose two remarks that itched on the tip of everyone's tongue: that the teacher was certainly a pious man, and that Inem's father was undoubtedly a reprobate.

Mother reinforced her scolding with words that I did not understand at the time: "Do you know something? They are people who have no respect for women," she said in a piercing voice.

And when the bridegroom came to be formally presented to the bride, Inem, who had been sitting on the nuptial seat, was led forth. The bridegroom had reached the veranda. Inem squatted and made obeisance to her future husband, and then washed his feet with flower water from a brass pot. Then the couple were tied together and conducted side by side to the nuptial seat. At that time the onlookers could be heard saying,

"One child becomes two. One child becomes two. One child becomes two."

And the women who were watching beamed as though they were to be the recipients of the happiness to come.

At that very moment I noticed that Inem was crying so much that her make-up was spoiled, and tears were trickling down her pretty face. At home I asked Mother, "Why was the bride crying, Mama?"

"When a bride cries, it's because she is thinking of her long-departed ancestors. Their spirits also attend the ceremony. And they are happy that their descendant has been safely married," replied Mother.

I never gave any thought to those words of hers. Later I found out why Inem had been crying. She had to urinate, but was afraid to tell anyone.

The celebration ended uneventfully. There were no more guests coming with contributions. The house resumed its everyday appearance, and by the time the moneylenders came to collect, Inem's father had left Blora. After the wedding, Inem's mother and Inem herself went on doing batik work—day and night. And if someone went to their house at three o'clock in the morning, he would be likely to find them still working. Puffs of smoke would be rising between them from the crucible in which the wax was melted. In addition to that, quarreling was often heard in that house.

And once, when I was sleeping with Mother in her bed, a loud scream awakened me: "I won't! I won't!"

It was still night then. The screams were repeated again and again, accompanied by the sound of blows and pounding on a door. I knew that the screams came from Inem's mouth. I recognized her voice.

"Mama, why is Inem screaming?" I asked.

"They're fighting. I hope nothing bad happens to that little girl," she said. But she gave no explanation.

"Why would anything bad happen to her, Mama?" I asked insistently.

Mother did not reply to my question. And then, when the screaming and shouting were over, we went back to sleep.

Such screams were almost sure to be heard every night. Screams and screams. And every time I heard them, I would ask my mother about them. Mother would never give a satisfactory answer. Sometimes she merely sighed, "What a pity, such a little child!"

One day Inem came to our house. She went straight in to find my mother. Her face was pale and bloodless. Before saying anything, she set the tone of the occasion by crying —crying in a respectful way.

"Why are you crying, Inem? Have you been fighting again?" Mother asked.

"Ma'am," said Inem between her sobs, "I hope that you will be willing to take me back here as before."

"But you're married, aren't you, Inem?"

And Inem cried some more. Through her tears she said, "I can't stand it, ma'am."

"Why, Inem? Don't you like your husband?" asked Mother.

"Ma'am, please take pity on me. Every night all he wants to do is wrestle, ma'am."

"Can't you say to him, 'Please, dear, don't be like that'?"

"I'm afraid, ma'am. I'm afraid of him. He's so big. And when he wrestles he squeezes me so hard that I can't breathe. You'll take me back, won't you, ma'am?" she pleaded.

"If you didn't have a husband, Inem, of course I'd take you back. But you have a husband . . ."

And Inem cried again when she heard what Mother said. "Ma'am, I don't want to have a husband."

"You may not want to, but the fact is that you do, Inem. Maybe eventually your husband will change for the better, and the two of you will be able to live happily. You wanted to get married, didn't you?" said Mother.

"Yes, ma'am . . . but, but . . ."

"Inem, regardless of anything else, a woman must serve her husband faithfully. If you aren't a good wife to your husband, your ancestors will curse you," said Mother.

Inem began crying harder. And because of her crying she was unable to say anything.

"Now, Inem, promise me that you will always prepare

your husband's meals. When you have an idle moment, you should pray to God to keep him safe. You must promise to wash his clothes, and you must massage him when he is tired from his work. You must rub his back vigorously when he catches cold."

Inem still made no reply. Only her tears continued to fall.

"Well now, you go home, and from this moment on be a good wife to him. No matter whether he is good or bad, you must serve him faithfully, because after all he *is* your husband."

Inem, who was sitting on the floor, did not stir.

"Get up and go home to your husband. You . . . if you just up and quit your husband the consequences will not be good for you, either now or in the future," Mother added.

"Yes, ma'am," Inem said submissively. Slowly she rose and walked home.

"How sad, she's so little," said Mother.

"Mama, does daddy ever wrestle you?" I asked.

Mother looked searchingly into my eyes. Then her scrutiny relaxed. She smiled. "No," she said. "Your father is the best person in the whole world, Muk."

Then Mother went to the kitchen to get the hoe, and she worked in the garden with me.

A year passed imperceptibly. On a certain occasion Inem came again. In the course of a year she had grown much bigger. It was quite apparent that she was mature, although only nine years old. As usual, she went directly to where Mother was and sat on the floor with her head bowed. She said, "Ma'am, now I don't have a husband any more."

"What?"

"Now I don't have a husband any more."

"You're divorced?" asked Mother.

"Yes, ma'am."

"Why did you separate from him?"

She did not reply.

"Did you fail to be a good wife to him?"

"I think I was always a good wife to him, ma'am."

"Did you massage him when he came home tired from work?" asked Mother probingly.

"Yes, ma'am, I did everything you advised me to."

"Well then, why did you separate?"

"Ma'am, he often beat me."

"Beat you? He beat a little child like you?"

"I did everything I could to be a good wife, ma'am. And when he beat me and I was in pain—was that part of being a good wife, ma'am?" she asked, in genuine perplexity.

Mother was silent. Her eyes scrutinized Inem. "He beat you," Mother whispered then.

"Yes, ma'am—he beat me just the way Mama and Papa do."

"Maybe you failed in some way after all in your duty to him. A husband would never have the heart to beat a wife who was really and truly a good wife to him."

Inem did not reply. She changed the subject: "Would you be willing to take me back, ma'am?"

There was no hesitation in Mother's reply. She said firmly, "Inem, you're a divorced woman now. There are lots of grown boys here. It wouldn't look right to people, would it?"

"But they wouldn't beat me," said the divorcee.

"No. That isn't what I mean. It just doesn't look right for a divorced woman as young as you to be in a place where there are lots of men."

"Is that because there's something wrong with me, ma'am?"

"No, Inem, it's a question of propriety."

"Propriety, ma'am? It's for the sake of propriety that I can't stay here?"

"Yes, that's the way it is, Inem."

The divorcee did not say anything more. She remained sitting on the floor, and seemed to have no intention of leaving the place where she was sitting. Mother went up to her and patted her shoulder consolingly. "Now, Inem . . . the best thing is for you to help your parents earn a living. I really regret that I can't take you back here."

Two tears formed in the corners of the little woman's eyes. She got up. Listlessly she moved her feet, leaving our house to return to her parents' house. And from then on she was seldom seen outside her house.

And thereafter, the nine-year-old divorcee—since she was

nothing but a burden to her family—could be beaten by anyone who wanted to: her mother, her brothers, her uncles, her neighbors, her aunts. Yet Inem never again came to our house.

Her screams of pain were often heard. When she moaned, I covered my ears with my hands. And Mother continued to uphold the respectability of her home.

FOR DISCUSSION

1. Why couldn't the injustices done to Inem be stopped? Why does the narrator's mother first object to Inem's marriage, then respond by sending her back to her husband when she asks for help? What is the irony of the story's last sentence?

2. How do you feel about this story? How would you have reacted if you were Inem?

3. It's a question of "propriety," or proper behavior and manners. Who decides what propriety is? How important do you think it is to uphold it? If you are living in a society, do you have to uphold its customs as well as its laws? What are the consequences of living outside the social customs of your people?

ACTIVITY

In what areas of the world are women treated as Inem was? What is the status of women of lower caste in India today?

INTRODUCTION

The following selection is from Joyce Maynard's *Looking Back: A Chronicle of Growing Up Old in the Sixties.* She tells about the experiences and environment that brought about the loss of her childhood innocence. In this section of the book she discusses the importance to a girl of being pretty in the culture she grew up in. She admits that her opinions and sometimes even her facts come from the beliefs of the majority of people.

from Looking Back: A Chronicle of Growing Up Old in the Sixties

Joyce Maynard

For a time, a longish time, it seemed to be a pattern in my life that the boys who liked me were not the ones I cared about. It was never the student council members and the sports stars who asked me to dance (the kinds of boys I wanted, more than to be with, to be seen with, boys whose acceptance of me would, I felt, make me acceptable). Instead, I had the impression, and a fairly elaborate one, that I was attracting a whole series of school misfits like me, boys whose own out-ness reminded me of mine. If they danced awkwardly—and they did—it was not the stiff, cool awkwardness of a basketball player who can't afford to look too ballet-graceful, but the awkwardness of the boys who strike out in baseball and finish last, panting, in races. Looking back, it seems to me that my partners invariably danced with their mouths open. I can still see them loping across the dance floor to get me, presumably eager to lay sweaty palms on my organdy and velvet, bought for other, dryer hands.

I hated them, these misfits, for how alike we were. Seeing them, I imagined how I must have looked. I criticized them most of all for their taste in girls. For anyone I liked to like me back would make me like him less. Their having chosen me only went to show what losers they were.

It wasn't that I didn't have a pretty exalted opinion of myself—I did. The fact that I wasn't wildly popular puzzled me for a long time. I decided that we weren't seeing the same person—me, when I looked in the mirror, and the boys who said "Hey, did you get the license number of the tractor that ran over your face?" They convinced me finally that it must be so; if I wasn't ugly, I was at least different, odd-looking, and that was maybe even worse. Mine was not the kind of face that reminds people of faces on TV. And it was those smoothly smiling faces that were my models. My face impressed me, not at all favorably, as untypical; I fell far short, I thought, of prettiness, and no amount of experimenting with clothes or hair styles or eyeshadow colors (each one just the barest fraction of a shade different from the last) could turn me into Gidget.

I grew up—we all did—to value the consensus. (What sex is the baby rabbit? Let's take a vote . . .) My eye is trained not to aesthetic absolutes but to the culturally accepted thing. (Are shaven legs and plucked eyebrows really more beautiful, or is it just the habit of seeing them that way which makes me think they are?) My taste is no longer my own—that much I know. I'm not a rider of bandwagons, quite, but, much as I try to disregard them, to think for myself, the opinions of other people matter to me. I liked the kind of faces I saw in magazines, the kind of boys who were well-liked by all, and while I didn't torment the ones many people made fun of, secretly I thought less of them for having failed to win majority approval. I thought less of myself too, for my own lack of popularity with boys, and so I scorned the boys who failed to scorn me because they liked a face I didn't like, myself.

Why do looks *matter* so much?

I do not know a single girl who's really satisfied with how she looks. Some toss their hair and smooth their skirts and stride like models, and I'll start out envying them and mentally

exchanging faces or shapes or hair color, but then I'll watch them looking at other girls as *they* stride by tossing *their* hair, and I'll see, in the faces I admired, the same sizing-up look that's on mine (How much does she weigh? Does she color her hair? Curl her eyelashes?) and realize that not one of us feels really *safe*. I study my reflection in every full-length mirror and window and shiny toaster I pass (less from sheer vanity, I think, than from insecurity, a dissatisfaction about the way I look) and when I do examine myself, I almost always see, reflected next to me, another insecure, dissatisfied girl doing the same thing. We put on our mirror expressions and glance hurriedly—sidelong, out of guilt—jumping a little when discovered, bent over the sink in a department store ladies' room, miming before the mirror. What we do before mirrors is an intensely private act. We are examining and repairing the illusions we're attempting to maintain (that *we* don't care about our looks, that how we look when we look good is just a lucky accident) and to be caught in mid-repair destroys the illusion. Like bald men discovered with their toupees off, women viewed early in the morning or at work before a mirror feel they can never regain, in the eyes of those who see them—*before*—the image of how they look *after*.

Why do we feel like unwelcome strangers in our own skins? I change clothes half a dozen times a day when I feel at my worst, leaving pools of discarded costumes on the floor, arranging myself in Outfit Number Nine, until, at last, I'm reasonably pleased with how I look and then, catching my image in a window two hours later, I find my shakily assembled image has disappeared—I must change again. I long for a face that I can count on; I'd like to have eyes that are never puffy, a skin that's uniformly olive (not sallow, never sallow), hair that bounces and emerges from convertibles and bike rides looking artfully tousled instead of just plain lousy. It isn't necessarily beauty I covet, but dependable attractiveness, a face I can catch off guard and be happy at the sight of.

When I talk about it, all this must sound like a casebook neurosis, but I think it's too commonplace to be labeled an abnormality. It's our culture that has put a premium on good looks—all the clothes designers and hairdressers and depart-

ment store buyers and magazine editors, all aware, at least subconsciously, that we—women—will suddenly and at long last escape the tyranny of fashions on the very day we wholeheartedly *like* the way we look. While constantly creating more products to help us reach that point, they have managed to keep it always slightly beyond us. Just getting to a state of fashionable attractiveness is hard enough because fashions change so quickly. Staying there is impossible. A newer, better model is always around the corner—built-in obsolescence—so that, no sooner do we buy a pair of suede hotpants, satisfying one season's requirements, than another more pressing need is created (a patchwork skirt, an Argyle vest . . .). Our insecurity is what the beauty industry depends on and encourages—the constant, one-step-behind limbo we live in where each purchase, each haircut, each diet is undertaken in the hopes that it will bring us to some stable point where we can look in the mirror and smile. Sometimes, of course, we do. Never for very long. Pretty soon someone even better-looking passes by on the street, or on the TV screen or in a magazine, and the quest is on again.

Early on, magazines brought out the worst in me—greed and jealousy, wild competition. In *Seventeen* the clothes and make-up and the hairstyles fascinated me, but what really held me to the page was the models. In *Vogue* and *Glamour* they are anonymous, so the envy is at least targetless, generalized. But *Seventeen* models were, like the characters in monthly serials, old friends and sometimes enemies. We knew their names, their beauty problems ("Lucy's skin is oily, so she scrubs nightly with astringent soap and steams her face for that extra zing . . ."), their dieting secrets, their special touches. (Colleen would be "an individualist" one month, with a flower painted on her cheek or a tiny gold bracelet around the ankle. Next month we'd all be sporting ankle chains and cheek flowers.) What we remembered from the ads they posed in was not the brand of clothes they wore but what the girls who wore them looked like. I'd notice when a model had gained weight or when her stock seemed to be going down, when she was no longer one of the girls the magazine was on a first-name basis with, and—secretly, of course—these failures pleased me.

Perhaps that's what the magazines depend on—our cattiness and envy and our less-than-entirely joyful reaction to New York-style model beauty. We buy the magazine, study the models, to study the competition. Then if we like the way they look and, most important, feel envy, maybe we'll buy their outfits too.

It's not true of just me, I think, but of nearly every sixties-bred girl, that no matter how bright or scholarly or talented or generally contented with her life she may be, she'll have some hidden weakness when it comes to models and modeling. To be loved for nothing but our looks, to make a living simply out of *being*, to be graceful and sweatless, cool and fashionable and most of all, looked at by other girls and envied—that is the hidden dream. The world is full of teen-age girls who long to model—short, plump, acne-scarred *Seventeen* readers who balance books on their heads behind closed doors or vamp in front of three-way mirrors, mouth slightly open, stomach forward, slouching, Twiggy style, toes in, knees knocking. Whatever our official goals, whatever we write on college applications, whatever we tell our parents that we plan to be when we grow up, the dream of modeling remains.

I went once to an agency, naïvely answering a want ad in the paper ("Glamorous modeling career?"). I was sixteen then, and my relatives had always told me "you could be a model." As soon as I arrived at the agency I saw I'd made a mistake, of course—all glass and chrome, with glossy pictures on all sides and deep shag rugs and a beautiful secretary (if *she* hadn't even made it as a model . . .) with one of the English, Carnaby Street accents that were so fashionable then. I had my interview anyway—a humiliating examination that made me feel ashamed of my presumptuousness to think, for even a moment, that I could be a model. I sensed, worse than contempt, my bell-bottomed, blue-booted interviewer's amusement. The agency's gambit was clear then—I'd pay them for a charm course and a set of photographs and for the privilege of being managed by them. I'd gone from employee to employer, with dazzling suddenness—asked to pay for their services as aging women hire gigolos.

So I abandoned my short-lived modeling career. I feel re-

sentment still, slipping through fashion magazines, although I buy them all and never miss an issue. Love-hate is what it amounts to, I guess, and a little self-flagellation. My comfort lies in the knowledge that fashion models, like fashions, go out of style. The crop I grew up with has almost turned over—*Vogue* models live forever, sometimes, but *Seventeen* cover girls go on to modeling nurse's uniforms and pantsuits in Sears catalogues. I know their faces and their wig collections well—Terry and Cheryl, from my earliest days, then Lucy and Colleen, Twiggy, of course, Mona and Cybill. I wait in mean, small-minded anticipation for their mid-twenties. I haven't really conquered my envy, I've only passed it on from one set of smooth faces to another. All of which is a pretty sad and unliberated commentary on female nature (or, more likely, on our conditioning).

I can't quite bring myself to throw out my back issues of *Seventeen* magazine—every copy, since 1965, so worn sometimes, especially the fat August issues, full of back-to-school fashions and back-to-school hopes that This Year Will Be Different; beauty make-overs, exercises, tips for shiny teeth (rub them with Vaseline). I should want to be rid of them; they are what enslaved me to the conventions of fashion, what made me miserable about how I looked. Their pages were always full of clothes I couldn't afford and helpful hints that never really worked. (Talcum powder on the eyelashes—to make them look thicker—was gilding for a lily, not a dandelion.) Cucumbers over the eyes, lemon in the hair, face exercises to be done watching TV—I tried them all, rushing to the mirror when the miracle operations had been performed, expecting changes and finding only cucumber seeds stuck to my cheek and sticky, lemon-smelling hair no lighter than before.

My nights, from fifth grade through the ninth, were spent not so much sleeping as waiting for my hair to curl. I slept on plastic rollers and metal clips, in pincurls that left my hair squared off like wire, in hair nets and hair sprays and setting gels and conditioning oils, propped up on three pillows because the curlers hurt so much, or with my head turban-wrapped in toilet paper. I went through half a roll a night. Every morning

I'd wake up with dark circles left under my eyes from a troubled half-sleep spent dreaming strange, curler-induced nightmares. I'd run to the mirror, when I woke, to unveil myself, never prepared—not even after all the other failed mornings when my efforts yielded only limp strands (or—worse—tight, greasy ringlets that would not come out)—for a new disaster. Then I'd rip off the curls I'd stuck, with Scotch tape, to my face, arranging my hair so the red splotches left on my cheeks from the tape wouldn't show, and tease my hair, when teasing was still done, so the back of my skull looked enormous. It amazes me now to think that all those ugly styles I wore looked good to me back then. Will what I'm wearing now seem just as strange ten years from now, I wonder?

I was a slave to fashion—chopping off my hair one year to look like Twiggy, sweltering under a Dynel wig the year wigs were being worn, disappearing altogether for a while beneath an eye-obstructing curtain of bangs. Even when straight hair became fashionable, when girls slept on tin cans and ironed out their curls and when, presumably, I should have felt free to be myself, I felt, instead, the need to change my hair some other way—to alter the color or the length, to bleach a racing stripe down one side or tint it some other shade of brown, no better, maybe, but *different.* I grew up a believer in variety above all else, in quantity over quality, in "change of pace" (I heard that in a Lipton tea commercial and it stayed with me). No matter what you looked like, the way to improve your looks, I believed, was to change them. All through the sixties I fought nature, wore my face like a mask, my clothes like armor and my hair that pinned, clipped, rolled, taped, teased, washed, set, sprayed mass, meant to hang straight forever—I wore it like a hat.

Oh, the money that went into make-up. We never bought the cheap Woolworth's stuff, my friends and I, because you don't skimp on Beauty, and the more expensive the make-up, the better it must be. Mostly we paid for the packaging: blusher (that was 1960s talk for the unthinkable—rouge) in a tiny thumb-sized compact with a little swivel-out brush attached with a chain; false eyelashes that we never really wore

except in the bathroom, packed in pastel carrying cases; lip glosses arranged like paints in a water-color box; face powder with silver sparkles; cheekbone contour brushes to give us the emaciated look. Lipsticks sometimes came in flowerpots and doll shapes (that's what they were—toys, finger paints you applied to skin instead of paper). Eyeshadow swung in colored globes and psychedelic buckets from the belts in our hip-hugger bell bottoms.

Make-up was joyously synthetic back then, before the natural look, before organic skin creams and lipsticks whose aim was to be invisible and ads for "down to earth" cosmetics filled with genuine Arizona mud. It was the era of fads, white lips and rainbow eyelids and, for one brief period, an idea that never caught on—body painting. Yardley sold (or didn't sell, but tried to) buckets of purple, pink, orange and green paint and rollers to apply it with—to legs (instead of stockings) and arms (instead of sleeves) and even faces. No one at my school wore it because along with the desire to be the first one, to get noticed, we were all afraid of going too far, and we stood for hours in front of the mirror, making sure that our see-through blouses (with strategically placed pockets) didn't show too much, agonizing over the exposure of a garter or a slip. ("Your slip is showing"—that dread whisper—always seemed a bit silly to me, when one of the big fashion fads of that year was dresses with matching bloomer-pantalets whose ruffle trailed at least an inch below the hem.) Those were loud, unsubtle, get-attention days, when wild and crazy and eye-catching meant fashionable.

FOR DISCUSSION

1. Maynard's description of her feelings about the misfits she danced with is an example of *projection*. That is, she sees in them parts of herself that she hates. What is the set of standards against which she is comparing herself and the other misfits?

2. Why *do* we feel like "unwelcome strangers in our own skins"? Or do you? Where do you get your own information about and standards of personal appearance? What

are the results for society, for business, and for women of the intense interest women take in personal appearance? How do the advantages compare to the disadvantages?

ACTIVITIES

1. Make a list of the people, institutions, organizations, traditions, and customs that have had a heavy influence on you. Then make another list of your own attitudes, traits, habits, and beliefs. Try to become aware of where each one comes from.

2. Do a study of women on television. What are the qualities they most commonly have? What kinds of jobs do they have? What is the level of their intelligence? What are they supposed to be most concerned about? Are most of the women you see "real"?

INTRODUCTION

Becoming a woman can involve watching someone older who is close to you become a woman. In "Like That," for example, Carson McCullers looks at growing up from the point of view of a young girl who sees the physical and emotional changes her eighteen-year-old sister is undergoing. For the younger girl, her sister's new life seems very strange. Apparently, there has been much silence in the family about sex, so that the different problems of appearing "feminine," starting menstruation, and beginning to go out with boys are all lumped together for the narrator into one greatly feared unknown. She sees her sister as a kind of captive princess in a fairy tale. And perhaps her sister is, to a certain degree, a prisoner of the special role given to women. The narrator doesn't ever want to be "like that."

Like That

Carson McCullers

Even if Sis is five years older than me and eighteen we used always to be closer and have more fun together than most sisters. It was about the same with us and our brother Dan, too. In the summer we'd all go swimming together. At nights in the wintertime maybe we'd sit around the fire in the living room and play three-handed bridge or Michigan, with everybody putting up a nickel or a dime to the winner. The three of us could have more fun by ourselves than any family I know. That's the way it always was before this.

Not that Sis was playing down to me, either. She's smart as she can be and has read more books than anybody I ever knew—even school teachers. But in High School she never did like to priss up flirty and ride around in cars with girls and pick up the boys and park at the drug store and all that sort of

thing. When she wasn't reading she'd just like to play around with me and Dan. She wasn't too grown up to fuss over a chocolate bar in the refrigerator or to stay awake most of Christmas Eve night either, say, with excitement. In some ways it was like I was heaps older than her. Even when Tuck started coming around last summer I'd sometimes have to tell her she shouldn't wear ankle socks because they might go downtown or she ought to pluck out her eyebrows above her nose like the other girls do.

In one more year, next June, Tuck'll be graduated from college. He's a lanky boy with an eager look to his face. At college he's so smart he has a free scholarship. He started coming to see Sis the last summer before this one, riding in his family's car when he could get it, wearing crispy white linen suits. He came a lot last year but this summer he came even more often—before he left he was coming around for Sis every night. Tuck's O.K.

It began getting different between Sis and me a while back, I guess, although I didn't notice it at the time. It was only after a certain night this summer that I had the idea that things maybe were bound to end like they are now.

It was late when I woke up that night. When I opened my eyes I thought for a minute it must be about dawn and I was scared when I saw Sis wasn't on her side of the bed. But it was only the moonlight that shone cool looking and white outside the window and made the oak leaves hanging down over the front yard pitch black and separate seeming. It was around the first of September, but I didn't feel hot looking at the moonlight. I pulled the sheet over me and let my eyes roam around the black shapes of the furniture in our room.

I'd waked up lots of times in the night this summer. You see Sis and I have always had this room together and when she would come in and turn on the light to find her nightgown or something it woke me. I liked it. In the summer when school was out I didn't have to get up early in the morning. We would lie and talk sometimes for a good while. I'd like to hear about the places she and Tuck had been or to laugh over different things. Lots of times before that night she had talked to me privately about Tuck just like I was her age—asking me if I

thought she should have said this or that when he called and giving me a hug, maybe, after. Sis was really crazy about Tuck. Once she said to me: "He's so lovely—I never in the world thought I'd know anyone like him—"

We would talk about our brother too. Dan's seventeen years old and was planning to take the co-op course at Tech in the fall. Dan had gotten older by this summer. One night he came in at four o'clock and he'd been drinking. Dad sure had it in for him the next week. So he hiked out to the country and camped with some boys for a few days. He used to talk to me and Sis about Diesel motors and going away to South America and all that, but by this summer he was quiet and not saying much to anybody in the family. Dan's real tall and thin as a rail. He has bumps on his face now and is clumsy and not very good looking. At nights sometimes I know he wanders all around by himself, maybe going out beyond the city limits sign into the pine woods.

Thinking about such things I lay in bed wondering what time it was and when Sis would be in. That night after Sis and Dan had left I had gone down to the corner with some of the kids in the neighborhood to chunk rocks at the street light and try to kill a bat up there. At first I had the shivers and imagined it was a smallish bat like the kind in Dracula. When I saw it looked just like a moth I didn't care if they killed it or not. I was just sitting there on the curb drawing with a stick on the dusty street when Sis and Tuck rode by slowly in his car. She was sitting over very close to him. They weren't talking or smiling—just riding slowly down the street, sitting close, looking ahead. When they passed and I saw who it was I hollered to them. "Hey, Sis!" I yelled.

The car just went on slowly and nobody hollered back. I just stood there in the middle of the street feeling sort of silly with all the other kids standing around.

That hateful little old Bubber from down on the other block came up to me. "That your sister?" he asked.

I said yes.

"She sure was sitting up close to her beau," he said.

I was mad all over like I get sometimes. I hauled off and chunked all the rocks in my hand right at him. He's three years younger than me and it wasn't nice, but I couldn't stand him in

the first place and he thought he was being so cute about Sis. He started holding his neck and bellering and I walked off and left them and went home and got ready to go to bed.

When I woke up I finally began to think of that too and old Bubber Davis was still in my mind when I heard the sound of a car coming up the block. Our room faces the street with only a short front yard between. You can see and hear everything from the sidewalk and the street. The car was creeping down in front of our walk and the light went slow and white along the walls of the room. It stopped on Sis's writing desk, showed up the books there plainly and half a pack of chewing gum. Then the room was dark and there was only the moonlight outside.

The door of the car didn't open but I could hear them talking. Him, that is. His voice was low and I couldn't catch any words but it was like he was explaining something over and over again. I never heard Sis say a word.

I was still awake when I heard the car door open. I heard her say, "Don't come out." And then the door slammed and there was the sound of her heels clopping up the walk, fast and light like she was running.

Mama met Sis in the hall outside her room. She had heard the front door close. She always listens out for Sis and Dan and never goes to sleep when they're still out. I sometimes wonder how she can just lie there in the dark for hours without going to sleep.

"It's one-thirty, Marian," she said. "You ought to get in before this."

Sis didn't say anything.

"Did you have a nice time?"

That's the way Mama is. I could imagine her standing there with her nightgown blowing out fat around her and her dead white legs and the blue veins showing, looking all messed up. Mama's nicer when she's dressed to go out.

"Yes, we had a grand time," Sis said. Her voice was funny—sort of like the piano in the gym at school, high and sharp on your ear. Funny.

Mama was asking more questions. Where did they go? Did they see anybody they knew? All that sort of stuff. That's the way she is.

"Goodnight," said Sis in that out of tune voice.

She opened the door of our room real quick and closed it. I started to let her know I was awake but changed my mind. Her breathing was quick and loud in the dark and she did not move at all. After a few minutes she felt in the closet for her nightgown and got in the bed. I could hear her crying.

"Did you and Tuck have a fuss?" I asked.

"No," she answered. Then she seemed to change her mind. "Yeah, it was a fuss."

There's one thing that gives me the creeps sure enough— and that's to hear somebody cry. "I wouldn't let it bother me. You'll be making up tomorrow."

The moon was coming in the window and I could see her moving her jaw from one side to the other and staring up at the ceiling. I watched her for a long time. The moonlight was cool looking and there was a wettish wind coming cool from the window. I moved over like I sometimes do to snug up with her, thinking maybe that would stop her from moving her jaw like that and crying.

She was trembling all over. When I got close to her she jumped like I'd pinched her and pushed me over quick and kicked my legs over. "Don't," she said. "Don't."

Maybe Sis had suddenly gone batty, I was thinking. She was crying in a slower and sharper way. I was a little scared and I got up to go to the bathroom a minute. While I was in there I looked out the window, down toward the corner where the street light is. I saw something then that I knew Sis would want to know about.

"You know what?" I asked when I was back in the bed.

She was lying over close to the edge as she could get, stiff. She didn't answer.

"Tuck's car is parked down by the street light. Just drawn up to the curb. I could tell because of the box and the two tires on the back. I could see it from the bathroom window."

She didn't even move.

"He must be just sitting out there. What ails you and him?"

She didn't say anything at all.

"I couldn't see him but he's probably just sitting there in the car under the street light. Just sitting there."

It was like she didn't care or had known it all along. She was as far over the edge of the bed as she could get, her legs stretched out stiff and her hands holding tight to the edge and her face on one arm.

She used always to sleep all sprawled over on my side so I'd have to push at her when it was hot and sometimes turn on the light and draw the line down the middle and show her how she really was on my side. I wouldn't have to draw any line that night, I was thinking. I felt bad. I looked out at the moonlight a long time before I could get to sleep again.

The next day was Sunday and Mama and Dad went in the morning to church because it was the anniversary of the day my aunt died. Sis said she didn't feel well and stayed in bed. Dan was out and I was there by myself so naturally I went into our room where Sis was. Her face was white as the pillow and there were circles under her eyes. There was a muscle jumping on one side of her jaw like she was chewing. She hadn't combed her hair and it flopped over the pillow, glinty red and messy and pretty. She was reading with a book held up close to her face. Her eyes didn't move when I came in. I don't think they even moved across the page.

It was roasting hot that morning. The sun made everything blazing outside so that it hurt your eyes to look. Our room was so hot that you could almost touch the air with your finger. But Sis had the sheet pulled up clear to her shoulders.

"Is Tuck coming today?" I asked. I was trying to say something that would make her look more cheerful.

"Gosh! Can't a person have *any* peace in this house?"

She never did used to say mean things like that out of a clear sky. Mean things, maybe, but not grouchy ones.

"Sure," I said. "Nobody's going to notice you."

I sat down and pretended to read. When footsteps passed on the street Sis would hold onto the book tighter and I knew she was listening hard as she could. I can tell between footsteps easy. I can even tell without looking if the person who passes is colored or not. Colored people mostly make a slurry sound between the steps. When the steps would pass Sis would loosen the hold on the book and bite at her mouth. It was the same way with passing cars.

I felt sorry for Sis. I decided then and there that I never would let any fuss with any boy make me feel or look like that. But I wanted Sis and me to get back like we'd always been. Sunday mornings are bad enough without having any other trouble.

"We fuss lots less than most sisters do," I said. "And when we do it's all over quick, isn't it?"

She mumbled and kept staring at the same spot on the book.

"That's one good thing," I said.

She was moving her head slightly from side to side—over and over again, with her face not changing. "We never do have any real long fusses like Bubber Davis's two sisters have—"

"No." She answered like she wasn't thinking about what I'd said.

"Not one real one like that since I can remember."

In a minute she looked up the first time. "I remember one," she said suddenly.

"When?"

Her eyes looked green in the blackness under them and like they were nailing themselves into what they saw. "You had to stay in every afternoon for a week. It was a long time ago."

All of a sudden I remembered. I'd forgotten it for a long time. I hadn't wanted to remember. When she said that it came back to me all complete.

It was really a long time ago—when Sis was about thirteen. If I remember right I was mean and even more hardboiled than I am now. My aunt who I'd liked better than all my other aunts put together had had a dead baby and she had died. After the funeral Mama had told Sis and me about it. Always the things I've learned new and didn't like have made me mad—mad clean through and scared.

That wasn't what Sis was talking about, though. It was a few mornings after that when Sis started with what every big girl has each month, and of course I found out and was scared to death. Mama then explained to me about it and what she had to wear. I felt then like I'd felt about my aunt, only ten times worse. I felt different toward Sis, too, and was so mad I wanted to pitch into people and hit.

I never will forget it. Sis was standing in our room before the dresser mirror. When I remembered her face it was white like Sis's there on the pillow and with the circles under her eyes and the glinty hair to her shoulders—it was only younger.

I was sitting on the bed, biting hard at my knee. "It shows," I said. "It does too!"

She had on a sweater and a blue pleated skirt and she was so skinny all over that it did show a little.

"Anybody can tell. Right off the bat. Just to look at you anybody can tell."

Her face was white in the mirror and did not move.

"It looks terrible. I wouldn't ever ever be like that. It shows and everything."

She started crying then and told Mother and said she wasn't going back to school and such. She cried a long time. That's how ugly and hardboiled I used to be and am still sometimes. That's why I had to stay in the house every afternoon for a week a long time ago . . .

Tuck came by in his car that Sunday morning before dinner time. Sis got up and dressed in a hurry and didn't even put on any lipstick. She said they were going out to dinner. Nearly every Sunday all of us in the family stay together all day, so that was a little funny. They didn't get home until almost dark. The rest of us were sitting on the front porch drinking ice tea because of the heat when the car drove up again. After they got out of the car Dad, who had been in a very good mood all day, insisted Tuck stay for a glass of tea.

Tuck sat on the swing with Sis and he didn't lean back and his heels didn't rest on the floor—as though he was all ready to get up again. He kept changing the glass from one hand to the other and starting new conversations. He and Sis didn't look at each other except on the sly, and then it wasn't at all like they were crazy about each other. It was a funny look. Almost like they were afraid of something. Tuck left soon.

"Come sit by your Dad a minute, Puss," Dad said. Puss is a nickname he calls Sis when he feels in a specially good mood. He still likes to pet us.

She went and sat on the arm of his chair. She sat stiff like Tuck had, holding herself off a little so Dad's arm hardly went around her waist. Dad smoked his cigar and looked out on the

front yard and the trees that were beginning to melt into the early dark.

"How's my big girl getting along these days?" Dad still likes to hug us up when he feels good and treat us, even Sis, like kids.

"O.K.," she said. She twisted a little bit like she wanted to get up and didn't know how to without hurting his feelings.

"You and Tuck have had a nice time together this summer, haven't you, Puss?"

"Yeah," she said. She had begun to see-saw her lower jaw again. I wanted to say something but couldn't think of anything.

Dad said: "He ought to be getting back to Tech about now, oughtn't he? When's he leaving?"

"Less than a week," she said. She got up so quick that she knocked Dad's cigar out of his fingers. She didn't even pick it up but flounced on through the front door. I could hear her half running to our room and the sound the door made when she shut it. I knew she was going to cry.

It was hotter than ever. The lawn was beginning to grow dark and the locusts were droning out so shrill and steady that you wouldn't notice them unless you thought to. The sky was bluish gray and the trees in the vacant lot across the street were dark. I kept sitting on the front porch with Mama and Papa and hearing their low talk without listening to the words. I wanted to go in our room with Sis but I was afraid to. I wanted to ask her what was really the matter. Was hers and Tuck's fuss so bad as that or was it that she was so crazy about him that she was sad because he was leaving? For a minute I didn't think it was either one of those things. I wanted to know but I was scared to ask. I just sat there with the grown people. I never have been so lonesome as I was that night. If ever I think about being sad I just remember how it was then—sitting there looking at the long bluish shadows across the lawn and feeling like I was the only child left in the family and that Sis and Dan were dead or gone for good.

It's October now and the sun shines bright and a little cool and the sky is the color of my turquoise ring. Dan's gone to Tech. So has Tuck gone. It's not at all like it was last fall,

though. I come in from High School (I go there now) and Sis maybe is just sitting by the window or writing to Tuck or just looking out. Sis is thinner and sometimes to me she looks in the face like a grown person. Or like, in a way, something has suddenly hurt her hard. We don't do any of the things we used to. It's good weather for fudge or for doing so many things. But no she just sits around or goes for long walks in the chilly late afternoon by herself. Sometimes she'll smile in a way that really gripes—like I was such a kid and all. Sometimes I want to cry or to hit her.

But I'm hardboiled as the next person. I can get along by myself if Sis or anybody else wants to. I'm glad I'm thirteen and still wear socks and can do what I please. I don't want to be any older if I'd get like Sis has. But I wouldn't. I wouldn't like any boy in the world as much as she does Tuck. I'd never let any boy or any thing make me act like she does. I'm not going to waste my time and try to make Sis be like she used to be. I get lonesome—sure—but I don't care. I know there's no way I can make myself stay thirteen all my life, but I know I'd never let anything really change me at all—no matter what it is.

I skate and ride my bike and go to the school football games every Friday. But when one afternoon the kids all got quiet in the gym basement and then started telling certain things—about being married and all—I got up quick so I wouldn't hear and went up and played basketball. And when some of the kids said they were going to start wearing lipstick and stockings I said I wouldn't for a hundred dollars.

You see I'd never be like Sis is now. I wouldn't. Anybody could know that if they knew me. I just wouldn't, that's all. I don't want to grow up—if it's like that.

FOR DISCUSSION

1. How do you explain the narrator's concern for her sister? How would the story be different if the sister told it? To what degree do you think the sister really is a captive of her culture's attitudes toward women? Is the story out-

dated in showing such anxiety and ignorance about sex on the part of the narrator?

2. What do you think the role of early and matter-of-fact sex education is in making growing up easier?

3. What do you think the role of myth is in setting women apart as a result of the physical changes they go through related to the cycles of ovulation and menstruation? What are the myths? What are the facts? Are there any connections between physical and emotional conditions?

ACTIVITIES

1. Find out how different cultures provide for the entrance of girls into young womanhood.

2. Look into the way women appear in fairy tales and myths. What are their typical roles? What are they like emotionally?

3. Invite the school nurse or physician to come into your class and discuss sex education for young children. Find out what is being done to eliminate mystery. Are girls and boys given the same facts?

INTRODUCTION

Poets have the gift of finding images in nature and of stating great truths in a few words. In the following poem, the action of a strong wind tossing about a tumbleweed represents the many forces pressing on an individual. However hard the individual tries to go with the wind, the wind has a destination of its own somewhere beyond. The poet suggests that it would be better for a young person to have some inward goals, safe from all the opposing winds that blow.

Tumbleweed

Ramona Garden

I stood in the shelter of a great tree,
Hiding from the wind that galloped over the land.
Robbing, and wrecking, and scattering. It soared.
I was earth bound.
It tugged at the leaves, 5
At the grass, at things not tied.
At me.
Urging, pulling, laughing in my ear.
I listened but stood.
Flitting away, it spied a tumbleweed 10
and coaxed it from its roots.
The brown weed soared
and became part of the wind.
Suddenly, with a wild yearning,
I ran stumbling, with arms outstretched. 15
It flew on beyond me.
It stopped.
The wind flew around me,
Leaving me there.

FOR DISCUSSION

1. Does the fact that the writer is a Native American woman give the poem any special meaning for you?
2. Have you ever felt like a tumbleweed? Try to write a poem or some descriptive or narrative prose that shows what it's like to be in conflict about some part of growing up.

INTRODUCTION

Althea Gibson won the women's singles title at Wimbledon in 1957. She had come a great distance from her childhood, during which she had been urged to settle down and become a lady. But she was too busy playing ball and settling arguments with her fists to do so. Her family encouraged her to follow her interest in sports. She never let the inactivity and gentleness expected of young women get in the way of her goals. The "becoming" of Althea Gibson resulted from her ability to choose the parts of femininity that made sense to her and to reject those that didn't complement an active life.

adapted from I Always Wanted to Be Somebody

Althea Gibson

Althea was all those things nice little girls are not supposed to be: rough, tough and athletic. She could fight like a champ and shoot baskets like a pro by the time she was thirteen. If she had been a boy, everyone would have considered her a daredevil. But girls are usually not praised for being big and strong—are not encouraged to compete and win. So people made fun of Althea's rugged manner and called her a "tomboy."

It hurt Althea when people made fun of her for doing what she did best and most naturally. She has this to say about her athletic ability:

> "Look at her throwing that ball just like a man," they would say, and they looked at me like I was a freak. I hated them for it. I felt as though they ought to see that I didn't do the things they did because I didn't know how to, and that I showed off on the football field because

*throwing passes better than the varsity quarterback was
a way for me to express myself, to show that there was
something I was good at.*

*Althea never outgrew this so-called tomboy stage. In-
stead, she used it to advantage. Although the street kid from
Harlem had to work hard to control her quick temper and her
hostile attitude toward school and responsibility, she managed
to develop her ability as a tennis player of the highest caliber.*

*In 1957, by winning the women's singles matches at
Wimbledon, Althea Gibson became world champion. That day
when the flashbulbs went off and reporters flocked around,
Althea knew she had come a long way.*

In a passage from her own story, I Always Wanted to Be
Somebody, *Althea tells about her rough childhood and about
the turn of events that started her on her way to becoming a
champion.*

The only thing I really liked to do was play ball. Basket-
ball was my favorite but any kind of ball would do. I guess the
main reason why I hated to go to school was because I couldn't
see any point in wasting all that time that I could be spending
shooting baskets in the playground.

"She was always the outdoor type," Daddy told a reporter
once. "That's why she can beat that tennis ball like nobody's
business."

If I had gone to school once in a while like I was supposed
to, Daddy wouldn't have minded my being a tomboy at all. In
fact, I'm convinced that he was disappointed when I was born
that I wasn't a boy. He wanted a son. So he always treated me
like one, right from when I was a little tot in Carolina and we
used to shoot marbles in the dirt road, with acorns for marbles.
He claims I used to beat him all the time, but seeing that I was
only three years old then, I think he's exaggerating a little bit.

One thing he isn't exaggerating about, though, is when he
says he wanted me to be a prize fighter. He really did. It was
when I was in junior high school, like maybe twelve or thirteen
years old, and he'd been reading a lot about professional bouts
between women boxers, sort of like the women's wrestling they

have in some parts of the country today. (Women's boxing is illegal now but in those days it used to draw some pretty good small-club gates.) Daddy wanted to put me in for it. "It would have been big," he says. "You would have been the champion of the world. You were big and strong, and you could hit."

I know it sounds indelicate, coming from a girl, but I could fight, too. Daddy taught me the moves, and I had the right temperament for it. I was tough, I wasn't afraid of anybody, not even him. . . .

Sometimes, in a tough neighborhood, where there is no way for a kid to prove himself except by playing games and fighting, you've got to establish a record for being able to look out for yourself before they will leave you alone. If they think you're an easy mark, they will all look to build up their own reputations by beating up on you. I learned always to get in the first punch.

There was one fight I had with a big girl who sat in back of me in school. Maybe because I wasn't there very often, she made life miserable for me when I did show up. I used to wear my hair long, in pigtails, then, and she would yank on those pigtails until I thought she was going to tear my hair out by the roots. If I turned around and asked her to leave me alone, she would just pull harder the next time. So one day I told her I'd had all of that stuff I was going to take, and I'd meet her outside after school and we would see just how bad she was.

The word that there was going to be a fight spread all around the school, and by the time I walked outside that afternoon, she was standing in the playground waiting for me, and half the school was standing behind her ready to see the fun. I was scared. I wished I hadn't started the whole thing. She was a lot bigger than me, and she had the reputation of being a tough fighter. But I didn't have any choice. I had to save my face the best way I could. Anyway, my whole gang was behind me, pushing me right up to her.

We stood there for a minute or so, our faces shoved up against each other, the way kids will do, and we cursed each other, and said what we were going to do to each other. Meanwhile I tried to get myself into position, so I'd have enough leverage to get off a good punch.

She had just got through calling me a pigtailed brat when I let her have it. I brought my right hand all the way up from the floor and smashed her right in the face with all my might. I hit her so hard she just fell like a lump. Honest, she was out cold. Everybody backed away from me and just stared at me, and I turned around like I was Joe Louis and walked on home. . . .

The 143rd Street block my mother and father lived on was a Police Athletic League play street, which means that the policemen put up wooden barricades at the ends of the street during the daytime and closed it to traffic so we could use it for a playground. One of the big games on the street was paddle tennis, and I was the champion of the block. In fact, I even won some medals representing 143rd Street in competition with other Harlem play streets. I still have them, too. I guess I've kept every medal or trophy I ever won anywhere.

Paddle tennis is played on a court marked off much like a tennis court, only about half the size. You use a wooden racket instead of a gut racket, and you can play with either a sponge rubber ball or a regular tennis ball. It's a lot different from real tennis, and yet it's a lot like it, too.

There was a musician fellow, Buddy Walker, who's known now as "Harlem's Society Orchestra Leader," but who in those days didn't get much work in the summer months and filled in by working for the city as a play leader. He was watching me play paddle tennis one day, when he suddenly got the idea that I might be able to play regular tennis just as well if I got the chance. So, out of the kindness of his heart, he bought me a couple of secondhand tennis rackets for five dollars apiece and started me out hitting balls against the wall on the handball courts at Morris Park.

Buddy got very excited about how well I hit the ball, and he started telling me all about how much I would like the game and how it would be a good thing for me to become interested in it because I would meet a better class of people and have a chance to make something out of myself. He took me up to his apartment to meet his wife, Trini, and their daughter, Fern, and we all talked about it.

The next thing that happened was that Buddy took me to the Harlem River Courts at 150th Street and Seventh Avenue

and had me play a couple of sets with one of his friends. He always has insisted that the way I played that day was phenomenal for a young girl with no experience, and I remember that a lot of the other players on the courts stopped their games to watch me. It was very exciting; it was a competitive sport and I am a competitive sort of person. When one of the men who saw me play that first time, a Negro schoolteacher, Juan Serrell, suggested to Buddy that he would like to try to work out some way for me to play at the Cosmopolitan Tennis Club, which he belonged to, I was more than willing. . . .

Mr. Serrell's idea was to introduce me to the members of the Cosmopolitan and have me play a few sets with the club's one-armed professional, Fred Johnson, so that everybody could see what I could do. If I looked good enough, maybe some of them would be willing to chip in to pay for a junior membership for me and to underwrite the cost of my taking lessons from Mr. Johnson. Lucky for me, that's the way it worked out. Everybody thought I looked like a real good prospect, and they took up a collection and bought me a membership.

I got a regular schedule of lessons from Mr. Johnson, and I began to learn something about the game of tennis. I already knew *how* to hit the ball but I didn't know *why*. He taught me some footwork and some court strategy, and along with that he also tried to help me improve my personal ways. He didn't like my arrogant attitude and he tried to show me why I should change.

I don't think he got too far in that department; my mind was set pretty strong. I was willing to do what he said about tennis, but I figured what I did away from the courts was none of his business. I wasn't exactly ready to start studying how to be a fine lady.

Those days, I probably would have been more at home training in Stillman's Gym than at the Cosmopolitan Club. I really wasn't the tennis type. But the polite manners of the game, that seemed so silly to me at first, gradually began to appeal to me. So did the pretty white clothes. I had trouble as a competitor because I kept wanting to fight the other player every time I started to lose a match. But I could see that certain things were expected, in fact required, in the way of behav-

ior on a tennis court, and I made up my mind that I would go along with the program.

After a while I began to understand that you could walk out on the court like a lady, all dressed up in immaculate white, be polite to everybody, and still play like a tiger and beat the liver and lights out of the ball. I remember thinking to myself that it was kind of like a matador going into the bull ring, beautifully dressed, bowing in all directions, following the fancy rules to the letter, and all the time having nothing in mind except sticking that sword into the bull's guts and killing him dead. I probably picked up that notion from some movie I saw.

I suppose if Fred Johnson or the club members who were paying for my tennis had known the whole truth about the way I was living I wouldn't have lasted long. The Cosmopolitan members were the highest class of Harlem people and they had rigid ideas about what was socially acceptable behavior. . . .

I'm ashamed to say I was still living pretty wild. I was supposed to be looking for a job but I didn't look very hard because I was too busy playing tennis in the daytime and having fun at night. The hardest work I did, aside from practicing tennis, was to report to the Welfare ladies once a week, tell them how I was getting along, and pick up my allowance. Then I would celebrate by spending the whole day in the movies and filling myself up with a lot of cheap food.

But I guess it would have been too much to expect me to change completely right away. Actually, I realize now that every day I played tennis and got more interested in the game I was changing a little bit. I just wasn't aware of it.

FOR DISCUSSION

1. What do you think of Althea's reasons for learning and accepting the ladylike behavior of the tennis court?
2. What does the story tell you about the forces that can tip the balance in a young woman's conflict between expected social behavior and inner needs?

ACTIVITY

Look up women in sports. Who have the greatest athletes been? What have they been good at? How did they get so good? What is the relationship between femininity and athletic ability? Review some answers to this question from people in your school. How much of your school's budget goes to women's sports?

INTRODUCTION

The final poem in this section was written by May Sarton when she was in her fifties, yet it seems to speak clearly of the process we have been trying to describe. It is the process of a woman finding her own inner purpose. She chooses of the world and time she lives in those things that are of help to her. In so doing she fulfills her sense of self.

Now I Become Myself

May Sarton

Now I become myself. It's taken
Time, many years and places;
I have been dissolved and shaken,
Worn other people's faces,
Run madly, as if Time were there, 5
Terribly old, crying a warning,
"Hurry, you will be dead before—"
(What? Before you reach the morning?
Or the end of the poem is clear?
Or love safe in the walled city?) 10
Now to stand still, to be here,
Feel my own weight and density!
The black shadow on the paper
Is my hand; the shadow of a word
As thought shapes the shaper 15
Falls heavy on the page, is heard.
All fuses now, falls into place
From wish to action, word to silence,
My work, my love, my time, my face
Gathered into one intense 20
Gesture of growing like a plant.
As slowly as the ripening fruit

Fertile, detached, and always spent,
Falls but does not exhaust the root,
So all the poem is, can give, 25
Grows in me to become the song,
Made so and rooted so by love.
Now there is time and Time is young.
O, in this single hour I live
All of myself and do not move. 30
I, the pursued, who madly ran,
Stand still, stand still, and stop the sun!

FOR DISCUSSION

1. The poet speaks of having worn other people's faces. What does she mean by this?
2. What change has the woman undergone? What does she mean when she says that she now "stops the sun"?

Women Being

CHAPTER TWO

Part One

Heritage

We are all the children of our mothers. They, in turn, are the daughters of their mothers, and so on through human history. The importance of this fact is one of heritage. Women, especially, are a culture's first nurturers and teachers. They are most responsible for the life-giving act of birth and for the upbringing and care of the young.

As infants we are dependent on them for physical needs. As we grow older, we depend on them for more involved social and cultural needs. In fulfilling these needs, the early teachers help to create strong emotional and cultural ties that unite members of a society. They also pass on much of themselves as part of that culture. Trying to separate the individual teacher from the whole heritage—in order to understand the importance of both—is a difficult process. It is, however, a useful one. It can show how expectations for women come from both their own heritage and from what their children (and children's children) have to say about women in their lives.

Here are women seen through the eyes of others—children, friends, and grandchildren—whose understanding of both the women and their own heritage is sharpened in the looking.

INTRODUCTION

Listen carefully to the voices in the next few selections. They talk about individuals. Yet, at the same time, a sense of heritage comes through. In these portraits of mothers and friends, try to find patterns that help define women's heritage.

Daughters and Mothers

Ingeborg Day

People are always saying how different I am from my mother. Lessie Ridley spent her whole life in the tiny town of Lumpkin, Georgia, had 10 kids, and worked most of the time as a domestic, cleaning the homes of servicemen from Fort Benning. I live in New York City, where I work with people in my community, raise money from foundations, and organize programs for change; first a community controlled child-care center and now a program of alternatives to welfare.

But it was Mother who gave me my political education. My mother, my five sisters, and I would talk for hours while we worked, especially when we quilted. It was our own personal women's group. The church and the schools didn't teach us to be independent, so she was really alone in preparing us for life. And she warned us that we would be alone, too, unless we did something to change the society we lived in. We learned from her words, and from her example: whenever there was a family crisis or problem, she always fought it through. She was never defeated. It was my mother who taught us to stand up to our problems, not only in the world around us but in ourselves.

When I first came to New York and started to make a little money, I got Mother to stop working since her physical condition wasn't too good. Now that my father has lost his job because of the economy, she has gone back to work. But this time, she's started her own business—making and selling quilts.

Whenever I have a problem, she calls me—I used to ask her how she knew, but she would just answer, "Tell me what's wrong." As we talked, I could almost see my problem get smaller. She keeps me going.

She is very dark and very beautiful, my mother. She is slim and tall, a friend and a teacher. And she is strong.

She once wrote me a letter that started with the story of two strangers in town. The first one met an old woman and asked her, "What kind of people do you have in this town?" The old woman said, "What kind of people were in the town you just left?" The stranger said, "Oh, horrible people. Cutthroats and murderers." And the old woman replied, "Well, you will find those same people in this town." The second stranger asked the old woman the same question—and she asked the same question in return: "What kind of people were in the town you just left?" He replied, "Oh, they were wonderful people. Kind and gentle." And the old woman said, "Then you will find those same people here."

I always remembered that story. Other people become what you expect them to be, and you carry yourself with you, wherever you are—Lumpkin, Georgia, or the streets of New York. You are a success or a failure, depending on how you see yourself, on what you make happen in your life and the world around you.

My mother is a success.

Dorothy Pitman Hughes is the founder of the West 80th Street Day Care Center and administrative director of the Westside Community Alliance, Inc., in New York City. She is presently serving on the Governor's Task Force for Human Services.

My mother and I now meet ritually. Every Monday we have dinner; on birthdays, Christmas, and Thanksgiving we feast; and each summer there are weekends together on Atlantic Beach. At the end of last summer, my mother, a pied piper of sandy children, introduced me to a child on the beach. "This is *my* little girl," my mother said to her. The child studied me gravely and observed, "She's going to be very tall."

I am six feet tall. I am 34, the age my mother was when I was in the third grade. My life is taking unexpected turns. I am not a mother, I am not married, I have a career, and recently I observed my mother in my shadow.

As a child, I wanted to be just like my mother. My first word was "pocketbook." The first healthy blush in my cheeks was her raspberry rouge, and my skinny hair was set in her twisted Kleenex. I practiced to swing a golf club in her breathtakingly effortless arc, to swim the ocean in her rhythmic crawl, and set a dry fly down on a stream with the same delicate flutter.

My friends have learned to chart the passage of seasons by my mother's annual spring fishing trip to the Beaverkill, a trout stream in Upper New York's Catskill mountains. For 25 years, she has fished there the week before Memorial Day; one of the few women on the stream. My brother and I leave schools and jobs to join her. We come to be with her, to share her excitement and try to catch her style as well as a few fish.

We freeze the trout and bring them home as prizes to our city friends at special dinners. Each year, my brother and I recognize the pasture where we ran into a cross bull when we were too young to fish, the road we climbed with my father picking violets before he decided fishing was my mother's sport, the rocks we turned over to inspect ant colonies, the spot where we surprised a doe and her fawn, the water by the power station where I lured a really big fish right out from under the bank, snakeville into which we will never again venture, the broad stretch at Cooks Falls in which we nearly drowned. Last year my brother's wife came along. This year they both stayed home to work, and my mother and I fished together. Waders to our chests, hats pulled down over sunglasses, rods waving, we looked identical.

Where the stream was narrow we fished apart. "You're the one who fishes with her mother," a man said to me as I was standing by the red barn looking for the two rocks that marked the deep water where the big fish were. "I saw you last year."

One evening, close to quitting time, I was fishing alone way upstream around some lovely rocks under ferns and branches and birches. My attention wandered from the fly to a tree trunk that looked just like a seal. The bank was a forest from fairy tales

and Arthur Rackham illustrations. Two little boys crashed through the bushes. "Your mother wants you," they called proudly, pointing way downstream to where she had left the water. And it made me smile that for the moment it was all so simple.

Wendy Weil is a literary agent in New York City.

from Daybreak

My Mother

Joan Baez

She can't stand anything phony. She refuses to go to teas, prefers young people to older. She works in the garden, making flowers come up out of the dirt. She wears her hair long, down her back, when she's at home, and up in a braided roll when she goes out. Her back is strong and her hands are gnarly and full of veins. I think she must have worked very hard when she was little to have such hands. Her eyes are huge, frightened, deep, and magnificent; her forehead almost always in a worry design; her mouth too tight and her chin tense. Yet there is an overwhelming strength in her face, and she is one of about five women I can think of who are in her category of beauty. Her figure is excellent. When she runs, on the beach, dressed in blue jeans and a T-shirt, with her hair all down, she looks nineteen. She is fifty-four.

Mother was born in Scotland, and brought to America when she was two. Her mother died when she was three. Her father was a very far-out Episcopalian minister who loved the theater, sang off-key from the pulpit, dressed his children out of the missionary barrel, fought a fiery public battle with the DAR, and had a weakness for marrying domineering women. Mother says I

would have loved him. I can think of only one picture of him, a portrait showing a weak, thin-nosed, rather nice-looking sad man. There comes to mind now a picture of Mother's mother, carrying Mother's sister on her back: She is very pretty, also sad, tilting her head back as though to bump it in a nice way against the baby's head. Now I think of the picture of Mother which I have hanging in my house. It was taken when she was ten. She is standing on a beach in the wind with the ocean in back of her, her arms outstretched in youthful grace, her dark legs poking out of an oversized black bathing costume, coming a bit together at the knees, the wind blowing her hair across her face, across an exquisite smile. Her head is tilted back, as though butting the wind. She is like a lovely bit of dark heather. She has kept the grace and beauty through unbelievable odds. Odds which have given her a power and wisdom which she tries very hard not to acknowledge.

Her first stepmother was classically frigid, and appears dressed in white, smiling very sweetly, in all the old albums. She's the one who would hand Mother and her sister fifteen cents and say, "Here's your allowance for this week," and before they could close their fingers over the coins, she'd say, "and now, because you've spilled the ink in the study and made a mess in the john and stolen peanut butter from the big jar, I am taking it away. Maybe you can learn to be good children, and then you will get your allowance." Money was dirty to touch, Jews were dirty to live near, sex was dirty to think about or have; children were taught by punishment; and in the meantime dressing everyone in white frocks would tide things over. Long before I learned these things, she was a favorite "auntie" of my childhood. She let go her grip long enough to produce a son, a half-brother for Mother and her sister to look after. He grew up to be a Right-wing fanatic, made it through medical school to become a urologist on sheer strength of will because his mother told him he was too stupid to pass the exams. I hear he's a good doctor.

The next stepmother was a six-foot-tall redhead schizophrenic who made puppets and dressed in purple and orange and was prone to chasing Mother's father around the house waving a butcher knife and screaming. Mother once ran to her father's church, entered in the middle of the Sunday sermon.

She reached the pulpit and stood there anxiously in her funny missionary clothing, waiting for her kindly but oblivious father to stop his ranting long enough to notice her. When he didn't, she leaned forward and caught his eye and said, "Daddy, please, you must come. Meg's beating up Pauline." "Heavens!" he said, sweeping down from the pulpit, and rushing out of the church. He arrived home too late, as Meg had dragged Mother's older sister around by the hair, beaten and kicked her until she was unrecognizable and locked her in her room.

Meg's sadistic energies were centered on the older sister, because of her closeness to her father, and Mother was more often than not just ignored.

She declared her independence when she was thirteen. Meg threw a pot of steaming boiled potatoes at her from across the room. Mother ducked the potatoes and went about washing the dishes. Meg came up behind her and slapped her full strength on the side of the face. Mother whirled around and said, "Damn you!" and Meg froze in shock. When she regained her fury she raised her arms to beat Mother, but Mother caught her arms mid-flight with her own slippery hands, and lowered them to her sides, saying, "Don't you ever do that again." Meg fumbled in her defeat, and finally said, "Go outside and fill this up with berries," handing Mother a pot, and Mother said, "If you want berries, pick them yourself." From then on Mother kept her coat hanging near the front door, with two nickels in the pocket, one for bus fare, and the other to call a friend.

At some point in her childhood she lived in a sort of gypsy camp for a while, eating potato crusts charcoaled in the fire on sticks. She and her little friends ate them because there wasn't much food around and no one bothered to feed the children. She found communion wafers delightful, but not very filling. And she *was* guilty of stealing peanut butter—she would steal it in great globs, knowing that she would eventually be caught and punished. She's not hungry like that any more, but she still has a craving for peanut butter.

There was one school she was sent to which she loved. They left her alone there, and she could sit by a brook and not go to class. She was good in drama and wanted to act, but the ghosts of stepmothers, sweetly and regretfully explaining to her

from Daybreak 81

that she was inadequate in every way and not very bright, kept her from pursuing anything beyond the first few steps. It was the same with nursing. She loves it, and is brilliant with sick people, but she never got beyond being a nurse's aide.

She has told me of when she was left in charge of a dying girl. The child had been in an accident, and was fatally hurt, and Mother was supposed to mark down the exact time of her death. She watched the little girl struggle, and give, and struggle again, always fading, and always in pain. When her small muscles sank into the hospital bed for the last time, Mother felt very deeply the blessing of that final defeat.

Her father by blindness to his children, and the step-mothers out of jealousy and the etiquette of the times, convinced Mother that she was not pretty. When she and her sister were little their hair was pulled tightly back and braided, lest anyone should notice that Pauline had soft yellow curls, and Mother had shiny handsome brown hair. Still, in every picture I've seen of her when she was young, she is nothing less than strikingly beautiful.

In a snapshot taken of her when she was about eighteen she stands sideways to the camera, dressed in satin, with some feathery shawl around her shoulders, her eyes looking into the lens. She is a vamp, a gypsy queen, a mystic, a blueblood. She is all of those things still, and the battle rages inside and outside Mother as to whether she will ever admit to the fact that she is glorious.

I have said little specifically about Mother's mind. There is little to say, as she refused to acknowledge its existence, let alone its depth and brilliance. My guess is that it will continue to remain an almost totally untapped uranium deposit.

Mother knows nothing of the theories of mysticism, but it seems as if God moves about her more freely than he does most people, and that the soul of Mother is in some way so familiar with His presence that she doesn't think to title their relationship. There is a spookiness which comes with that side of Mother—the kind of spookiness which provides demons for her dreams, and sometimes accompanies them to her bedroom window. "Oh I remember! It wasn't a dream. It was Kit. She came to the window in the form of a ghastly angel, and leaned in

over the bed and flapped her wings. I couldn't speak to ask her what she wanted, and I wished she would leave, because she was horrible, and I was scared to death."

I think now of the stories Mother has told me of Meg setting an extra place at the table for a deceased member of the family. Namely, Mother's real mother. Meg would give her a plate of food, and say to the children, "Shhhh. Elizabeth has something to say." And they would stare at the empty chair while Meg nodded and spoke, sympathetically pausing to listen and respond. The ghost never ate her dinner.

The family lived for a while in a big house in the woods a few miles from a men's prison. Escapees came often to the house looking for food, and Mother and her sister were often alone and frightened. At night they fought because there was a candle to light the room, and Mother couldn't go to sleep if it was lit because she was afraid of fire, and Pauline wouldn't blow it out because she was afraid of the dark.

Mother and me. Tea and Vivaldi and Mozart and Jussi Bjoerling singing Puccini . . . comfort at home from the misery at school. "Is there anything important you should be doing at school?" "No," I would say, and the nice thing was that both Mother and I knew that nothing very important was ever going to happen at school. The habit of running home in the morning began when I was in first grade. Mother delivered me to a new school, and left me in line with thirty other kids, waiting for the bell. I didn't know if I was in the right line, and a huge empty feeling was growing in my stomach, and my chest was beginning to tighten, and instead of asking someone which line was for first-graders, I tied my sweater sleeves in a knot around my waist and ran home. It was easy enough to find my house, because it was the only place in the world I wanted to be. I don't remember if Mother made me go back that time. Probably not.

In 1951, the year we spent in Baghdad, Iraq, after an explosive two weeks of trying to adjust to a French-English Catholic school, during which time the three disruptive Baez girls broke every rule that had ever been written for that school, and I had presented a case for some new rules to be written, Mother said, "Oh for heaven's sake," and took me out of school for the rest of

that year. I stayed home and did things. I made cakes—real ones, not out of a box. I learned about ants by carefully digging into their hills and finding the nursery and transplanting bunches of unborn babies and nurses and workers into a huge treacle bottle filled with dirt. The trick was to try and find a queen, and then watch them establish a new colony. I sprayed scorpions with DDT until they were groggy, and picked them up and put them in matchboxes to get a closer look at them, with their scary spiked tails, and to draw pictures of them. I didn't know they were poisonous. I was commissioned by my father to make large ink drawings of some pictures of cells and hair follicles and epidermal tissue as seen through a microscope, for a biology professor at the University of Baghdad. I studied flies under my father's microscope, and drew pictures in colored pencil of their wings and legs and eyes. I made miniature houses out of mud and twigs, two and three stories high. And every morning, around ten, Mother and I would sit in the back yard, in the sun, and eat oranges and have some tea, and maybe some of the cake I had made, and I'd show her my projects. She always appreciated everything. I didn't realize until now the creativity that was let out of chains when Mother gave me that year of freedom.

It is worth mentioning the three months I was sick that same year. There were times when I felt that if I wasn't in Mother's hands, I would float off toward the vicinity of death. Mother was never out of earshot when things were at the worst. Once I was in such a high fever, and so weak, that I thought I would simply die of heat. I wanted a sip of lemonade which was in a glass by my bed. I had the choice of reaching down for it, which seemed impossibly difficult to do, or calling for Mother, who sat reading twenty feet away. I took a deep breath and let it make a noise on the way out. Mother was by the bed by the time I'd breathed all the way out, saying, "You want some lemonade, honey?" She sat through days of my fits of diarrhea, holding my head and rubbing my back as I sweated and cried and shook on the cold little potty, which she then had to empty downstairs. I remember apologizing to her about the smell, telling her she didn't have to stay, but praying she wouldn't leave . . . She never left.

Once in that time I had a dream which was so vivid that I called Mother in to tell her. I dreamed I was riding a bicycle across an empty plain, on a road which began to get smaller and smaller and full of potholes, until eventually I couldn't even ride, but had to guide the bike with my feet and coast. I came to the edge of the plain, and there was a drop-off into a great canyon, and on the other side of the canyon was a beautiful field of green grass. I didn't stop to deliberate, but gave the bicycle a good push with my foot, and sailed over the cliff toward the lovely field. I woke up as I was floating through the air. Mother listened to the dream and nodded, and years later told me she thought I had meant to die then. It was during those months that I had a split of about a quarter of an inch in my life-line, and the only way I could make the line come together was by stretching the skin over the split until there was a faint red line showing. I was too embarrassed and frightened to tell even Mother that I thought it meant I would die soon. The line has grown back so completely that it is impossible to tell where the split once was.

Though Mother and I admit that she must have been, in part, responsible for helping build my house of fears, she was one of the few people who had the key to get me out. Does that mean she must have put me in? Perhaps. But she and her sister Pauline, and my sister Mimi, were the only ones who knew how to push the terror aside when it was enveloping me. I can see that pushing it aside cures nothing, but by age five the fears were so solid that I had already become a genius at running from them, and running like that is a hard habit to break. Mother nursed me through terror from that early age until I moved out of the house at age nineteen. Perhaps the blows of adolescence made junior high and early high school the roughest time.

"It will pass. It always passes. Take a deep breath. Another one. That's right. There, can you feel that breeze?" I would grip her hand with all my strength, and imagine that her blood was flowing into my veins and giving me energy. I shut my eyes and saw a chart with a graph on it, and while I was at the worst part I could see the line dip below the bottom of the page, and then I knew it would start up again. I breathed deeply, through my nose, the way anyone does when he's trying to keep from throwing up, and then, eventually, as Mother said, it would

begin to go away. "You're getting better now," she'd say. "I can feel it in your hands." I would always come out joking. When the line on the graph was up to safety level, my first impulse was to ridicule the whole thing, and then Mother would go off to put on the tea kettle, and sometimes I would be asleep before she got back. Each bout like that used up all my strength, and left me dazed and exhausted, and sometimes, after the really big ones, in a queer melancholy sort of state. And each time when it was over I'd put it aside in my mind and forget, or not care that there would be another. But now I think how Mother must have suffered through all that, wondering what had brought it about and why her little girl should have to carry such a strange load . . . and, no doubt, how she must be to blame. . . .

Mothers

Nikki Giovanni

the last time i was home
to see my mother we kissed
exchanged pleasantries
and unpleasantries pulled a warm
comforting silence around 5
us and read separate books

i remember the first time
i consciously saw her
we were living in a three room
apartment on burns avenue 10

mommy always sat in the dark
i don't know how i knew that but she did

that night i stumbled into the kitchen
maybe because i've always been
a night person or perhaps because i had wet 15
the bed

she was sitting on a chair
the room was bathed in moonlight diffused through
those thousands of panes landlords who rented
to people with children were prone to put in windows 20

she may have been smoking but maybe not
her hair was three-quarters her height
which made me a strong believer in the samson myth
and very black

i'm sure i just hung there by the door 25
i remember thinking: what a beautiful lady

she was very deliberately waiting
perhaps for my father to come home
from his night job or maybe for a dream
that had promised to come by 30
"come here" she said "i'll teach you
a poem: *i see the moon*
 the moon sees me
 god bless the moon
 and god bless me" 35
i taught it to my son
who recited it for her
just to say we must learn
to bear the pleasures
as we have borne the pains 40

Fellow Traveler

Lorenza Calvillo Schmidt

Fellow traveler
Sister

silent bodies in a room
facing each other
shrouded in a cloud of pain. 5

Our pain
 permeating the room
 non-verbal articulation
 flowing from our eyes

Somewhere 10
 in the space between our two bodies
 our pain meets and merges
 a spiritual communion
 for we
 who are allowed nothing more. 15

Dear sister
 I was baptized today
 by the tears
 i shed for thee

 filled with your pain 20
 i cried
 at the recognition of my own.

FOR DISCUSSION

1. Why does Hughes give her mother's name as Lessie Ridley?
 In what ways is Hughes's mother a "success"? Is Weil's
 mother the same kind of success? Is Baez's?

2. What does it mean to say "I observed my mother in my
 shadow"? In what sense are children usually in the shad-
 ows of their parents?

3. Wendy Weil meets her mother "ritually." Find other ex-
 amples from the preceding selections of shared rituals and
 patterns.

4. In what ways do you want to be like your mother? Can you
 be like her if you are her son? Can you be like her yet dif-
 ferent, too? When was the first time you really noticed that
 your mother was a special person separate from her role as
 mother? How did you feel? Are there rituals in your life
 that you share especially with your mother? What are they?
 Which do you think you will pass on to others?

ACTIVITIES

1. Make a list of words that describe your mother. Emphasize her qualities as a person rather than the qualities of the role. Write a short biography of her, using as many qualities from the list as you can.

2. Following the pattern of lines and words in Schmidt's poem, write a poem of your own to a "fellow traveler" that shares a different feeling or idea than pain. Can you keep the last two lines from the original? If you do, how are the meaning and emphasis changed?

INTRODUCTION

The narrators of the following three pieces feel a deep sense of heritage from their grandmothers, a sense that seems to know no cultural boundaries. We can see their great appreciation of, and admiration for, what their grandmothers have been. And, finally, we feel their great loss at their grandmothers' aging and death.

Lineage

Margaret Walker

My grandmothers were strong.
They followed plows and bent to toil.
They moved through fields sowing seed.
They touched earth and grain grew.
They were full of sturdiness and singing. 5
My grandmothers were strong.

My grandmothers are full of memories
Smelling of soap and onions and wet clay
With veins rolling roughly over quick hands
They have many clean words to say. 10
My grandmothers were strong.
Why am I not as they?

To My Grandmother: All Your Time

Kitty Tsui

I have not been old and lonely / I am not semi-invalid, forced to face four walls until someone comes to take me out. I am not my grandmother / I do not know how it feels.

I know only that her love for me is great / as great as her hate her shame of me / of my sin. And my sin is that I love a man who is black. She cannot see her loved grand daughter unmarried and living with a *hak gwei*. And it is not because I am unmarried or too young to marry but because he is *hak* and all *hak gweis* are lazy and thieves and other low sorts. Chinese are prejudiced against blacks; as racist as whites. The reason why they are is because they have confused the victim with the devil.

I cannot help her. She is old / she is set in her ways. She will die not knowing the truth. She will die knowing only that I disobeyed her.

When I visit I must force myself to stay longer, another hour, the rest of the afternoon. I tell her I will stay for dinner / that makes her happy. I know what it is to eat dinner alone, across the table from yourself, silent / and appetiteless. It also makes her happy to nag at me / it makes her feel that she is not alone. We play gin rummy in the dimming afternoon. She wins / my stack of quarters disappears.

It is 5 / she rises with effort / walks across the new yellow rug (take your shoes off!) to the kitchen and starts to wash rice for dinner. I grab my coat and call—I'll be back.

Chinatown Programs office 915A Grant / kids are rapping, using the phone / KDIA on the air, soul music down the corridor / cigarette smoke, the shuffling of cards / smell strong of scotch and coffee. I pour myself some Chivas and sit down for a few hands. An hour goes by. I look at my watch. One more hand. I call grandma, her voice / soft, shaking. I am coming, I say. Anything to buy?

Dinner is waiting for me. I take off my shoes before stepping on the rug. The rice is good / the *sung* is good. It is as always. *Hau bau*, I say as I have some more *hau bau*.

Most nights she would go out of the house after dinner, to a room behind a smoke shop, where four of them would play mahjong. She is unable to now / she injured her waist and cannot sit that long. I know she yearns to go / to play with her friends / to chat, to smoke. She is lonely. What can I do. She is lonely. She can only sit on a straight backed chair in front of the T.V. and watch the programs and the commercials and the news, knowing only three, four words of English:

<div align="center">hallo godbye dank que</div>

I know I was never lonely in childhood. She was always there. Next to me when I slept, holding my hand on the street / feeding me always the choicest from bowls. Brewing me herb tea and making me drink . . . a long time ago when her hair was black and her body strong.

Grandma, writing this won't give you back your strength or years / or your lost daughter / or the tears and pain in you. This is for me to read when I am carefree and in leisure / when I am driving to the ocean or seeking the sunrise in the hills / this is for me when I am playing. This is to tell me to spend more hours, more days by your side.

When I was a child you were always there / you gave me all your time.

For Kima

Leslee Kimiko Inaba

I.

My grandmother
is dying—dissolving
like a sugar cube
when it sprinkles
sweet rain. 5

Her mind slides away,
catching on pieces of memories—
wringing them out
like the napkin
she twists in her hands. 10

II.

Ba-chan with black parasol, oil
 clothed to keep us dry,
 waiting in mud,
 slanted rain everywhere.

Ba-chan, you're suppose to be there, 15
 suppose to be waiting
 suppose to hold the um-brella
over my head—walking
like a queen in tropical
wetness, one block to home. 20

Until I asked you: quit coming.
My friends laugh—i'd rather
 walk with them and no
 one else's grand-
mother who can't 25
speak english comes
after them.

III.

When did I come to know?
When the moon rimmed
your eyes and found you clutching 30
your chair.

Ba-chan, don't die.

Two pegs for legs
gone out by last year's stroke.
This month your left side, 35

sagging like a swing
when one chain pulls
too long.

Kima, Kima namesake.
Born on your birthday. 40

You slipped through my life,
your no-answered voice
woven with TV sounds
till you were beige
like our walls. 45

I'll give you my legs.

I lift your body,
 carcass of dead cattle
sit you on the toilet.
You pinch my arms. 50
 little girl, me, calls
 "Ba-chan! I'm done!"
 old lady comes, wipes
 lifting the girl down.
 I pinch your arms. 55

Old Time-Reaper, You can't have her!
She's *my* grandmother.

Lump in the bed.
Coma state.
Mother pumps fluid from her mouth, 60
Gives enema every other day;
While breathing draws from deeper,
Still deeper wells.

FOR DISCUSSION

It is sometimes said that the relationships between grand-
parents and grandchildren are happier than those between

parents and children. Have you seen this to be true in your reading or life experience?

ACTIVITY

Following the directions for a word list and biography of your mother, write a biography of your grandmother or of a woman a generation or more older than you whom you know well. How are the two biographies different? How are they similar? What can you tell about your own heritage by comparing the two biographies?

Part Two

Women Alone

Perhaps some of the most lasting stereotypes of women are those of single women—women alone. Many of us have learned that women without men are pitiable, frail shadows who spend most of their time knitting booties for other women's babies or caring for dozens of evil smelling cats. Of course we know these are not realistic pictures of any one person, much less a whole range of people. In the portraits that follow we see that such ideas are foolish and uninformed. The sisters in "A Mistaken Charity" surmount their own physical infirmities as well as the crippling effects of the good deeds of others. Jane Eyre lived in a time when single women led rather grim lives indeed. But she learns from positive women models to assert herself as the moral and intellectual equal of anyone she meets. Seventy-three-year-old Mountain Wolf Woman, telling her own story long after her husbands are gone from her life, has an independence of spirit that has sustained her throughout a long and vigorous life.

These women alone are not shadows. They are full figures, each with a place of her own, in a landscape filled with real people.

INTRODUCTION

Harriet and Charlotte Shattuck have lived alone throughout their adult lives. Although old and physically weak, they have not lost their independence and strength of spirit. Proud and self-sufficient, they neither want nor need "mistaken charity" from others.

A Mistaken Charity

Mary Wilkins Freeman

There were in a green field a little, low, weather-stained cottage, with a foot-path leading to it from the highway several rods distant, and two old women—one with a tin pan and old knife searching for dandelion greens among the short young grass, and the other sitting on the door-step watching her, or, rather, having the appearance of watching her.

"Air there enough for a mess, Harriét?" asked the old woman on the door-step. She accented oddly the last syllable of the Harriet, and there was a curious quality in her feeble, cracked old voice. Besides the question denoted by the arrangement of her words and the rising inflection, there was another, broader and subtler, the very essence of all questioning, in the tone of her voice itself; the cracked, quavering notes that she used reached out of themselves, and asked, and groped like fingers in the dark. One would have known by the voice that the old woman was blind.

The old woman on her knees in the grass searching for dandelions did not reply; she evidently had not heard the question. So the old woman on the door-step, after waiting a few minutes with her head turned expectantly, asked again, varying her question slightly, and speaking louder:

"Air there enough for a mess, do ye s'pose, Harriét?"

The old woman in the grass heard this time. She rose

slowly and laboriously; the effort of straightening out the rheumatic old muscles was evidently a painful one; then she eyed the greens heaped up in the tin pan, and pressed them down with her hand.

"Wa'al, I don't know, Charlotte," she replied hoarsely. "There's plenty on 'em here, but I ain't got near enough for a mess; they do bile down so when you get 'em in the pot; an' it's all I can do to bend my j'ints enough to dig 'em."

"I'd give consider'ble to help ye, Harriét," said the old woman on the door-step.

But the other did not hear her; she was down on her knees in the grass again, anxiously spying out the dandelions.

So the old woman on the door-step crossed her little shrivelled hands over her calico knees, and sat quite still, with the soft spring wind blowing over her.

The old wooden door-step was sunk low down among the grasses, and the whole house to which it belonged had an air of settling down and mouldering into the grass as into its own grave.

When Harriet Shattuck grew deaf and rheumatic, and had to give up her work as tailoress, and Charlotte Shattuck lost her eyesight, and was unable to do any more sewing for her livelihood, it was a small and trifling charity for the rich man who held a mortgage on the little house in which they had been born and lived all their lives to give them the use of it, rent and interest free. He might as well have taken credit to himself for not charging a squirrel for his tenement in some old decaying tree in his woods.

So ancient was the little habitation, so wavering and mouldering, the hands that had fashioned it had lain still so long in their graves, that it almost seemed to have fallen below its distinctive rank as a house. Rain and snow had filtered through its roof, mosses had grown over it, worms had eaten it, and birds built their nests under its eaves; nature had almost completely overrun and obliterated the work of man, and taken her own to herself again, till the house seemed as much a natural ruin as an old tree-stump.

The Shattucks had always been poor people and common people; no especial grace and refinement or fine ambition had

ever characterized any of them; they had always been poor and coarse and common. The father and his father before him had simply lived in the poor little house, grubbed for their living, and then unquestioningly died. The mother had been of no rarer stamp, and the two daughters were cast in the same mould.

After their parents' death Harriet and Charlotte had lived alone in the old place from youth to old age, with the one hope of ability to keep a roof over their heads, covering on their backs, and victuals in their mouths—an all-sufficient one with them.

Neither of them had ever had a lover; they had always seemed to repel rather than attract the opposite sex. It was not merely because they were poor, ordinary, and homely; there were plenty of men in the place who would have matched them well in that respect; the fault lay deeper—in their characters. Harriet, even in her girlhood, had a blunt, defiant manner that almost amounted to surliness, and was well calculated to alarm timid adorers, and Charlotte had always had the reputation of not being any too strong in her mind.

Harriet had gone about from house to house doing tailor-work after the primitive country fashion, and Charlotte had done plain sewing and mending for the neighbors. They had been, in the main, except when pressed by some temporary anxiety about their work or the payment thereof, happy and contented, with that negative kind of happiness and contentment which comes not from gratified ambition, but a lack of ambition itself. All that they cared for they had had in tolerable abundance, for Harriet at least had been swift and capable about her work. The patched, mossy old roof had been kept over their heads, the coarse, hearty food that they loved had been set on their table, and their cheap clothes had been warm and strong.

After Charlotte's eyes failed her, and Harriet had the rheumatic fever, and the little hoard of earnings went to the doctors, times were harder with them, though still it could not be said that they actually suffered.

When they could not pay the interest on the mortgage they were allowed to keep the place interest free; there was as much fitness in a mortgage on the little house, anyway, as there would have been on a rotten old apple-tree; and the people about, who were mostly farmers, and good friendly folk, helped them out

with their living. One would donate a barrel of apples from his abundant harvest to the two poor old women, one a barrel of potatoes, another a load of wood for the winter fuel, and many a farmer's wife had bustled up the narrow foot-path with a pound of butter, or a dozen fresh eggs, or a nice bit of pork. Besides all this, there was a tiny garden patch behind the house, with a straggling row of currant bushes in it, and one of gooseberries, where Harriet contrived every year to raise a few pumpkins, which were the pride of her life. On the right of the garden were two old apple-trees, a Baldwin and a Porter, both yet in a tolerably good fruit-bearing state.

The delight which the two poor old souls took in their own pumpkins, their apples and currants, was indescribable. It was not merely that they contributed largely toward their living; they were their own, their private share of the great wealth of nature, the little taste set apart for them alone out of her bounty, and worth more to them on that account, though they were not conscious of it, than all the richer fruits which they received from their neighbors' gardens.

This morning the two apple-trees were brave with flowers, the currant bushes looked alive, and the pumpkin seeds were in the ground. Harriet cast complacent glances in their direction from time to time, as she painfully dug her dandelion greens. She was a short, stoutly built old woman, with a large face coarsely wrinkled, with a suspicion of a stubble of beard on the square chin.

When her tin pan was filled to her satisfaction with the sprawling, spidery greens, and she was hobbling stiffly towards her sister on the door-step, she saw another woman standing before her with a basket in her hand.

"Good-morning, Harriet," she said, in a loud, strident voice, as she drew near. "I've been frying some doughnuts, and I brought you over some warm."

"I've been tellin' her it was real good in her," piped Charlotte from the door-step, with an anxious turn of her sightless face toward the sound of her sister's footstep.

Harriet said nothing but a hoarse "Good-mornin', Mis' Simonds." Then she took the basket in her hand, lifted the towel off the top, selected a doughnut, and deliberately tasted it.

"Tough," said she. "I s'posed so. If there is anything I 'spise on this airth it's a tough doughnut."

"Oh, Harriét!" said Charlotte, with a frightened look.

"They air tough," said Harriet, with hoarse defiance, "and if there is anything I 'spise on this airth it's a tough doughnut."

The woman whose benevolence and cookery were being thus ungratefully received only laughed. She was quite fleshy, and had a round, rosy, determined face.

"Well, Harriet," said she, "I am sorry they are tough, but perhaps you had better take them out on a plate, and give me my basket. You may be able to eat two or three of them if they are tough."

"They air tough—turrible tough," said Harriet, stubbornly; but she took the basket into the house and emptied it of its contents nevertheless.

"I suppose your roof leaked as bad as ever in that heavy rain day before yesterday?" said the visitor to Harriet, with an inquiring squint toward the mossy shingles, as she was about to leave with her empty basket.

"It was turrible," replied Harriet, with crusty acquiescence—"turrible. We had to set pails an' pans everywheres, an' move the bed out."

"Mr. Upton ought to fix it."

"There ain't any fix to it; the old ruff ain't fit to nail new shingles on to; the hammerin' would bring the whole thing down on our heads," said Harriet, grimly.

"Well, I don't know as it can be fixed, it's so old. I suppose the wind comes in bad around the windows and doors too?"

"It's like livin' with a piece of paper, or mebbe a sieve, 'twixt you an' the wind an' the rain," quoth Harriet, with a jerk of her head.

"You ought to have a more comfortable home in your old age," said the visitor, thoughtfully.

"Oh, it's well enough," cried Harriet, in quick alarm, and with a complete change of tone; the woman's remark had brought an old dread over her. "The old house'll last as long as Charlotte an' me do. The rain ain't so bad, nuther is the wind; there's room enough for us in the dry places, an' out of the way of the doors an' windows. It's enough sight better than goin' on the

town." Her square, defiant old face actually looked pale as she uttered the last words and stared apprehensively at the woman.

"Oh, I did not think of your doing that," she said, hastily and kindly. "We all know how you feel about that, Harriet, and not one of us neighbors will see you and Charlotte go to the poorhouse while we've got a crust of bread to share with you."

Harriet's face brightened. "Thank ye, Mis' Simonds," she said, with reluctant courtesy. "I'm much obleeged to you an' the neighbors. I think mebbe we'll be able to eat some of them doughnuts if they air tough," she added, mollifyingly, as her caller turned down the foot-path.

"My, Harriét," said Charlotte, lifting up a weakly, wondering, peaked old face, "what did you tell her them doughnuts was tough fur?"

"Charlotte, do you want everybody to look down on us, an' think we ain't no account at all, just like beggars, 'cause they bring us in vittles?" said Harriet, with a grim glance at her sister's meek, unconscious face.

"No, Harriét," she whispered.

"Do you want *to go to the poor-house?*"

"No, Harriét." The poor little old woman on the door-step fairly cowered before her aggressive old sister.

"Then don't hender me agin when I tell folks their doughnuts is tough an' their pertaters is poor. If I don't kinder keep up an' show some sperrit, I sha'n't think nothing of myself, an' other folks won't nuther, and fust thing we know they'll kerry us to the poorhouse. You'd 'a been there before now if it hadn't been for me, Charlotte."

Charlotte looked meekly convinced, and her sister sat down on a chair in the doorway to scrape her dandelions.

"Did you git a good mess, Harriét?" asked Charlotte, in a humble tone.

"Toler'ble."

"They'll be proper relishin' with that piece of pork Mis' Mann brought in yesterday. O Lord, Harriét, it's a chink!"

Harriet sniffed.

Her sister caught with her sensitive ear the little contemptuous sound. "I guess" she said, querulously, and with more pertinacity than she had shown in the matter of the doughnuts,

"that if you was in the dark, as I am, Harriét, you wouldn't make fun an' turn up your nose at chinks. If you had seen the light streamin' in all of a sudden through some little hole that you hadn't known of before when you set down on the door-step this mornin', and the wind with the smell of the apple blows in it came in your face, an' when Mis' Simonds brought them hot doughnuts, an' when I thought of the pork an' greens jest now—O Lord, how it did shine in! An' it does now. If you was me, Harriét, you would know there was chinks."

Tears began starting from the sightless eyes, and streaming pitifully down the pale old cheeks.

Harriet looked at her sister, and her grim face softened. "Why, Charlotte, hev it that thar *is* chinks if you want to. Who cares?"

"Thar *is* chinks, Harriét."

"Wa'al, thar *is* chinks, then. If I don't hurry, I sha'n't get these greens in in time for dinner."

When the two old women sat down complacently to their meal of pork and dandelion greens in their little kitchen they did not dream how destiny slowly and surely was introducing some new colors into their web of life, even when it was almost completed, and that this was one of the last meals they would eat in their old home for many a day. In about a week from that day they were established in the "Old Ladies' Home" in a neighboring city. It came about in this wise: Mrs. Simonds, the woman who had brought the gift of hot doughnuts, was a smart, energetic person, bent on doing good, and she did a great deal. To be sure, she always did it in her own way. If she chose to give hot doughnuts, she gave hot doughnuts; it made not the slightest difference to her if the recipients of her charity would infinitely have preferred ginger cookies. Still, a great many would like hot doughnuts, and she did unquestionably a great deal of good.

She had a worthy coadjutor in the person of a rich and childless elderly widow in the place. They had fairly entered into a partnership in good works, with about an equal capital on both sides, the widow furnishing the money, and Mrs. Simonds, who had much the better head of the two, furnishing the active schemes of benevolence.

The afternoon after the doughnut episode she had gone to

the widow with a new project, and the result was that entrance fees had been paid, and old Harriet and Charlotte made sure of a comfortable home for the rest of their lives. The widow was hand in glove with officers of missionary boards and trustees of charitable institutions. There had been an unusual mortality among the inmates of the "Home" this spring, there were several vacancies, and the matter of the admission of Harriet and Charlotte was very quickly and easily arranged. But the matter which would have seemed the least difficult—inducing the two old women to accept the bounty which Providence, the widow, and Mrs. Simonds were ready to bestow on them—proved the most so. The struggle to persuade them to abandon their tottering old home for a better was a terrible one. The widow had pleaded with mild surprise, and Mrs. Simonds with benevolent determination; the counsel and reverend eloquence of the minister had been called in; and when they yielded at last it was with a sad grace for the recipients of a worthy charity.

It had been hard to convince them that the "Home" was not an almshouse under another name, and their yielding at length to anything short of actual force was only due probably to the plea, which was advanced most eloquently to Harriet, that Charlotte would be so much more comfortable.

The morning they came away, Charlotte cried pitifully, and trembled all over her little shrivelled body. Harriet did not cry. But when her sister had passed out the low, sagging door she turned the key in the lock, then took it out and thrust it slyly into her pocket, shaking her head to herself with an air of fierce determination.

Mrs. Simonds's husband, who was to take them to the depot, said to himself, with disloyal defiance of his wife's active charity, that it was a shame, as he helped the two distressed old souls into his light wagon, and put the poor little box, with their homely clothes in it, in behind.

Mrs. Simonds, the widow, the minister, and the gentleman from the "Home" who was to take charge of them, were all at the depot, their faces beaming with the delight of successful benevolence. But the two poor old women looked like two forlorn prisoners in their midst. It was an impressive illustration of the truth of the saying that "it is more blessed to give than to receive."

Well, Harriet and Charlotte Shattuck went to the "Old Ladies' Home" with reluctance and distress. They stayed two months, and then—they ran away.

The "Home" was comfortable, and in some respects even luxurious; but nothing suited those two unhappy, unreasonable old women.

The fare was of a finer, more delicately served variety than they had been accustomed to; those finely flavored nourishing soups for which the "Home" took great credit to itself failed to please palates used to common, coarser food.

"O Lord, Harriét, when I set down to the table here there ain't no chinks," Charlotte used to say. "If we could hev some cabbage, or some pork an' greens, how the light would stream in!"

Then they had to be more particular about their dress. They had always been tidy enough, but now it had to be something more; the widow, in the kindness of her heart, had made it possible, and the good folks in charge of the "Home," in the kindness of their hearts, tried to carry out the widow's designs.

But nothing could transform these two unpolished old women into two nice old ladies. They did not take kindly to white lace caps and delicate neckerchiefs. They liked their new black cashmere dresses well enough, but they felt as if they broke a commandment when they put them on every afternoon. They had always worn calico with long aprons at home, and they wanted to now; and they wanted to twist up their scanty gray locks into little knots at the back of their heads, and go without caps, just as they always had done.

Charlotte in a dainty white cap was pitiful, but Harriet was both pitiful and comical. They were totally at variance with their surroundings, and they felt it keenly, as people of their stamp always do. No amount of kindness and attention—and they had enough of both—sufficed to reconcile them to their new abode. Charlotte pleaded continually with her sister to go back to their old home.

"O Lord, Harriét," she would exclaim (by the way, Charlotte's "O Lord," which, as she used it, was innocent enough, had been heard with much disfavor in the "Home," and she, not knowing at all why, had been remonstrated with concerning it), "let us go home. I can't stay here no ways in this world. I don't

A Mistaken Charity 105

like their vittles, an' I don't like to wear a cap; I want to go home
and do different. The currants will be ripe, Harriét. O Lord,
thar was almost a chink, thinking about 'em. I want some of 'em;
an' the Porter apples will be gittin' ripe, an' we could have some
apple-pie. This here ain't good; I want merlasses fur sweeting.
Can't we get back no ways, Harriét? It ain't far, an' we could
walk, an' they don't lock us in, nor nothin'. I don't want to die
here; it ain't so straight up to heaven from here. O Lord, I've felt
as if I was slantendicular from heaven ever since I've been here,
an' it's been so awful dark. I ain't had any chinks. I want to go
home Harriét."

"We'll go to-morrow mornin'," said Harriet, finally; "we'll
pack up our things an' go; we'll put on our old dresses, an' we'll
do up the new ones in bundles, an' we'll jest shy out the back
way to-morrow mornin'; an' we'll go. I kin find the way, an' I
reckon we kin git thar, if it is fourteen mile. Mebbe somebody
will give us a lift."

And they went. With a grim humor Harriet hung the new
white lace caps with which she and Charlotte had been so pes-
tered, one on each post at the head of the bedstead, so they
would meet the eyes of the first person who opened the door.
Then they took their bundles, stole slyly out, and were soon on
the high-road, hobbling along, holding each other's hands, as ju-
bilant as two children, and chuckling to themselves over their es-
cape, and the probable astonishment there would be in the
"Home" over it.

"O Lord, Harriét, what do you s'pose they will say to them
caps?" cried Charlotte, with a gleeful cackle.

"I guess they'll see as folks ain't goin' to be made to wear
caps agin their will in a free kentry," returned Harriet, with an
echoing cackle, as they sped feebly and bravely along.

The "Home" stood on the very outskirts of the city, luckily
for them. They would have found it a difficult undertaking to
traverse the crowded streets. As it was, a short walk brought
them into the free country road—free comparatively, for even
here at ten o'clock in the morning there was considerable trav-
eling to and from the city on business or pleasure.

People whom they met on the road did not stare at them as
curiously as might have been expected. Harriet held her bris-
tling chin high in air, and hobbled along with an appearance of

being well aware of what she was about, that led folks to doubt their own first opinion that there was something unusual about the two old women.

Still their evident feebleness now and then occasioned from one and another more particular scrutiny. When they had been on the road a half-hour or so, a man in a covered wagon drove up behind them. After he had passed them, he poked his head around the front of the vehicle and looked back. Finally he stopped, and waited for them to come up to him.

"Like a ride, ma'am?" said he, looking at once bewildered and compassionate.

"Thankee," said Harriet, "we'd be much obleeged."

After the man had lifted the old women into the wagon, and established them on the back seat, he turned around, as he drove slowly along, and gazed at them curiously.

"Seems to me you look pretty feeble to be walking far," said he. "Where were you going?"

Harriet told him with an air of defiance.

"Why," he exclaimed, "it is fourteen miles out. You could never walk it in the world. Well, I am going within three miles of there, and I can go on a little farther as well as not. But I don't see— Have you been in the city?"

"I have been visitin' my married darter in the city," said Harriet, calmly.

Charlotte started, and swallowed convulsively.

Harriet had never told a deliberate falsehood before in her life, but this seemed to her one of the tremendous exigencies of life which justify a lie. She felt desperate. If she could not contrive to deceive him in some way, the man might turn directly around and carry Charlotte and her back to the "Home" and the white caps.

"I should not have thought your daughter would have let you start for such a walk as that," said the man. "Is this lady your sister. She is blind, isn't she? She does not look fit to walk a mile."

"Yes, she's my sister," replied Harriet, stubbornly, "an' she's blind; an' my darter didn't want us to walk. She felt reel bad about it. But she couldn't help it. She's poor, and her husband's dead, an' she's got four leetle children."

Harriet recounted the hardships of her imaginary daughter

with a glibness that was astonishing. Charlotte swallowed again.

"Well," said the man, "I am glad I overtook you, for I don't think you would ever have reached home alive."

About six miles from the city an open buggy passed them swiftly. In it were seated the matron and one of the gentlemen in charge of the "Home." They never thought of looking into the covered wagon—and indeed one can travel in one of those vehicles, so popular in some parts of New England, with as much privacy as he could in his tomb. The two in the buggy were seriously alarmed, and anxious for the safety of the old women, who were chuckling maliciously in the wagon they soon left far behind. Harriet had watched them breathlessly until they disappeared on a curve of the road; then she whispered to Charlotte.

A little after noon the two old women crept slowly up the foot-path across the field to their old home.

"The clover is up to our knees," said Harriet; "an' the sorrel and the white-weed; an' there's lots of yaller butterflies."

"O Lord, Harriét, thar's a chink, an' I do believe I saw one of them yaller butterflies go past it," cried Charlotte, trembling all over, and nodding her gray head violently.

Harriet stood on the old sunken door-step and fitted the key, which she drew triumphantly from her pocket, in the lock, while Charlotte stood waiting and shaking behind her.

Then they went in. Everything was there just as they had left it. Charlotte sank down on a chair and began to cry. Harriet hurried across to the window that looked out on the garden.

"The currants air ripe," said she; *"an'* them pumpkins hev run all over everything."

"O Lord, Harriét," sobbed Charlotte, "thar is so many chinks that they air all runnin' together!"

FOR DISCUSSION

1. Why is it important for Harriet to "show some spirit" by belittling Mrs. Simonds's doughnuts and inquiries about the two sisters' living arrangements? What other examples of spirit do Harriet and Charlotte show in this story?

2. The life-style and needs of the two sisters conflict with Mrs. Simonds's well-meant attempts to help them. How does this conflict result in "mistaken charity"?
3. Notice the many references to "chinks." How does the meaning of the word change in the story? Why is it significant that Charlotte thinks she sees a yellow butterfly go past one?
4. Have you ever found it easier to give than to receive? Have you ever been an unwilling receiver of someone else's need to give? Describe how you felt in these situations.
5. What stereotyped role does Mrs. Simonds fit? Where else, in your own reading and experience, have you seen this kind of female stereotype?

INTRODUCTION

In the following poem, Minerva Allen describes a woman who has lived a full life and now waits, somewhat wearily, "to meet old friends again." What are the differences between this woman waiting to move out of life and the sisters you just met?

She Is Alone

Minerva Allen

She is alone
wrinkled and gray.

Alone with clear memories.

Hard work shows its reflection on her. Tired
worn feet and hands. Holes in her teeth where 5
sinew was pulled. Eyes dimmed so light & dark
have no meaning. Hands tired & worn from tanning hides
and buffalo robes. She's too weary to think and hope.

Loneliness she has, for long time friends
who have gone away. Many moons & suns have passed; 10
time has no meaning, but life keeps marching on.

Old songs. Smell of pipe smoke.
Dry meat cooking brings the past back clear

 set aside to wait
 to meet old friends again. 15

FOR DISCUSSION

1. Why has time lost its meaning for the woman in the poem?
2. Does the loneliness of the woman result from an unfulfilled life? Explain. What resources does she call upon to combat this loneliness?

INTRODUCTION

This selection is a critical essay on Charlotte Brontë's novel *Jane Eyre.* The reading may be somewhat tough here, but the piece is important for at least two reasons. First, Jane Eyre is an excellent example of a young woman freeing herself from a crippling heritage. Second, the format of the piece is one that you might want to follow, learning how to use both primary and secondary source material to illustrate your ideas. As you read, try to keep in mind the differences between the format of this selection and others—biography, short story, poem—that you have read thus far.

Jane Eyre: The Temptations of a Motherless Woman

Adrienne Rich

Like Thackeray's daughters, I read *Jane Eyre* in childhood, carried away "as by a whirlwind." Returning to Charlotte Brontë's most famous novel, as I did over and over in adolescence, in my twenties, thirties, now in my forties. I have never lost the sense that it contains, through and beyond the force of its creator's imagination, some nourishment I needed then and still need today. Other novels often ranked greater, such as *Persuasion, Middlemarch, Jude the Obscure, Madame Bovary, Anna Karenina, The Portrait of a Lady*—all offered their contradictory and compelling versions of what it meant to be born a woman. But *Jane Eyre* has for us now a special force and survival value.

Comparing *Jane Eyre* to *Wuthering Heights*, as people tend to do, Virginia Woolf had this to say:

The drawbacks of being Jane Eyre are not far to seek. Always to be a governess and always to be in love is a serious limitation in a world which is full, after all, of people who are neither one nor the other. . . . [Charlotte Brontë] *does not attempt to solve the problems of human life; she is even unaware that such problems exist; all her force, which is the more tremendous for being constricted, goes into the assertion, "I love," "I hate," "I suffer"* . . . [Virginia Woolf, *The Common Reader.* Vintage Harvest Books, pp. 161–2.]

She goes on to state that Emily Brontë is a greater poet than Charlotte because "there is no 'I' in *Wuthering Heights.* There are no governesses. There are no employers. There is love, but not the love of men and women." In short, and here I would agree with her, *Wuthering Heights* is mythic. The bond between Catherine and Heathcliff is the archetypal bond between the split fragments of the psyche, the masculine and feminine elements ripped apart and longing for reunion. But *Jane Eyre* is different from *Wuthering Heights,* and not because Charlotte Brontë lodged her people in a world of governesses and employers, of the love between men and women. *Jane Eyre* is not a novel in the Tolstoyan, the Flaubertian, even the Hardyesque sense. *Jane Eyre* is a tale.

The concern of the tale is not with social mores, though social mores may occur among the risks and challenges encountered by the protagonist. Neither is it an anatomy of the psyche, the fated chemistry of cosmic forces. It takes its place between the two: between the realm of the given, that which is changeable by human activity, and the realm of the fated, that which lies outside human control: between realism and poetry. The world of the tale is above all a "vale of soul-making," and when a novelist finds herself writing a tale, it is likely to be because she is moved by that vibration of experience which underlies the social and political, though it constantly feeds into both of these.

In her essay on *Jane Eyre,* critic Q. D. Leavis perceives the novel's theme as ". . . an exploration of how a woman comes to maturity in the world of the writer's youth." [Q. D. Leavis, Introduction to *Jane Eyre.* Penguin Books, p. 11.] I would

suggest that a novel about how a man "comes to maturity in the world of the writer's youth"—*Portrait of the Artist,* for example—would not be dismissed as lacking in range, or, in Woolf's words, a sense of "human problems." I would suggest further, that Charlotte Brontë is writing—not a *Bildungsroman*—but the life story of a woman who is *incapable* of saying *I am Heathcliff* (as the heroine of Emily's novel does) because she feels so unalterably herself. Jane Eyre, motherless and economically powerless, undergoes certain traditional female temptations, and finds that each temptation presents itself along with an alternative—the image of a nurturing or principled or spirited woman on whom she can model herself, or to whom she can look for support.

II

In her recent book, *Women and Madness* (Doubleday), Phyllis Chesler notes that "women are motherless children in patriarchal society." By this she means that women have had neither power nor wealth to hand on to their daughters; they have been dependent on men as children are on women; and the most they can do is teach their daughters the tricks of surviving in the patriarchy by pleasing, and attaching themselves to, powerful or economically viable men. Even the heiress in 19th-century fiction is incomplete without a man; her wealth, like Dorothea Brooke's or Isabel Archer's, must be devoted to the support of some masculine talent or dilettantism; economically the heiress is, simply, a "good match" and marriage her only real profession. In 19th-century England the poor and genteel woman had one possible source of independence if she did not marry: the profession of governess. But, as I have suggested, Jane Eyre is *not* "always a governess." She addresses us first as a literally motherless, and also fatherless, child under the guardianship of her aunt, Mrs. Reed, who despises and oppresses her. The tale opens with images of coldness, bleakness, banishment. Jane is seated behind the curtains in a window-embrasure, trying to conceal herself from her aunt, her two girl cousins, and her boorish boy cousin John. With the icy coldness of the winter landscape outside on one hand, this chilly family circle on the

other, she looks at a book of engravings of Arctic wastes and legendary regions of winter.

III

Moments after the novel begins, John Reed provokes Jane's childish rage by striking her in the face and taunting her with her poverty and dependency. Thus, immediately, the political/social circumstances of Jane's life are established: as a female she is exposed to male physical brutality and whim; as an economically helpless person she is vulnerable in a highly class-conscious society. Her response to John's gratuitous cruelty is to "fly at him" and threat to be dragged off and locked into the "Red Room," where her uncle had died and which is rumored to be a haunted chamber.

Here begins the ordeal which represents Jane's first temptation. For a powerless little girl in a hostile household, where both psychic and physical violence are used against her, used indeed to punish her very spiritedness and individuality, the temptation of victimization is never far away. To see herself as the sacrificial lamb or scapegoat of this household, and act out that role, or conversely to explode into violent and self-destructive hysterics which can only bring on more punishment and victimization, are alternatives all too ready at hand.

In the Red Room, Jane experiences the bitter isolation of the outsider, the powerlessness of the scapegoat to please, the abjectness of the victim. But above all, she experiences her situation as unnatural:

> *Unjust!—unjust! said my reason, forced by the agonizing stimulus into precocious though transitory power; and Resolve, equally wrought up, instigated some strange expedient to achieve escape from insupportable oppression—as running away, or if that could not be effected, never eating or drinking more, and letting myself die.*

I want to recall to you that the person who is going through this illumination—for "dark" and "turbid" as her feelings are, they are illuminating—is a girl of ten, without material means or

any known recourse in the outer world, dependent on the household she lives in for physical support and whatever strands of human warmth she can cling to. She is, even so, conscious that it could be otherwise; she imagines alternatives, though desperate ones. It is at this moment that the germ of the person we are finally to know as Jane Eyre is born: a person determined to live, and to choose her life with dignity, integrity, and pride.

Jane's passion in the Red Room comes to its climax; she hallucinates, screams, is thrust back into the dreaded deathchamber, and blacks out. Her ensuing illness, like much female illness, is an acting-out of her powerlessness and need for affection, and a psychic crisis induced by these conditions. During her convalescence from this "fit," she experiences for the first time the decency of the family apothecary and the gentle and caring side of the sharp-tongued young servant Bessie. Bessie is the first woman to show Jane affection; and it is partly the alliance with her that makes it possible for the child Jane to maintain her hope for the future, her will to survive; which prevents her from running away—a self-destructive act under the circumstances—or from relapsing into mere hysteria or depression. It is this, too, which helps her retain the self-respect and the spirit of rebellion in which she finally confronts her aunt:

Shaking from head to foot, thrilled with ungovernable excitement, I continued—

"I am glad you are no relation of mine. I will never call you aunt again as long as I live. I will never come to see you when I am grown up; and if anyone asks me how I liked you, and how you treated me, I will say the very thought of you makes me sick, and that you treated me with miserable cruelty."

. . . Ere I had finished this reply, my soul began to expand, to exult, with the strangest sense of freedom, of triumph, I ever felt. It seemed as if an invisible bond had burst and that I had struggled out into unhoped-for liberty.

This outburst, like much anger of the powerless, leaves Jane only briefly elated. The depressive, self-punishing reac-

tion sets in; she is only pulled out of it by Bessie's appearance and a confirmed sense of Bessie's affection and respect for her. Bessie tells her that she must not act afraid of people, because it will make them dislike her—an odd aslant bit of counsel, yet Jane's precocious courage is able to respond. The next chapter finds Jane on her way to Lowood Institution.

IV

Lowood is a charity school for the poor or orphaned genteel female destined to become a governess. It is a school for the poor controlled by the rich, an all-female world presided over by the hollow, Pharisaical male figure of Mr. Brocklehurst. He is the embodiment of class and sexual double-standards and of the hypocrisy of the powerful, using religion, charity, and morality to keep the poor in their place and to repress and humiliate the young women over whom he is set in charge. He is absolute ruler of this little world. However, within it, and in spite of his sadistic public humiliation of her, Jane finds two women unlike any she has ever met: the superintendent Miss Temple, and the older student Helen Burns.

Miss Temple has no power in the world at large, or against Mr. Brocklehurst's edicts; but she has great personal attractiveness, mental and spiritual charm and strength. Unlike the Reeds, she is of gentle birth yet not a snob; unlike Bessie she is not merely sympathetic but admirable. She cannot change the institution she is hired to administer but she does quietly try to make life more bearable for its inmates. She is maternal in a special sense: not simply sheltering and protective, but encouraging of intellectual growth. Of her Jane says later in the novel:

> . . . to her instruction, I owed the best part of my acquirements; her friendship and society had been my continual solace; she had stood me in the stead of mother, governess, and, latterly, companion.

Helen Burns is strong of will, awkward and blundering in the practical world yet intellectually and spiritually mature beyond her years. Severe, mystical, convinced of the transitory

and insignificant nature of earthly life, she still responds to Jane's hunger for contact with a humane and sisterly concern. She is consumptive, soon to die, burning with an other-worldly intensity. Jane experiences Helen's religious asceticism as something impossible for herself, tinged with "an inexpressible sadness"; yet Helen gives her a glimpse of female character without pettiness, hysteria, or self-repudiation; it is Helen who tells her,

> *"If all the world hated you, and believed you wicked, while your own conscience approved you, and absolved you from guilt, you would not be without friends."*

Both Miss Temple's self-respect and sympathy, and Helen's transcendent philosophical detachment, are needed by Jane after her earthly humiliation by Mr. Brocklehurst. For if at Gateshead Hall Jane's temptations were victimization and hysteria, at Lowood, after her public ordeal, they are self-hatred and self-immolation.

Jane is acutely conscious of her need for love: she expresses it passionately to Helen Burns.

> *". . . to gain some real affection from you, or Miss Temple, or any other whom I truly love, I would willingly submit to have the bone of my arm broken, or to let a bull toss me, or to stand behind a kicking horse, and let it dash its hoof at my chest—"*

Her need for love is compounded with a female sense that love must be purchased through suffering and self-sacrifice; the images that come to her are images of willing submission to violence, of masochism. Helen calms her, tells her she thinks "too much of the love of human beings," calls on her to think beyond this life to the reward God has prepared for the innocent beyond the grave. Like Simone Weil, like St. Teresa, like Héloïse, Helen Burns substitutes a masculine God for the love of earthly men (or women)—a pattern followed by certain gifted imaginative women in the Christian era.

The discipline of Lowood and the moral and intellectual force of Helen and Miss Temple combine to give the young Jane a sense of her own worth and of ethical choice. Helen dies of consumption with Jane in her arms held like "a little child"; Miss Temple later marries an "excellent clergyman" and leaves Lowood. Thus Jane loses her first real mothers. Yet her separation from these two women enables Jane to move forward into a wider realm of experience.

> *My world had for some years been in Lowood: my experience had been of its rules and systems; now I remembered that the real world was wide . . .*
>
> *I desired liberty; for liberty I gasped; for liberty I uttered a prayer; it seemed scattered on the wind then faintly blowing. I abandoned it and framed a humbler supplication. For change, stimulus. That petition, too, seemed swept off into vague space. "Then," I cried, half desperate, "grant me at least a new servitude!"*

One of the impressive qualities of Charlotte Brontë's heroines, the quality which makes them more valuable to the woman reader than Anna Karenina, Emma Bovary, and Catherine Earnshaw combined, is their determined refusal of the romantic. They are not immune to it; in fact, they are far more tempted by it than are the cooler-headed heroines of Jane Austen; there is far more in their circumstances of orphaned wandering and intellectual eroticism to heat their imaginations—they *have*, in fact, more imagination. Jane Eyre is a passionate girl and woman; but she displays early an inner clarity which helps her to distinguish between intense feelings which can lead to greater fulfillment, and those which can only lead to self-destructiveness. The thrill of masochism is not for her, though it is one of her temptations as we have seen; having tasted a drop of it, she rejects it. In the central episode of the novel, her meeting with Mr. Rochester at Thornfield, Jane, young, inexperienced, and hungry for experience, has to confront the central temptation of the female condition—the temptation of romantic love and surrender.

V

It is interesting that the Thornfield episode is often recalled or referred to as if it *were* the novel *Jane Eyre*. So truncated and abridged, that novel would become the following: A young woman arrives as governess at a large country house inhabited by a small French girl and an older housekeeper. She is told that the child is the ward of the master of the house, who is traveling abroad. Presently the master comes home and the governess falls in love with him, and he with her. Several mysterious and violent incidents occur in the house which seem to center around one of the servants, and which the master tells the governess will all be explained once they are married. On the wedding day, it is revealed that he has a wife still alive, a madwoman who is kept under guard in the upper part of the house and who is the source of the sinister incidents. The governess decides that her only course of action is to leave her lover forever. She steals away from the house and settles in another part of the country. After some time she returns to the manor house to find it has burned to the ground, the madwoman is dead, and her lover, though blinded and maimed by the fire, is free to marry her.

Thus described, the novel becomes a blend of Gothic horror and Victorian morality. That novel might have been written by many a contributor to ladies' magazines, but it is not the novel written by Charlotte Brontë. If the Thornfield episode is central, it is because in it Jane comes to womanhood and to certain definitive choices about what it means to her to be a woman. There are three aspects of this episode: the house, Thornfield itself; Mr. Rochester, the Man; and the madwoman, Jane's alter ego.

Charlotte Brontë gives us an extremely detailed and poetically convincing vision of Thornfield. Jane reaches its door by darkness, after a long journey; she scarcely knows what the house is like till the next day when Mrs. Fairfax, the housekeeper, takes her through it on a tour which ends in the upper regions, on the rooftop. The reader's sense of its luxury, its isolation, and its mysteries is precisely Jane's, seen with the eyes of a young woman just come from the dormitory of a charity

school—a young woman of strong sensuality. But it is the upper regions of the house which are of crucial importance—the part of the house Jane lives in least, yet which most affects her life. Here she first hears that laugh—"distinct, formal, mirthless" —which is ascribed to the servant Grace Poole and which she will later hear outside her own bedroom door. Here, too, standing on the roof, or walking up and down in the corridor, close to the very door behind which the madwoman is kept hidden, she gives silent vent to those feelings which are introduced by the telling phrase: "Anybody may blame me who likes . . ."

The phrase introduces a passage which is Charlotte Brontë's feminist manifesto. Written one hundred and twenty-six years ago, it is still having to be written over and over today, in different language but with essentially the same sense that sentiments of this kind are still unacceptable to many, and that in uttering them one lays oneself open to blame and to entrenched resistance:

> *It is in vain to say human beings ought to be satisfied with tranquility: they must have action; and they will make it if they cannot find it. Millions are condemned to a stiller doom than mine, and millions are in silent revolt against their lot. Nobody knows how many rebellions besides political rebellions ferment in the masses of life which people earth. Women are supposed to be very calm generally; but women feel just as men feel; they need exercise for their faculties, and a field for their efforts as much as their brothers do; they suffer from too rigid a restraint, too absolute a stagnation, precisely as men would suffer; and it is narrow-minded in their more privileged fellow-creatures to say that they ought to confine themselves to making puddings and knitting stockings, to playing on the piano and embroidering bags. It is thoughtless to condemn them, or laugh at them, if they seek to do more or learn more than custom has pronounced necessary for their sex.*

Immediately thereafter we are made to hear again the laugh of the madwoman. I want to remind you of another mad wife who appears in a novel of our own time—the woman Lynda in

The Temptations of a Motherless Woman 121

Doris Lessing's *The Four-Gated City* (Knopf), who inhabits not the upper story but the cellar, and with whom the heroine Martha (like Jane Eyre an employee and in love with her employer) finally goes to live, experiencing her madness with her.

For Jane Eyre, the upper regions are not what Gaston Bachelard calls in *The Poetics of Space* "the rationality of the roof" as opposed to the unconscious and haunted world of the cellar. [Gaston Bachelard, *The Poetics of Space.* Orin Press, pp. 17–18.] Or, the roof is where Jane is visited by an expanding vision, but this vision, this illumination, brings her close to the madwoman captive behind the door. In Lessing's novel the madwoman is herself a source of illumination. Jane has no such contact with Bertha Rochester. Yet Jane's sense of herself as a woman—as equal to and with the same needs as a man—is next-door to insanity in England in the 1840s. Jane never feels herself to be going mad, but there is a madwoman in the house who exists as her opposite, her image horribly distorted in a warped mirror, a threat to her happiness. Just as her instinct for self-preservation saves her from earlier temptations, so it must save her from becoming this woman by curbing her imagination at the limits of what is bearable for a powerless woman in the England of the 1840s.

VI

We see little of Bertha Rochester; she is heard and sensed rather than seen. Her presence is revealed by three acts when she escapes into the inhabited part of the house. Two of these are acts of violence against men—the attempted burning of Mr. Rochester in his bedchamber, and the stabbing of her brother when he visits Thornfield. The third act is the visit to Jane's bedroom on the night before her wedding and the tearing of the wedding veil, the symbol of matrimony. (She does not, interestingly enough, attack Jane.) Only after Bertha's existence is publicly revealed is Jane taken into the madwoman's chamber and sees again, waking, "that purple face—those bloated features." Bertha is described as big, corpulent, virile, with a "grizzled mane" of hair like an animal's; earlier Jane had seen her as re-

sembling "the foul German spectre—the Vampyr." In all this she is the antithesis of Jane, as Mr. Rochester points out:

> *"That is my wife," said he. "Such is the sole conjugal embrace I am ever to know—such are the endearments which are to solace my leisure hours! And this is what I wished to have" (laying his hand on my shoulder) "this young girl, who stands so grave and quiet at the mouth of hell, looking collectedly at the gambols of a demon . . ."*

In his long account of the circumstances of his marriage to Bertha—a marriage arranged for financial reasons by his father, but which he undertook for Bertha's dark sensual beauty—Rochester makes no pretense that he was not acting out of lust. Yet he repeatedly asserts *her* coarseness, "at once intemperate and unchaste," as the central fact of his loathing for her. Once she is pronounced mad, he has her locked up, and goes forth on a life of sexual adventures, one result of which has been the child Adèle, daughter of his French mistress. Rochester's story is part Byronic romance, but it is based on a social and psychological reality: the 19th-century loose woman might have sexual feelings, but the 19th-century *wife* did not and must not; Rochester's loathing of Bertha is described repeatedly in terms of her physical strength and her violent will—both unacceptable qualities in the 19th-century female, raised to the nth degree and embodied in a monster.

VII

Mr. Rochester is often seen as the romantic Man of Fate, Byronic, brooding, sexual. But his role in the book is more interesting: he is certainly that which culture sees as Jane's fate, but he is not the fate she has been seeking. When she leaves Lowood for Thornfield, when she stands on the roof of Thornfield or walks across its fields longing for a wider, more expansive life, she is not longing for a man. We do not know what she longs for, she herself does not know; she uses terms like liberty, a new servitude, action. Yet the man appears, romantically and mysteriously, in the dusk, riding his horse—and slips and falls

The Temptations of a Motherless Woman 123

on the ice, so that Jane's first contact with him is with someone in need of help; he has to lean on her to regain his seat on horseback. Again at the novel's end it is she who must lead him, blinded by fire. There is something more working here than the introduction of a stock romantic hero.

Mr. Rochester offers Jane wider horizons than any she has known; travel, riches, brilliant society. Throughout the courtship there is a tension between her growing passion for him and her dislike of and uneasiness with the *style* of his lovemaking. It is not Rochester's sensuality that brings her up short, but his tendency to make her his object, his creature, to want to dress her up, lavish jewels on her, remake her in another image. She strenuously resists being romanticized as a beauty or a houri; she will, she tells him, be no part of his harem.

In his determination to possess Jane, Rochester is arrogant enough to lie to her three times. During the house party at which Jane, as governess, has to suffer the condescension and contempt of the ladies of the neighborhood, Rochester, disguised as an old Gypsy woman, comes to the door to read fortunes, and he attempts to trick Jane into revealing her feelings for him. It is clear, in this scene, that Rochester is well aware of the strength of Jane's character and is uneasy as to the outcome of his courtship and the kind of marriage he is going to propose to her. In making as if to read Jane's fate in her features, he tells her:

> ". . . that brow professes to say—'I can live alone, if self-respect and circumstances require me to do so. I need not sell my soul to buy bliss. I have an inward treasure born with me, which can keep me alive if all the extraneous delights should be withheld, or offered only at a price I cannot afford to give.'"

Abruptly, at the end of this scene, he reveals himself. But he continues to carry on a flirtation with the heiress Miss Ingram, in order to arouse Jane's jealousy; he pretends to the last possible moment that he intends to marry Miss Ingram, till Jane, in turmoil at the prospect, confesses her grief at having to leave him. Her grief—but also, her anger at the position in which she has been placed:

"I tell you I must go!" I retorted, roused to something like passion. "Do you think I can stay to become nothing to you? Do you think I am automaton?—a machine without feelings? . . . Do you think because I am poor, obscure, plain, and little, I am soulless and heartless? You think wrong!—I have as much soul as you—and full as much heart! . . . I am not talking to you now through the medium of custom, conventionalities, nor even of mortal flesh: it is my spirit that addresses your spirit; just as if both had passed through the grave and we stood at God's feet, equal—as we are!"

(Always a governess and always in love? Had Virginia Woolf really read this novel?)

VIII

Jane's parting interview with Mr. Rochester is agonizing; he plays on every chord of her love, her pity and sympathy, her vulnerability. On going to bed, she has a dream. Carried back to the Red Room, the scene of her first temptation, her first ordeal, in the dream, Jane is reminded of the "syncope," or swoon, she underwent there, which became a turning point for her; she is then visited by the moon, symbol of the matriarchal spirit and the "Great Mother of the night sky." [Erich Neumann, *The Great Mother.* Bollengen Press, pp. 55–59.]

I watched her come—watched with the strangest anticipation; as though some word of doom were to be written on her disc. She broke forth as moon never yet burst from cloud: a hand first penetrated the sable folds and waved them away; then, not a moon, but a white human form shone in the azure, inclining a glorious brow earthward. It gazed and gazed on me. It spoke to my spirit: immeasurably distant was the tone, yet so near, it whispered in my heart—
"My daughter, flee temptation."
"Mother, I will."

The Temptations of a Motherless Woman

Her dream is profoundly, imperiously, archetypal. She is in danger, as she was in the Red Room; but her own spiritual consciousness is stronger in womanhood than it was in childhood: she is in touch with the matriarchal aspect of her psyche which now warns and protects her against that which threatens her integrity. Bessie, Miss Temple, Helen Burns, even at moments the gentle housekeeper Mrs. Fairfax, have acted as mediators for her along the way she has come thus far; even, it may be said, the terrible figure of Bertha has come between Jane and a marriage which was not yet ripe, which would have made her simply the dependent adjunct of Mr. Rochester instead of his equal. Individual women have helped Jane Eyre to the point of her severest trial; at that point she is in relation to the Great Mother herself. On waking from this dream, she leaves Thornfield, with a few pieces of clothing and twenty shillings in her purse, to set forth on foot to an unknown destination.

Jane's rebellion against Rochester's arrogance—for in pleading with her to stay with him against the laws of her own integrity, he is still arrogant—forces her to act on her own behalf even if it causes him intense suffering, even though she still loves him. Like many women in similar circumstances, she feels that such an act of self-preservation requires her to pay dearly. She goes out into the world without a future, without money, without plans—a "poor, obscure, plain, and little" figure of a woman, risking exposure to the elements, ostracism, starvation. By an act which one can read as a final unconscious sacrificial gesture, she forgets her purse with its few shillings in the stagecoach, and thus is absolutely destitute, forced to beg for the leftovers a farmer's wife is about to feed to her pig. In this whole portion of the novel, in which Jane moves through the landscape utterly alone, there is a strong counterpull between female self-immolation—the temptation of passive suicide—and the will and courage which are her survival tools.

She is literally saved from death by two sisters, Diana and Mary, living in a parsonage with their brother, the clergyman St. John Rivers. Diana and Mary bear the names of the pagan and Christian aspects of the Great Goddess—Diana or Artemis, the Virgin huntress, and Mary the Virgin Mother. These women are unmarried bluestockings; they delight in learning; in their re-

mote parsonage they study German and read poetry aloud. They live as intellectual equals with their brother; yet with Jane, in her illness and convalescence, they are maternally tender and sensitive. As time passes and Jane recovers and begins to teach in the village school, Diana and Mary become her friends; for the first time since the death of Helen Burns she has an intellectually sympathetic companionship with young women of her own age.

Once again, a man offers her marriage. St. John has been observing her for his own purposes, and finding her "docile, diligent, disinterested, faithful, constant, and courageous; very gentle, and very heroic" he invites her to accompany him as his fellow-missionary to India, where he intends to live and die in the service of his God. He needs a helpmate to work among Indian women; he offers her marriage without love, a marriage of duty and service to a cause. The cause is of course defined by him; it is the cause of patriarchal religion: self-denying, stern, prideful, and ascetic. In a sense he offers her the destiny of Milton's Eve: "He for God only, she for God in him." What St. John offers Jane is perhaps the deepest lure for a spiritual woman, that of adopting a man's cause or career and making it her own. For more than one woman, still today, the felt energy of her own existence is still diffuse, the possibilities of her life vague; the man who pressures to define it for her may be her most confusing temptation. *He* will give shape to her search for meaning, her desire for service, her feminine urge toward self-abnegation: in short—as Jane becomes soon aware—he will *use* her.

But St. John is offering Jane this "meaning" under the rubric of marriage—and from this "use" of herself she draws back in healthy repulsion.

> *Can I receive from him the bridal ring, endure all the forms of love (which I doubt not he would scrupulously observe) and know that the spirit was quite absent? Can I bear the consciousness that every endearment he bestows is a sacrifice made on principle? No: such martyrdom would be monstrous. . . .*
>
> *As his curate, his comrade, all would be right: I would*

cross oceans with him in that capacity; toil under Eastern suns, in Asian deserts with him . . . admire and emulate his courage and devotion . . . smile undisturbed at his ineradicable ambition; discriminate the Christian from the man; profoundly esteem the one, and freely forgive the other. . . . But as his wife—at his side always, and always restrained, and always checked—forced to keep the fire of my nature continually low . . . this would be unendurable. . . .

"If I were to marry you, you would kill me. You are killing me now" [she tells him].

His lips and cheeks turned white—quite white.

"I should kill you—I am killing you? Your words are such as ought not to be used—they are violent, unfeminine [sic!] *and untrue . . ."*

So she refuses his cause; and so he meets her refusal. In the meantime she has inherited an income; she has become independent; and at this point an extrasensory experience calls her back to Thornfield.

IX

"Reader, I married him." These words open the final chapter of *Jane Eyre.* The question is, how and why is this a happy ending? Jane returns to Thornfield to find it "a blackened ruin"; she discovers Rochester, his left hand amputated and his eyes blinded by the fire in which he vainly attempted to save the life of his mad wife. Rochester has paid his dues; a Freudian critic would say he has been symbolically castrated. Discarding this phallic-patriarchal notion of his ordeal, we can then ask, what kind of marriage is possible for a woman like Jane Eyre? Certainly not marriage with a castrate, psychic or physical. (St. John repels Jane in part because he is *emotionally* castrated.) The wind that blows through this novel is the wind of sexual equality—spiritual and practical. The passion that Jane feels as a girl of twenty or as a wife of thirty is the same passion—that of a strong spirit demanding its counterpart in another. Mr. Rochester needs Jane now—

". . . to bear with my infirmities . . . to overlook my deficiencies."

"Which are none, sir, to me."

She feels, after ten years of marriage, that "I am my husband's life as fully as he is mine." This feeling is not that of romantic love or romantic marriage.

To be together is for us to be at once as free as in solitude, as gay as in company. We talk—I believe, all day long; to talk to each other is but a more animated and an audible thinking.

Coming to her husband in economic independence and by her free choice, Jane can become a wife without sacrificing a grain of her Jane Eyre-ity. Charlotte Brontë sets up the possibility of this relationship in the early passages of the Thornfield episode, the verbal sparring of this couple who so robustly refuse to act out the paradigms of romantic, Gothic fiction. We believe in the erotic and intellectual sympathy of this marriage because it has been prepared by the woman's refusal to accept it under circumstances which were mythic, romantic, or sexually oppressive. The last paragraphs of the novel concern St. John Rivers: whose ambition is that of "the high master-spirit, which aims to a place in the first rank of those who are redeemed from the earth—who stand without fault before the throne of God, who share the last victories of the Lamb, who are called, and chosen, and faithful." We can translate St. John's purism into any of a number of kinds of patriarchal arrogance of our own day, whether political, intellectual, aesthetic, or religious. It is clear that Charlotte Brontë believes that human relations require something quite different: a transaction between people which is "without painful shame or damping humiliation" and in which nobody is made into an object for the use of anybody else.

In telling the tale of Jane Eyre, Charlotte Brontë was quite conscious, as she informed her publisher, that she was not telling a moral tale. Jane is not bound by orthodoxy, though superficially she is a creature of her time and place. As a child, she rejects the sacredness of adult authority; as a woman, she insists on

The Temptations of a Motherless Woman 129

regulating her conduct by the pulse of her own integrity. She will not live with Rochester as his dependent mistress because she knows that relationship would become destructive to her; she would live unmarried with St. John as an independent co-worker; it is he who insists this would be immoral. The beauty and depth of the novel lie in part in its depiction of alternatives—to convention and traditional piety, yes, but also to social and cultural reflexes internalized within the female psyche. In *Jane Eyre*, moreover, we find an alternative to the stereotypical rivalry of women; we see women in real and supportive relationship to each other, not simply as points on a triangle or as temporary substitutes for men. Marriage is the completion of the life of Jane Eyre, as it is for Miss Temple and Diana and Mary Rivers; but for Jane at least it is marriage radically understood for its period, in no sense merely a solution or a goal. It is not patriarchal marriage in the sense of a marriage that stunts and diminishes the woman; but a continuation of this woman's creation of herself.

FOR DISCUSSION

1. How does Adrienne Rich introduce her main idea? Could you put that main idea into your own words? After reading the selection carefully, perhaps more than once, try to make an outline of the key points Rich makes about the character Jane Eyre.
2. Look back at the study questions in Part One: Heritage. How is Jane Eyre like or unlike the people there? How is her heritage related to that of the people you read about earlier—Joan Baez's, for example?
3. Is Jane Eyre more alone than other people you've read about in this text? For what reasons?

ACTIVITY

Read *Jane Eyre*. Write a critical interpretation of your own, using Rich's ideas as a starting place. Quote parts of the novel to support your ideas.

INTRODUCTION

Mountain Wolf Woman, like the sisters in "A Mistaken Charity," has a vigorous strength of spirit. Through two marriages and for over twenty years after her last husband's death, she has kept her sense of independence. She had the courage to leave a husband she hated who was chosen for her, and she decided that her children would choose their own mates. Self-sufficient even at the age of seventy-three, she refuses the offers of help from her children, preferring to take care of herself.

Mountain Wolf Woman: Excerpts from Her Autobiography

Nancy Oestrich Lurie

Mountain Wolf Woman, a Winnebago Indian, was born in Wisconsin, the youngest of eight children in the family. She was seventy-three years old when she permitted her adopted kinswoman, anthropologist Nancy Lurie, to tape-record reminiscences of her life. Mountain Wolf Woman spoke first in Winnebago, and then immediately translated her own words into English.

Traditionally, the Winnebagos subsisted by male hunting and female gardening and wild food gathering. As the tribes were driven from their homelands by white settlers, they gradually became dependent on a cash economy and went to work harvesting crops for white employers or producing basketry and beadwork for the increasing tourist trade. Mountain Wolf Woman became a basketmaker, although this is not remarked upon in her autobiography. As Dr. Lurie notes in an appendix to the reminiscences, "Mountain Wolf Woman takes her produc-

tive activity so much for granted that she does not even mention that during most of her adult life and throughout her wide travels and changes of residence she has made baskets to obtain cash. She implies that men are the providers and speaks approvingly of her second husband as industrious. In plain fact, she has always contributed a large amount to the family income and furthermore exercised primary control over family finances."

Mountain Wolf Woman died in her sleep, at her home in Black River Falls, Wisconsin, after having caught pneumonia and pleurisy while sealing up windows and preparing her house for the winter months. Her life spanned traveling by pony to flying in an airplane, from baking bread in the embers of an open fire to purchasing a television set for her young granddaughters as an inducement for them to stay home evenings.

Earliest Recollections

Mother said she had me at our grandfather's home,—at East Fork River. We lived there in the spring, April, at the time they were making maple sugar. She said that after a while the weather became pleasant, everything was nice and green, and we moved from this place back to where we usually lived,—at Levis Creek, near Black River Falls. There father built a log house. I suppose it took a long time to build it because mother said the log house was newly finished when I walked there for the first time. There, where we regularly lived, mother and father planted their garden.

In the summer that followed the second spring,—after my first birthday, we went to Black River Falls. Mother, oldest sister White Thunder and I went to town. We were returning and mother carried me on her back. I was restless and she had taken me off the cradleboard. I remember being there on mother's back. We crossed a creek and I saw the water swirling swiftly. Mother said, "Ahead is your older sister." A woman was walking in front of us carrying an empty cradleboard. I saw that she held up her skirt just high enough to wade through the water. After that I forgot.

Once I asked mother if that ever happened. I told her what I had seen.

"Oh," mother said, "I remember, that was your oldest sister White Thunder who carried your empty cradle on her back.—Do you remember that?"

"Yes," I said.

"You were probably frightened," she said, "and perhaps that is why you remember."

White Thunder was the oldest child in our family and Crashing Thunder was second. Then followed second older sister Wihanga Bald Eagle. Next was Henaga, the second son; he was called Strikes Standing. Then came the third son, Hagaga, and he was called Big Winnebago. Haksigaga, the third daughter, died when she was quite small. They did not know how this death came about. However, there was an old lady who was related to my mother, and any time that my father brought home deer from hunting, summer, winter, any time my father killed deer, this old lady got some. Yet, the old lady was envious of my mother about her share of the meat. Mother used to say that she poisoned Haksigaga. She killed her because of jealousy about meat. Next was the fourth daughter Hinakega. She was called Distant Flashes Standing. And then I was the last child.—"Poor quality" they used to say of that one.

According to Winnebago tradition, children were given sex-birth order names along with more formal names aligned with their particular clan. After the fourth son, succeeding boys' names were diminutive forms of that given the fourth, while succeeding girls' names after the fourth daughter were diminutive forms of the third girl's name. Mountain Wolf Woman's sex-birth order name was Haksigaxunuga. She was usually called Haksigaxununinka—Little Fifth Daughter— because of her small size.

Once when I recalled that we camped at a place where the country was very beautiful, Mother said, "You were then about two years old." I remember there was a fish there. That beauti-

ful country where we were camping was at Black River Falls at the old depot in back of what is now the general store. There was not a house around.

We lived there in the spring of the year and my father fished. I suppose all of the Indians fished. There my father speared a big fish, an enormous fish, a sturgeon. When my father brought it home, carrying it over his shoulder, the tail dragged on the ground.

He brought it back to where we were living. There I saw this big fish that looked like a man with a big fat belly, lying on his side with his belly protruding. I remembered that and then I forgot.

We must have been camped at the Black River where the bank is very steep. There they lost me and everybody helped my mother look for me.

They were afraid I fell in the water there, over on that high bank. There was an old lady and my mother brought her tobacco. Anything they asked of her, the old lady always knew the answer. They brought her tobacco because she was able to do this. Before she was able to say anything, somebody came back from town. They all said, "Sigaxunuga is lost! Sigaxunuga is lost!"

Then the person who returned from town said, "Oh, her father is in town with his daughter, leading her by the hand."

It seems that father was going toward town. On the way there was a cow which was probably tethered there and I was frightened by that cow. Father did not know that I was following along behind him. Evidently, in fear of that cow, I began to cry. Then father led me by the hand. He went to town, taking me with him. In time we returned, and so they brought me back alive.

We probably went back to our home again that spring as it must have been at that time that I was sick. I was very sick and my mother wanted me to live. She hoped that I would not die, but she did not know what to do. At that place there was an old lady whose name was Wolf Woman and mother had them bring her. Mother took me and let the old woman hold me.

"I want my little girl to live," mother said, "I give her to

you. Whatever way you can make her live, she will be yours."

That is where they gave me away.

That old lady wept. "You have made me think of myself. You gave me this dear little child. You have indeed made me think of myself. Let it be thus. My life, let her use it. My grandchild, let her use my existence. I will give my name to my own child. The name that I am going to give her is a holy name. She will reach an old age."

There they named me with a Wolf Clan name; Xechaciwinga they called me.—It means to make a home in a bluff or a mountain, as the wolf does, but in English I just say my name is Mountain Wolf Woman.

Family Work

In March we usually traveled to the Mississippi River close to La Crosse, sometimes even across the river, and then we returned again in the last part of May. We used to live at a place on the edge of the Mississippi called Caved In Breast's Grave.

My father, brother-in-law and brothers used to trap there for muskrats. When they killed the muskrats my mother used to save the bodies and hang them up there in great numbers. When there were a lot of muskrats then they used to roast them on a rack.

They prepared a lot of wood and built a big fire. They stuck four crotched posts into the ground around the fire and placed poles across the crotches. Then they removed the burning wood and left the embers. They put a lot of fire wood crisscross and very dense on the frame. On this the muskrats were roasted, placed all above the fireplace.

As the muskrats began roasting, the grease dripped off nice and brown and then the women used long pointed sticks to turn them over and over. The muskrat meat made a lot of noise as it cooked.

When these were cooked, the women put them aside and placed some more on the rack. They cooked a great amount of muskrats.—When they were cooled, the women packed them together and stored them for summer use.

In the spring when my father went trapping on the Mississippi and the weather became very pleasant my sister once said, "It is here that they dig yellow water lily roots."

So, we all went out, my mother and sisters and everybody. When we got to a slough where the water lilies were very dense, they took off their shoes, put on old dresses and went wading into the water.

They used their feet to hunt for the roots. They dug them out with their feet and then the roots floated up to the surface.

Eventually, my second oldest sister happened upon one. My sister took one of the floating roots, wrapped it about with the edge of her blouse and tucked it into her belt.

I thought she did this because it was the usual thing to do. I saw her doing this and when I happened upon a root I took it and did the same thing. I put it in my belt too.

And then everybody laughed at me! "Oh, Little Siga is doing something! She has a water lily root in her belt!"

Everybody laughed at me and yelled at me. My sister had done that because she was pregnant.

I suppose she did that to ward off something because she was pregnant. Thus she would not affect the baby and would have good luck finding the roots. Because I saw her do that, I did the same thing, and so they teased me.

When they dug up a lot of roots in this fashion they put them in a gunny sack, filling it half full and even more. Then we carried them back to camp and my mother and all my sisters scraped them.

The roots have an outside covering and they scraped that off and sliced them.—They look something like a banana. The women then strung the slices and hung them up to dry in order to store them. They dried a great amount, flour sacks full. During the summer they sometimes cooked them with meat and they were really delicious.

Feasting and Fasting

At the place where they hunted, father and older brother killed as many deer as they would need for a feast.

They set aside ten deer on a high, narrow rack made for

storing meat. They cut down crotched poles and set them up in a rectangle with poles across the crotches and other poles forming a platform, similar to the open-sided square shelters used as sun shades, but narrower and higher. They put the deer on it and covered them with the hides.

Father used to hold big feasts, ten fireplaces they said. The row of fireplaces used to stretch off into the distance. Many Indians attended and father used to feed a wigwam full of people.

There we would dance all night. Sometimes children were named at feasts. This is what they used to do time and again. Sometimes, those who had been fasting would then eat at the feast.

My older brother Hagaga fasted in the woods. Brother was allowed to return at the time of the feast since at that time one who fasts for a vision may eat.

My older sister Hinakega and I also used to fast.

In Dr. Lurie's notes to the reminiscences, she observes that girls fasted without the specific intention of the vision quest although occasionally they were so blessed. The basic idea was that such appeals to the spirits would reward girls in a general way with a long and useful life, a good husband, and a large family of healthy children.

They used to make us do this. We would blacken our cheeks and would not eat all day. That was at the time of the hunting I have told about, before we returned from hunting. We used to blacken our cheeks with charcoal at the time father left in the morning to go hunting. We used coals from the fire to blacken our cheeks and we did not eat all day.

I used to play outside but my older sister used to sit indoors and weave yarn belts. When my father returned from hunting in the evening he used to say to us, "Go cry to the Thunders." When father was ready to eat he would give us tobacco and say to us, "Here, go cry to the Thunders."

Just as it was getting dark my sister and I used to go off a certain distance and she would say to me, "Go stand by a tree and I am going to go farther on." We used to stand there and

look at the stars and cry to the Thunders. This is what we used to sing:

> *"Oh, Good Spirits*
> *Will they pity me? Here am I, pleading."*

We used to sing and scatter tobacco, standing there and watching the stars and the moon.

Many American Indian tribes held tobacco to be a sacred plant. It was offered to the spirits to ward off evil and also used as a gift of thanks for benefits supposedly derived from the supernatural.

We used to cry because, after all, we were hungry. We used to think we were pitied by the spirits. We really wanted to mean what we were saying.

When we finished with our song we scattered tobacco at the foot of the tree and returned home. When we got back home father ate and we ate too. We did not eat all day, only at night, and when we had finished eating we put the dishes away.

Then father used to say, "All right, prepare your bedding and go to bed and I will tell you some stories."

I really enjoyed listening to my father tell stories. Everybody, the entire household, was very quiet and in this atmosphere my father used to tell stories. He used to tell myths, the sacred stories, and that is why I also know some myths. I do not know all of them any more, I just remember parts of stories.

Becoming a Woman

The family went on a short hunting trip. After that they went off to find cranberries and on our return we stopped at the home of grandfather Naqi-Johnga. There it was that mother told me how it is with little girls when they become women.

"Some time," she said, "that is going to happen to you. From about the age of thirteen years this happens to girls. When that happens to you, run to the woods and hide some place. You should not look at any one, not even a glance. If you look at a

138

man you will contaminate his blood. Even a glance will cause you to be an evil person. When women are in that condition they are unclean."

Once, after our return to grandfather's house, I was in that condition when I awoke in the morning.

Because mother had told me to do so, I ran quite far into the woods where there were some bushes. The snow was still on the ground and the trees were just beginning to bud. In the woods there was a broken tree and I sat down under this fallen tree.

I bowed my head with my blanket wrapped over me and there I was, crying and crying. Since they had forbidden me to look around, I sat there with my blanket over my head. I cried.

Then, suddenly I heard the sound of voices. My sister Hinakega and my sister-in-law found me. Because I had not come back in the house, they had looked for me. They saw my tracks in the snow, and by my tracks they saw that I ran. They trailed me and found me.

"Stay here," they said. "We will go and make a shelter for you," and they went home again.

Near the water's edge of a big creek at the rapids of East Fork River, they built a little wigwam. They covered it with canvas. They built a fire and put straw there for me, and then they came to get me.

There I sat in the little wigwam. I was crying. It was far, about a quarter of a mile from home. I was crying and I was frightened. Four nights they made me sleep there. I never ate. There they made me fast. That is what they made me do. After the third time that I slept, I dreamed.

There was a big clearing in my dream. I came upon it, a big, wide open field, and I think there was a rise of land there. Somewhat below this rise was the big clearing. There, in the wide meadow, there were all kinds of horses, all colors. I must have been one who dreamed about horses.

Marriage

As a teen-age girl, Mountain Wolf Woman attended a Lutheran mission school.

I stopped attending school. They took me out of school. Alas, I was enjoying school so much, and they made me stop. They took me back home. They had let me go to school and now they made me quit. It was then that they told me I was going to be married.

I cried but it did not do any good. What would my crying avail me? They had already arranged it. As they were telling me about it my mother said, "My little daughter, I prize you highly. You alone are the youngest child. I prize you highly but nothing can be done about this matter. It is your brothers' doing. You must do whatever your brothers say. If you do not do so, you are going to embarrass them. They have been drinking again, but if you do not do this they will be disgraced. They might even experience something unfortunate." Thus mother spoke to me. She rather frightened me.

To go against the brothers' decision would be to break a taboo, and the men would suffer for it.

My father said, "My little daughter, you do not have very many things to wear, but you will go riding on your little pony. You do not have anything, but you will not walk there."

I had a little horse, a dapple gray kind of pony that was about three years old. Father brought it for me and there the pony stood.

They dressed me. I wore a ribbon embroidery skirt and I wore one as a shawl. I wore a heavily beaded binding for the braid of hair down my back, and I had on earrings. It looked as if I were going to a dance.

It was the custom among Winnebago women to wear as many as five or six pairs of long earrings.

That man was sitting nearby. He started out leading the pony and I followed after. When we reached a road that had high banks on the side he mounted the horse and I got on behind him.

That is the way he brought me home. We rode together. That is how I became a daughter-in-law.

As a daughter-in-law I arrived. When I arrived he had me go in the wigwam and I went in and sat down. They told me to sit on the bed and I sat there.

I took off all the clothing that I was wearing when I got there. I took it all off. I laid down a shawl and whatever I had, all the finery, I put on it; beads, the necklaces, clothing, even the blouse that I was wearing.

Finally, the man's mother came in. Outside the wigwam there were canvas-covered wigwams standing here and there. The woman took the things and left.

There were women sitting all about outside. They were his female relatives. They divided the things among themselves. As they distributed the things around, everybody contributed something in return.

Two or three days from the time of my arrival they took me back with four horses and a double shawl so full of things they could barely tie the corners together. They took me home and later I received two more horses, so they gave me six horses in all.

Young married couples frequently remained with the wife's family for a while, the husband working for them, but when they began to have children of their own, they left—going back to the husband's family or setting up near them.

That is how they used to arrange things for young women in the past. They made the girls marry into whatever family they decided upon. They made the arrangements. That is the way they used to do.

At the time that my mother was combing my hair and I was weeping at the prospect of becoming a daughter-in-law she told me, "Daughter, I prize you very much, but this matter cannot be helped. When you are older and know better, you can marry whomever you yourself think that you want to marry." Mother said that to me and I did not forget it!

In the first place, before they made me get married, my older brother had been drinking and was asleep. I guess he slept there all day and when he awoke, that man they made me marry, who was not a drinker, was there.

He sat there using his hat to fan away the mosquitoes from my brother's face. That is why they made me marry that man. My brother awoke and he surmised, "He is doing this for me because I have sisters. That is what he is thinking to himself." So they made me marry that man. That is what the Indians used to do in the past.

Mountain Wolf Woman determined that her own children would not have arranged marriages, and all her children chose their own mates.

Leavetaking

That man was very easily aroused to jealousy of other men. He used to accuse me of being with other men. That made me angry. I hated him. He used to watch me too.

So, I said to him one time, "No matter how closely you watch me, if I am going to leave you, I am going to leave you! There are a lot of things right now that I do not like."

It was considered acceptable among the Winnebago for a wife to leave a jealous husband.

But that man was jealous. He used to accuse me of having affairs with other men, even my own male relatives. I hated him. Then when my second daughter was an infant I wanted to go to Black River Falls. They said there was going to be a powwow there.

We arrived there in a two-seated buggy I had which belonged to my mother and father. I owned a horse but we left my horse behind and used a horse that belonged to his family. We also used the new harness that his parents owned.

Soon after we arrived, father and mother left for Nebraska. Father was sick and they said he might get better if he went there. So they went to Nebraska.

When the powwow was over and the people were going home, he said, "Well, are we not going to return?"

"No," I said to him, "for my part, I am not going back."

"Well," he said, "We have to take back the things that we

borrowed. We brought a horse of theirs. After all, it belongs to them."

"And you belong to them too," I said. "Take the horse and let him carry the harness on his back and ride him and go home," I told him. "Leave the wagon here for me, it belongs to my mother and father."

That man stayed around for a while but I would not go back so he finally left.

As for myself, I went to my grandmother. We had our own tent. "Grandmother," I said, "I am going to borrow some things."

"All right," she said, "I am caring for the baby."

I said to her, "When I come back, we are going to move."

My sister was also going to move. I went to the mission, to my niece, the wife of Bright Feather. I said to her, "Niece, I came to borrow something."

"All right," she said, "what did you come to borrow?"

"A one-horse harness and buggy hitch."

"All right, wherever they are take them. What am I using them for? They are yours," she said.

There was a wagon going back to the powwow ground and I asked the people to carry the harness and the hitch. I rode back with them too.

When we got back, the man with the wagon attached the single hitch to the buggy and took our double harness and hitch. He said, "I will take these back to your niece at the mission because I will be going that way. They can probably use them."

That is what he did. The only horse I had was a big one and I let him pull the buggy alone. I packed everything and headed for the home of my older sister. Thus I left that man.

I took grandmother with me in the one-horse buggy. We stayed for a while where one of my sisters was living at Black River Falls. She was there at a cranberry marsh where picking was in progress.

Then I moved again to a different marsh where another older sister lived. We used to pick cranberries there every day.

We stayed there and picked cranberries until the end of the season, and then we moved back to my other older sister's place. There my older brother asked for the use of a horse, and there

Four Women, my brother's wife, gave me some things: a blouse decorated with little silver brooches, a very nice one, and necklaces and a hair ornament and earrings. They gave me much finery and again I became a woman to be envied.

I remained single and lived at my sister's place all winter long. Whenever there was a feast that winter my niece Queen of Thunder and I used to go to the feast, and we used to dance. There they accused me concerning a man. They gossiped at the winter feast. Alas, I was not even looking at any men.

The man that they linked me with began writing letters to me. Well, after all, they were accusing him of it.

Second Marriage

Then it became spring and in the spring we camped near Black River Falls where my sister was staying. I went to town to get some things and as I was coming back somebody behind me said, "Sister, sister."

I stopped. It was my oldest brother. "Sister," he said, "whoever is saying things to you, I would like it if you do as he says. Little sister, your first husband was not any good. You would never have had any place for yourself and at his home you would have always been doing all the work. But this lad who is now talking to you lives alone. He knows how to care for himself. If you make a home someplace, then I will have someplace to go to visit." That is what my older brother said to me.

I did not say anything. And just standing right there was that man, Bad Soldier.

The name Bad Soldier did not mean that he was cowardly, quite the reverse: "bad" in the sense of fierce.

I still did not say anything.

Then my brother went toward town and the man followed me home. We arrived at the place where my sister was living temporarily near Black River Falls.

After we arrived, the man took the water pail and went after some water. He got the water and brought it back and then later he went into the woods and brought back a lot of firewood.

He began working for us, and sister was smiling broadly about it.

He said to me, "If you would like it, tomorrow we can go to the courthouse and get our marriage license. If she hears about it, she will give up." He was talking about his wife.

He had a wife and I did not want him, but he was persistent in courting me. "We will go to the courthouse and take out a marriage license so that woman cannot bother us," he said.

So that is what we did, we went to the courthouse and took out a marriage license. It was early spring when we did this.

Mountain Wolf Woman's sister Hinakega had no children of her own and she looked after the two daughters of Mountain Wolf Woman's first marriage. By her second husband, Mountain Wolf Woman had two sons who died, then a daughter was born and then another son, and eventually a large brood. They went west to where the Sioux lived in South Dakota. Bad Soldier rented a house for the family to live in, and he went to work for a white man who had a big general store. His job was to drive a truck out to the Sioux reservation and trade food for cowhides. After a few years Mountain Wolf Woman became homesick for her own people and they returned first to her parents in Nebraska and then to Black River Falls in Wisconsin. The children went to school there and the family all became Christians.

Widowhood

It was April 24, 1936, that my husband died. We told the undertaker, who took him and brought him back. They buried him in the mission cemetery. In the evenings I used to think as I sat there, "Maybe this is not happening to me. Maybe this is not happening to me. Maybe he did not die." Children of mine died. My relatives died, father and mother. My older sister died. But it was never as hard as when my man died.

"Maybe I am having a bad dream," I thought. I would pinch my arms to see if I were awake.

Then the doctor came. He used to come and see my husband when he was sick. He came there and said to me, "Have

them dismantle this house and build it someplace else. Your husband had double pneumonia and tuberculosis set in. That is what he died of. Tear down your house and build it over. You have a lot of small children. Don't stay in this house."

So, one time I was sitting on the roof of the house with a hammer. The roof was covered with tarpaper and I was trying to get it off. A car came by and then it turned back. It was one of my nephews and another young man. "What are you doing, auntie?" he said.

"This house has to be taken apart to move someplace else. I am supposed to get it rebuilt. I am trying to get the roof off."

"Oh, auntie, we will do that for you," he said, and they got out of the car and started to work. They took the whole house apart. They stacked the boards. They went home in the evening and they came back early in the morning. They took everything apart and piled the boards on top of each other. They said, "Auntie, where are you going to have them build the house?"

"Well, let it be on the mission grounds," I said. Then they told me that it was partly government land.

"Put it there," I said, and pointed out the spot to them and they hauled the boards over there. They certainly did me a great kindness.

The government agent and another man came. "How big a house do you want?" they said.

Across from the airport there was a little square house. I told them that I always liked that house. It was not too big and it was not too small. "I have a lot of little children and when my married children come back with their families I am crowded. Two of them with their children come home to visit. I used to be crowded. That square house is just about the right size. I like that one."

They went to look at it. They said I was right, that house was the right size. They made my little square house. There was no one around who could build houses, so the Indian boys got together and made the house. They finished it for me and I am living there today.

I am old, but though I am seventy-three years old my body is strong. I make my own clothing. There are women living

here and there today who are younger than I am who are helplessly infirm. I am able to move about.

Where I live I care for myself. My children sometimes say they would take care of me. "Wait a while," I say, "until I am older. You can take care of me when I can no longer take care of myself."

I always say I am happy the way I am and that I hope to continue in that fashion. If I am good to people, after while, when my life ends, I expect to go to heaven. I say no more.

FOR DISCUSSION

1. How does Mountain Wolf Woman find fulfillment and space to breathe as a traditional, Native American woman? Is there a difference between Mountain Wolf Woman and other women you have studied in this section because of their different heritages?

2. Mountain Wolf Woman has much "family" support: She lives in a tightly knit society, drawing on the common lifestyles of women from generations back. Do you feel that kind of support? Do modern women in our culture have anything similar? If not, how might we be different because of this lack?

Part Three

Women and Culture

As the story of Mountain Wolf Woman has just shown, culture plays an important role in shaping lives. Its force is a combination of philosophical, social, physical, and economic influences. Historically, people who do not do what their culture expects of them have suffered punishments as serious as death.

Cultural expectations for women can be harsh or gentle, limiting or expanding, but they are always compelling. How women manage their lives within cultural bounds is an important part of any portrait of them. Recall again the compelling nature of the culture that Mountain Wolf Woman lived in, yet remember too that she was able to shape *herself* within that culture.

Trying to live within established cultural boundaries, some women appear to cope with quiet dignity and acceptance. Others go mad. Still others find traditional roles very fulfilling. Whatever way she lives, a woman is a complex product of both what she expects and reaches for in life and what is expected of her. The women in this section are being defined by culture and, on the other hand, taking part in defining it as well.

INTRODUCTION

The narrator of this poem feels deeply the loss to her people of their Native American traditions. She has been greatly influenced by her culture, which seems to define her very identity.

Navajo Sighs

Winifred Fields Walters

How can you know, or understand, our loss
The rough-edged feel of poverty that came
To us in broken treaties' scourging hour?
Your skin is much too pale, or else too black
(Though white or colored skin is not the point). 5
You never lived with legend, ancient tales,
Told many times around a hogan fire
While bitter winter sapped the very flames.
You never slept an infant's passive sleep
Bound in a cradleboard, handcarved and laced 10
The way the Holy Ones taught us in days
Long past, beyond our farthest memory.
You never tended sheep in lambing time
Nor watched lambs frolic, stiff-kneed, in the rain.
You never knew serenity of life 15
In tune with nature's balanced give and take,
That total, grateful sense of solitude,
That prayer of thanks breathed out for hunter's skill,
A prayer which reaches silently to the
Great Source, as close in red rock canyons as 20
In rich and hallowed chapels made by men.
To you, tradition seems a binding thing,
But there are those of us who turn ourselves,
At least within our hearts, to that which was,
And was so handsomely; reluctant still 25

To lay away such beauty and such peace,
As brotherhood beyond the clan or tribe,
That precious dignity in which a people walked
The pollen path: that timeless way,
So simple, so complex, so nearly gone. 30

FOR DISCUSSION

1. To whom is the poem addressed? Why does Walters say that we can never understand the loss?

2. How do the very concrete, physical images in the poem relate to what Walters is trying to say? The poem ends by mentioning "that timeless way, / So simple, so complex." Is the *manner* of the poem itself "so simple, so complex"?

3. Is this poem a lament? If so, is it a hopeless one? Whatever your answer is, what language clues lead you to answer as you do?

4. What other cultures are you aware of that are suffering or undergoing "defeat" through the influence of another culture? Most of us have grandparents whose experiences are very different from our own. What will the effect on us be when they are gone? Will it be similar to that described by Walters in her poem?

INTRODUCTION

The selection that follows is an example of "reportage." It is a report of something that happened. The author and her anthropologist husband lived with and studied the Taute people of New Guinea for two years. Ask yourself the following as you read: Is the author visible at all in the piece? How do you know? Is she "fair"? What standards do you use to decide?

Reporters are involved in a process of selection. They pick and choose what events and details to include as well as what style to use in describing them. All this affects our response.

"Life and Birth in New Guinea" is a report of something that happened. Nothing but the facts. But is it? If it is nothing but a clean, objective account, why do we respond as we do?

Life and Birth in New Guinea

Joyce S. Mitchell

When morning comes to our village of Taute in the West Sepik area of New Guinea, each of the women picks up a piece of smoldering wood from the fire, some tobacco, a bamboo tool used to chop the sago palm, and a basket to carry the food back. They give their babies to their husbands—this is one of the few cultures of the world where men have a major responsibility for child care. Then, in groups of twos and threes, the women take off for the bush to gather food, not to return until almost dark. In the late afternoon, the little children and fathers go over to the edge of the ridge, a dramatic drop straight down to the Sibi River several hundred feet below, and call to their mothers and wives. In their native tongue, Olo, they sing and wail: "Mamma—you come—too dark—hurry up!" Throughout the mountains, you can hear the calling for mothers to hurry home before dark, before the bush spirits get to them and make them sick.

On this morning, our village is awakened at 5 A.M. by wailing and crying. I go to the house it is coming from, climb the post with notches for stairs, and go into this house on stilts. The sides of the house are made from the stems of sago palm leaves, the roof is thatched with palm leaves, and the floor is made from palm bark, like slab wood. There are no windows or openings that could let the demons and ghosts in the house—even the doorway is covered with palm strips.

It is dark inside, but I can see Maiawa on the floor, rubbing stinging nettles over her body to distract herself from the labor pains. I hear her call out the names of the bush spirits who she is afraid are holding back the delivery of her baby. She is having a long, difficult labor.

Maiawa wears a skirt of strings made by rubbing tree bark into strands. The strings are worn front and back center, leaving her hips uncovered. Her hair, like that of all the Wape tribe, is cut short and shaved almost to the top; she has tinea, a common skin infection, all over her body.

Soon there are 20 of us crowded inside the small one-room house that is divided into sleeping areas of palm stem beds separated by fires on earthen hearths. Everyone is trying to help or comfort Maiawa. Usually, a mother delivers her baby, expels the placenta, and cuts the cord herself with only one older woman there to help in emergencies.

By 7 o'clock, the time our village usually gets up, Maiawa is calling out a spirit's name, following her cry with, "I want to go to Lumi." She is having real trouble, and she wants to go to the native hospital in Lumi, a small government station that is three hours away on foot, to see the missionary doctor there, whom she knows from her medical visits to our village each month.

If Maiawa does go to Lumi, she will be the first woman in labor to go out of our village to the hospital—ever. Her husband, Witauwa, knows that if Maiawa leaves, she must be carried by eight men, and he will have to pay them with an expensive pig. He stands, with his name tattooed in pidgin on his chest and one earlobe cut to make a loop, arguing with her about exorcising the bad spirits and having the medicine man see her first, before deciding to go to Lumi.

The argument is interrupted by a very painful contraction and by the arrival of Maiawa's best friend, Naiasu. Naiasu rubs her with nettles which sting intensely, and holds her legs apart after the contraction. Maiawa stands up quickly, squats down, stands up, goes to another section in her house, lies flat on her back on the floor, jumps up, and comes back. Finally, she sits on the floor leaning against another friend, Yoki. The three women laugh a very raucous laugh, and hoot as they do in the bush when they are working sago together. They call out when Maiawa does. They are sharing Maiawa's labor.

Taute women have the friendship that often comes when people have worked closely together. Their group includes single and married women, women with and without children. The women build small shelters in the bush where they gather during the workday to sit and rest around a fire, have a smoke, chew betel, and visit. Their camaraderie is continued late at night when everyone in the village meets on the verandas of a few houses to sit in front of a fire and smoke and chew. Their laughing and joking and hooting contrast dramatically with the quiet and immobile faces they present to the Europeans when they go into Lumi.

Taute people are very different from the Europeans they see in Lumi. They don't have radios or kerosene lamps, or nails, or any plastic or paper products whatsoever; very few have matches; and they don't have watches or clocks or the European concept of time. But it isn't simply the lack of material things that makes them different. For the Taute people, there is only one world. And in that world live human beings, animals, ghosts, and demons.

For instance, the major difference between the Taute people and our family, the first Westerners ever to live with them, is that the Tautes don't separate their own world from the world of their dead ancestors. Their ancestors have as much influence over their behavior as their living relatives. A woman takes her dead brother's power of protection as seriously as she does the protection of her husband who is sitting beside her.

The constant consideration given to spiritual ancestors, as well as the concern over offending or appeasing them, takes up a

major part of Taute life. To attempt control over their short lives, poor health, and the demons and ghosts with whom they coexist, they turn to magic.

Thus, Maiawa's husband agonizes over which spirits are holding back the baby. He consults several of the village men; their talk is punctuated by the howls of the babies they are holding. Perhaps, they speculate, Maiawa has offended a spirit.

There are six of us with Maiawa; she now appears unconscious. Solo'oke comes into the house with fresh stinging nettles: it has been decided that some of his ancestors are making the trouble. Solo'oke, blowing gently on the nettles and whispering the name of his ancestors, says, "Maiawa is a neighbor. Go down out of her body and leave her." Then he rubs the nettles on her face and ear. Maiawa still seems to be asleep.

Naiasu explains to me that when the pains come, Maiawa cries; when they go away, Maiawa sleeps. I tell her it is the same in America, and she immediately tells the others. They all laugh. The Taute people ask me if European women have babies, and deliver and nurse them as Taute women do. They ask if European women menstruate—and why they aren't always pregnant the way Taute women are.

Fiu, the medicine man, has been called in to help Maiawa deliver her baby. He is the only one in the village who is trained in the old ways of a healing man, truly a man of magic. Fiu is very old, but taller and straighter than most of his people. He looks like something out of the past: wearing a G-string, he carries his bow and arrows as he goes from village to village to cure the sick. He is very serious and direct and gives me a feeling of professionalism and warmth.

As soon as Fiu comes into the house, Maiawa stands up. She reaches up and hangs onto a bamboo stick on the ceiling; her eyes closed, her head hanging down, she looks like a dancer in her string skirt. Fiu pushes all around her stomach, blows on it, and presses downward against the baby. One of the women holds my kerosene lantern, the only light in the house, close to Maiawa. Another tells Fiu the baby must be turned; it is lying the wrong way for delivery. Maiawa hasn't moved. She acts as if no one were there.

During a contraction, Fiu pushes down, rubs nettles on her

huge protruding stomach, walks toward the door, stoops, and throws out both hands briskly, as if throwing something away. Then he quickly leaves. He did not speak to anyone the entire time he was here. Naiasu takes Maiawa's hands, loosens her fingers from the bamboo, and helps her sit down. The silence initiated by Fiu's presence is shattered as Maiawa's water breaks with a sudden gush. Everyone jumps away from her and excitedly talks about what to do next.

Because Maiawa's difficulty continues despite the breaking of her water, Witauwa decides to build a stretcher to take his wife to the Lumi hospital. The village men gather to help him. They work well together, knowing what each can do. They have often cooperated to organize pig hunts, and to plan the elaborate ceremonies at which they communicate with the spirits to banish illness from the sick in the village.

Maiawa is helped into a cloth skirt by her many friends and guided out of her house to the ground. Rubbed with nettles twice more, she appears unable to move as we finally get her onto the stretcher.

It is midmorning, and, ankle deep in mud, we go quickly down the mountain on a steep, narrow bush trail. We wade across the unbridged Sibi River, which often floods with the day's rain; then we trek up another mountain on the other side of the river. Eight men (including Witauwa), Maiawa on the stretcher, three of her children, and I arrive three hours later in the pouring rain that comes regularly every afternoon to Lumi.

Maiawa tells the hospital orderly that she wants to see the woman doctor who comes to Taute. Doctor Lyn and Nurse Betty deliver the baby one hour later. The baby, much bigger than most Taute babies, had been in a posterior (face down) position which caused the prolonged labor. The placenta is given to Witauwa to bury, just as if the child had been born in the village.

Soon, Witauwa and the two older children, Waiyo and Yenga, are eating hospital food of rice and fish. The youngest child, Suwe, is sitting on the wood-slatted bed with his mother and the new baby. Maiawa and Witauwa name the new baby Bill, after the one male Westerner they know well—my husband.

Within a month after our return to America, we received a letter from Nurse Betty: Maiawa died suddenly of unknown causes. (New Guinea is a hard place for survival: pneumonia, malaria, skin infections, TB, and leprosy, together with poor nutrition, weaken the Tautes' stamina, and death often comes early.)

Witauwa, the family's only hunter and provider of meat, left the village shortly after we did. He has gone to a plantation for two years of indentured labor. The oldest daughter, Waiyo, is now gathering the food for her brothers and sister.

A neighbor, who can nurse him, has adopted Bill.

FOR DISCUSSION

1. What heritage does Maiawa inherit as a woman? How does it compare with other heritages that you've read about?
2. How does Joyce Mitchell feel about her subject? How can you tell? Try to find specific passages to support your answer.
3. Why do you respond as you do to this selection? Is it because of Mitchell's skill as a reporter in placing you in the situation? Is the situation itself gripping or sad or fascinating? What makes it so? What situations similar to this one might affect us strongly, even if described in the most objective terms?
4. A specific detail that Mitchell chooses to include is the fact that Maiawa dies. Why, if the article is titled "Life and Birth in New Guinea," does she do so? What effect does this have on you?
5. What might you say if you were writing a piece called "Life and Birth in America"? How do most Americans feel about the process of giving birth? Is it regarded primarily as women's responsibility? Is change occurring in this area? If so, can you think of some reasons why?

INTRODUCTION

The following two selections again deal with women who are culture-bound. But the culture here is not Taute or Navajo. These women are housewives.

Living within the limits of a culture can be difficult. Sometimes women not only manage, but do well, within such limits. But sometimes, too, they do not do very well. Sometimes they go mad.

The Story of an Hour

Kate Chopin

Knowing that Mrs. Mallard was afflicted with a heart trouble, great care was taken to break to her as gently as possible the news of her husband's death.

It was her sister Josephine who told her, in broken sentences; veiled hints that revealed in half concealing. Her husband's friend Richards was there, too, near her. It was he who had been in the newspaper office when intelligence of the railroad disaster was received, with Brently Mallard's name leading the list of "killed." He had only taken the time to assure himself of its truth by a second telegram, and had hastened to forestall any less careful, less tender friend in bearing the sad message.

She did not hear the story as many women have heard the same, with a paralyzed inability to accept its significance. She wept at once, with sudden, wild abandonment, in her sister's arms. When the storm of grief had spent itself she went away to her room alone. She would have no one follow her.

There stood, facing the open window, a comfortable, roomy armchair. Into this she sank, pressed down by a physical ex-

haustion that haunted her body and seemed to reach into her soul.

She could see in the open square before her house the tops of trees that were all aquiver with the new spring life. The delicious breath of rain was in the air. In the street below a peddler was crying his wares. The notes of a distant song which some one was singing reached her faintly, and countless sparrows were twittering in the eaves.

There were patches of blue sky showing here and there through the clouds that had met and piled one above the other in the west facing her window.

She sat with her head thrown back upon the cushion of the chair, quite motionless, except when a sob came up into her throat and shook her, as a child who has cried itself to sleep continues to sob in its dreams.

She was young, with a fair, calm face, whose lines bespoke repression and even a certain strength. But now there was a dull stare in her eyes, whose gaze was fixed away off yonder on one of those patches of blue sky. It was not a glance of reflection, but rather indicated a suspension of intelligent thought.

There was something coming to her and she was waiting for it, fearfully. What was it? She did not know; it was too subtle and elusive to name. But she felt it, creeping out of the sky, reaching toward her through the sounds, the scents, the color that filled the air.

Now her bosom rose and fell tumultuously. She was beginning to recognize this thing that was approaching to possess her, and she was striving to beat it back with her will—as powerless as her two white slender hands would have been.

When she abandoned herself a little whispered word escaped her slightly parted lips. She said it over and over under her breath: "free, free, free!" The vacant stare and the look of terror that had followed it went from her eyes. They stayed keen and bright. Her pulses beat fast, and the coursing blood warmed and relaxed every inch of her body.

She did not stop to ask if it were or were not a monstrous joy that held her. A clear and exalted perception enabled her to dismiss the suggestion as trivial.

She knew that she would weep again when she saw the

kind, tender hands folded in death; the face that had never looked save with love upon her, fixed and gray and dead. But she saw beyond that bitter moment a long procession of years to come that would belong to her absolutely. And she opened and spread her arms out to them in welcome.

There would be no one to live for her during those coming years; she would live for herself. There would be no powerful will bending hers in that blind persistence with which men and women believe they have a right to impose a private will upon a fellow-creature. A kind intention or a cruel intention made the act seem no less a crime as she looked upon it in that brief moment of illumination.

And yet she had loved him—sometimes. Often she had not. What did it matter! What could love, the unsolved mystery, count for in face of this possession of self-assertion which she suddenly recognized as the strongest impulse of her being!

"Free! Body and soul free!" she kept whispering.

Josephine was kneeling before the closed door with her lips to the keyhole, imploring for admission. "Louise, open the door! I beg; open the door—you will make yourself ill. What are you doing, Louise? For heaven's sake open the door."

"Go away. I am not making myself ill." No; she was drinking in a very elixir of life through that open window.

Her fancy was running riot along those days ahead of her. Spring days, and summer days, and all sorts of days that would be her own. She breathed a quick prayer that life might be long. It was only yesterday she had thought with a shudder that life might be long.

She arose at length and opened the door to her sister's importunities. There was a feverish triumph in her eyes, and she carried herself unwittingly like a goddess of Victory. She clasped her sister's waist, and together they descended the stairs. Richards stood waiting for them at the bottom.

Some one was opening the front door with a latchkey. It was Brently Mallard who entered, a little travel-stained, composedly carrying his grip-sack and umbrella. He had been far from the scene of accident, and did not even know there had been one. He stood amazed at Josephine's piercing cry; at Richards' quick motion to screen him from the view of his wife.

But Richards was too late.

When the doctors came they said she had died of heart disease—of joy that kills.

I Stand Here Ironing

Tillie Olsen

I stand here ironing, and what you asked me moves tormented back and forth with the iron.

"I wish you would manage the time to come in and talk with me about your daughter. I'm sure you can help me understand her. She's a youngster who needs help and whom I'm deeply interested in helping."

"Who needs help?" Even if I came what good would it do? You think because I am her mother I have a key, or that in some way you could use me as a key? She has lived for nineteen years. There is all that life that has happened outside of me, beyond me.

And when is there time to remember, to sift, to weigh, to estimate, to total? I will start and there will be an interruption and I will have to gather it all together again. Or I will become engulfed with all I did or did not do, with what should have been and what cannot be helped.

She was a beautiful baby. The first and only one of our five that was beautiful at birth. You do not guess how new and uneasy her tenancy in her now-loveliness. You did not know her all those years she was thought homely, or see her poring over her baby pictures, making me tell her over and over how beautiful she had been—and would be, I would tell her—and was now, to the seeing eye. But the seeing eyes were few or nonexistent. Including mine.

I nursed her. They feel that's important nowadays. I nursed all the children, but with her, with all the fierce rigidity of first motherhood, I did like the books said. Though her cries battered me to trembling and my breasts ached with swollenness, I waited till the clock decreed.

160

Why do I put that first? I do not even know if it matters, or if it explains anything.

She was a beautiful baby. She blew shining bubbles of sound. She loved motion, loved light, loved color and music and textures. She would lie on the floor in her blue overalls patting the surface so hard in ecstasy her hands and feet would blur. She was a miracle to me, but when she was eight months old I had to leave her daytimes with the woman downstairs to whom she was no miracle at all, for I worked or looked for work and for Emily's father, who "could no longer endure" (he wrote in his goodbye note) "sharing want" with us.

I was nineteen. It was the pre-relief, pre-WPA world of the depression. I would start running as soon as I got off the streetcar, running up the stairs, the place smelling sour, and, awake or asleep to startle awake, when she saw me she would break into a clogged weeping that could not be comforted, a weeping I can hear yet.

After a while I found a job hashing at night so I could be with her days, and it was better. But it came to where I had to bring her to his family and leave her.

It took a long time to raise the money for her fare back. Then she got chicken pox and I had to wait longer. When she finally came, I hardly knew her, walking quick and nervous like her father, looking like her father, thin, and dressed in a shoddy red that yellowed her skin and glared at the pock marks. All the baby loveliness gone.

She was two. Old enough for nursery school, they said, and I did not know then what I know now—the fatigue of the long day, and the lacerations of group life in the kinds of nurseries that are only parking places for children.

Except that it would have made no difference if I had known. It was the only place there was. It was the only way we could be together, the only way I could hold a job.

And even without knowing, I knew. I knew that the teacher was evil because all these years it has curdled into my memory, the little boy hunched in the corner, her rasp, "Why aren't you outside, because Alvin hits you? That's no reason, go out, scaredy." I knew Emily hated it even if she did not clutch and implore, "Don't go, Mommy," like the other children, mornings.

She always had a reason why we should stay home. Momma, you look sick. Momma, I feel sick. Momma, the teachers aren't there today, they're sick. Momma there was a fire there last night. Momma it's a holiday today, no school, they told me.

But never a direct protest, never rebellion. I think of our others in their three-, four-year-oldness—the explosions, the tempers, the denunciations, the demands—and I feel suddenly ill. I stop the ironing. What in me demanded that goodness in her? And what was the cost, the cost to her of such goodness?

The old man living in the back once said in his gentle way, "You should smile at Emily more when you look at her." What *was* in my face when I looked at her? I loved her. There were all the acts of love.

It was only with the others I remembered what he said, so that it was the face of joy, and not of care or tightness or worry I turned to them—too late for Emily. She does not smile easily, let alone almost always, as her brothers and sisters do. Her face is closed and somber, but when she wants, how fluid. You must have seen it in her pantomimes, you spoke of her rare gift for comedy on the stage that rouses a laughter out of the audience so dear they applaud and applaud and do not want to let her go.

Where does it come from, that comedy? There was none of it in her when she came back to me that second time, after I had had to send her away again. She had a new daddy now to learn to love, and I think perhaps it was a better time. Except when we left her alone nights, telling ourselves she was old enough.

"Can't you go some other time, Mommy, like tomorrow?" she would ask. "Will it be just a little while you'll be gone? Do you promise?"

The time we came back, the front door open, the clock on the floor in the hall. She rigid awake. "It wasn't just a little while. I didn't cry. Three times I called you, just three times, and then I ran downstairs to open the door so you could come faster. The clock talked loud. I threw it away, it scared me what it talked."

She said the clock talked loud that night I went to the hospital to have Susan. She was delirious with the fever that comes before red measles, but she was fully conscious all the week I

was gone and the week after we were home when she could not come near the new baby or me.

She did not get well. She stayed skeleton thin, not wanting to eat, and night after night she had nightmares. She would call for me, and I would sleepily call back, "You're all right, darling, go to sleep, it's just a dream," and if she still called, in a sterner voice, "Now go to sleep, Emily, there's nothing to hurt you." Twice, only twice, when I had to get up for Susan anyhow, I went in to sit with her.

Now when it is too late (as if she would let me hold and comfort her like I do the others) I get up and go to her at her moan or restless stirring. "Are you awake? Can I get you something?" And the answer is always the same: "No, I'm all right, go back to sleep, Mother."

They persuaded me at the clinic to send her away to a convalescent home in the country where "she can have the kind of food and care you can't manage for her, and you'll be free to concentrate on the new baby." They still send children to that place. I see pictures on the society page of sleek young women planning affairs to raise money for it, or dancing at the affairs, or decorating Easter eggs or filling Christmas stockings for the children.

They never have a picture of the children, so I do not know if they still wear those gigantic red bows and the ravaged looks on the every other Sunday when parents can come to visit "unless otherwise notified"—as we were notified the first six weeks.

Oh, it is a handsome place, green lawns and tall trees and fluted flower beds. High up on the balconies of each cottage the children stand, the girls in their red bows and white dresses, the boys in white suits and giant red ties. The parents stand below shrieking up to be heard and the children shriek down to be heard, and between them the invisible wall "Not To Be Contaminated by Parental Germs or Physical Affection."

There was a tiny girl who always stood hand in hand with Emily. Her parents never came. One visit she was gone. "They moved her to Rose Cottage," Emily shouted in explanation. "They don't like you to love anybody here."

She wrote once a week, the labored writing of a seven-year-old. "I am fine. How is the baby. If I write my leter nicly I

will have a star. Love." There never was a star. We wrote every other day, letters she could never hold or keep but only hear read—once. "We simply do not have room for children to keep any personal possessions," they patiently explained when we pieced one Sunday's shrieking together to plead how much it would mean to Emily to keep her letters and cards.

Each visit she looked frailer. "She isn't eating," they told us.

(They had runny eggs for breakfast or mush with lumps, Emily said later. I'd hold it in my mouth and not swallow. Nothing ever tasted good, just when they had chicken.)

It took us eight months to get her released home, and only the fact that she gained back so little of her seven lost pounds convinced the social worker.

I used to try to hold and love her after she came back, but her body would stay stiff, and after a while she'd push away. She ate little. Food sickened her, and I think much of life too. Oh, she had physical lightness and brightness, twinkling by on skates, bouncing like a ball up and down up and down over the jump rope, skimming over the hill; but these were momentary.

She fretted about her appearance, thin and dark and foreign-looking at a time when every little girl was supposed to look or thought she should look a chubby blond replica of Shirley Temple. The doorbell sometimes rang for her, but no one seemed to come and play in the house or be a best friend. Maybe because we moved so much.

There was a boy she loved painfully through two school semesters. Months later she told me how she had taken pennies from my purse to buy him candy. "Licorice was his favorite and I brought him some every day, but he still liked Jennifer better'n me. Why Mommy why?" The kind of question for which there is no answer.

School was a worry to her. She was not glib or quick, in a world where glibness and quickness were easily confused with ability to learn. To her overworked and exasperated teachers she was an overconscientious "slow learner" who kept trying to catch up and was absent entirely too often.

I let her be absent, though sometimes the illness was imaginary. How different from my now-strictness about attendance

with the others. I wasn't working. We had a new baby, I was home anyhow. Sometimes, after Susan grew old enough, I would keep her home from school, too, to have them all together.

Mostly Emily had asthma, and her breathing, harsh and labored, would fill the house with a curiously tranquil sound. I would bring the two old dresser mirrors and her boxes of collections to her bed. She would select beads and single earrings, bottle tops and shells, dried flowers and pebbles, old postcards and scraps, all sorts of oddments; then she and Susan would play "Kingdom," setting up landscapes and furniture, peopling them with action.

Those were the only times of peaceful companionship between her and Susan. I have edged away from it, that poisonous feeling between them, that terrible balancing of hurts and needs I had to do between the two, and did so badly, those earlier years.

Oh, there are conflicts between the others too, each one human, needing, demanding, hurting, taking—but only between Emily and Susan, no, Emily toward Susan, that corroding resentment. It seems so obvious on the surface, yet it is not obvious. Susan, the second child, Susan, golden and curly-haired and chubby, quick and articulate and assured, everything in appearance and manner Emily was not; Susan, not able to resist Emily's precious things, losing or sometimes clumsily breaking them; Susan telling jokes and riddles to company for applause while Emily sat silent (to say to me later: That was *my* riddle, Mother, I told it to Susan); Susan, who for all the five years' difference in age was just a year behind Emily in developing physically.

I am glad for that slow physical development that widened the difference between her and her contemporaries, though she suffered over it. She was too vulnerable for that terrible world of youthful competition, of preening and parading, of constant measuring of yourself against every other, of envy: "If I had that copper hair," or "If I had that skin . . ." She tormented herself enough about not looking like the others, there was enough of the unsureness, the having to be conscious of words before you speak, the constant caring—what are they thinking of me? what kind of an impression am I making—without having it all magnified unendurably by the merciless physical drives.

Ronnie is calling. He is wet and I change him. It is rare there is such a cry now. That time of motherhood is almost behind me when the ear is not one's own but must always be racked and listening for the child cry, the child call. We sit for a while and I hold him, looking out over the city spread in charcoal with its soft aisles of light. "*Shoogily*," he breathes and curls closer. I carry him back to bed, asleep. *Shoogily*. A funny word, a family word, inherited from Emily, invented by her to say: *comfort*.

In this and other ways she leaves her seal, I say aloud. And startle at my saying it. What do I mean? What did I start to gather together, to try and make coherent? I was at the terrible, growing years. War years. I do not remember them well. I was working again, there were four smaller ones now, there was not time for her. She had to help be a mother, and housekeeper, and shopper. She had to set her seal. Mornings of crisis and near-hysteria trying to get lunches packed, hair combed, coats and shoes found, everyone to school or Child Care on time, the baby ready for transportation. And always the paper scribbled on by a smaller one, the book looked at by Susan, then mislaid, the homework not done. Running out to that huge school where she was one, she was lost, she was a drop; suffering over her unpreparedness, stammering and unsure in her classes.

There was so little time left at night after the kids were bedded down. She would struggle over books, always eating (it was in those years she developed her enormous appetite that is legendary in our family) and I would be ironing, or preparing food for the next day, or writing V-mail to Bill, or tending the baby. Sometimes, to make me laugh, or out of her despair, she would imitate happenings or types at school.

I think I said once, "Why don't you do something like this in the school amateur show?" One morning she phoned me at work, hardly understandable through the weeping: "Mother, I did it. I won, I won; they gave me first prize; they clapped and clapped and wouldn't let me go."

Now suddenly she was Somebody, and as imprisoned in her difference as she had been in her anonymity.

She began to be asked to perform at other high schools, even in colleges, then at city and state-wide affairs. The first

166

one we went to, I only recognized her that first moment when, thin, shy, she almost drowned herself into the curtains. Then: Was this Emily? The control, the command, the convulsing and deadly clowning, the spell: then the roaring, stamping audience, unwilling to let this rare and precious laughter out of their lives.

Afterwards: You ought to do something about her with a gift like that—but without money or knowing how, what does one do? We have left it all to her, and the gift has as often eddied inside, clogged and clotted, as been used and growing.

She is coming. She runs up the stairs two at a time with her light graceful step, and I know she is happy tonight. Whatever it was that occasioned your call did not happen today.

"Aren't you ever going to finish the ironing, Mother? Whistler painted his mother in a rocker. I'd have to paint mine standing over an ironing board." This is one of her communicative nights and she tells me everything and nothing as she fixes herself a plate of food out of the icebox.

She is so lovely. Why did you want me to come in at all? Why were you concerned? She will find her way.

She starts up the stairs to bed. "Don't get *me* up with the rest in the morning." "But I thought you were having midterms." "Oh, those," she comes back in and says quite lightly, "in a couple of years when we'll all be atom-dead they won't matter a bit."

She has said it before. She *believes* it. But because I have been dredging the past, and all that compounds a human being is so heavy and meaningful in me, I cannot endure it tonight.

I will never total it all. I will never come in to say: She was a child seldom smiled at. Her father left me before she was a year old. I had to work away from her her first six years when there was work, or I sent her home and to his relatives. There were years she had care she hated. She was dark and thin and foreign-looking in a world where the prestige went to blondness and curly hair and dimples, she was slow where glibness was prized. She was a child of anxious, not proud, love. We were poor and could not afford for her the soil of easy growth. I was a young mother, I was a distracted mother. There were the other children pushing up, demanding. Her younger sister seemed all that she was not. There were years she did not want me to touch her. She kept too much in herself, her life was such she

had to keep too much in herself. My wisdom came too late. She has much to her and probably little will come of it. She is a child of her age, of depression, of war, of fear.

Let her be. So all that is in her will not bloom—but in how many does it? There is still enough left to live by. Only help her to know—help make it so there is cause for her to know—that she is more than this dress on the ironing board, helpless before the iron.

FOR DISCUSSION

1. In "The Story of an Hour," do you think it unlikely that Mrs. Mallard could both have a happy marriage and be thrilled at the thought of that marriage ending? Why?
2. Would you say that, before her husband's "death," her culture had a total grip on Mrs. Mallard? Why didn't she free herself from the culturally acceptable, yet unsatisfying, relationship with her husband?
3. The mother in "I Stand Here Ironing" seems to accept her role. Does acceptance mean victory? Does the mother "win" in this story? Does the daughter? How generally cheerful does the mother seem? What does this tell you about whether she "wins" or not?
4. What is a symbol? Tillie Olsen's last paragraph includes the mother's hope that her daughter will believe "that she is more than [the] dress on the ironing board, helpless before the iron." Is ironing symbolic of something? What? Who is helpless before the iron? Does this have anything to do with the influence of culture?
5. The women in these two stories share the same culture, but their responses to their roles are quite different. Do the two responses seem equally valid to you? Which one can you identify better with? Why? Which woman is most bound by what her culture expects of her?

INTRODUCTION

In this story you will see three people. Two of them, a mother and her daughter, live more or less ordinary lives in their culture. The third, another daughter, chooses to step outside that culture. You decide on the results.

Everyday Use

Alice Walker

I will wait for her in the yard that Maggie and I made so clean and wavy yesterday afternoon. A yard like this is more comfortable than most people know. It is not just a yard. It is like an extended living room. When the hard clay is swept clean as a floor and the fine sand around the edges lined with tiny, irregular grooves, anyone can come and sit and look up into the elm tree and wait for the breezes that never come inside the house.

Maggie will be nervous until after her sister goes: she will stand hopelessly in corners, homely and ashamed of the burn scars down her arms and legs, eyeing her sister with a mixture of envy and awe. She thinks her sister has held life always in the palm of one hand, that "no" is a word the world never learned to say to her.

You've no doubt seen those TV shows where the child who has "made it" is confronted, as a surprise, by his own mother and father, tottering in weakly from backstage. (A pleasant surprise, of course: what would they do if parent and child came on the show only to curse out and insult each other?) On TV mother and child embrace and smile into each other's faces. Sometimes the mother and father weep, the child wraps them in his arms and leans across the table to tell how he would not have made it without their help. I have seen these programs.

Sometimes I dream a dream in which Dee and I are sud-

denly brought together on a TV program of this sort. Out of a dark and soft-seated limousine I am ushered into a bright room filled with many people. There I meet a smiling, gray, sporty man like Johnny Carson who shakes my hand and tells me what a fine girl I have. Then we are on the stage and Dee is embracing me with tears in her eyes. She pins on my dress a large orchid, even though she has told me once that she thinks orchids are tacky flowers.

In real life I am a large big-boned woman with rough, man-working hands. In the winter I wear flannel nightgowns to bed and overalls during the day. I can kill and clean a hog as mercilessly as a man. My fat keeps me hot in zero weather. I can work outside all day, breaking ice to get water for washing; I can eat pork liver cooked over the open fire minutes after it comes steaming from the hog. One winter I knocked a bull calf straight in the brain between the eyes with a sledgehammer and had the meat hung up to chill before nightfall. But of course all this does not show on television. I am the way my daughter would want me to be; a hundred pounds lighter, my skin like an uncooked barley pancake. My hair glistens in the hot bright lights. Johnny Carson has much to do to keep up with my quick and witty tongue.

But that is a mistake. I know even before I wake up. Who ever knew a Johnson with a quick tongue? Who can even imagine me looking a strange white man in the eye? It seems to me I have talked to them always with one foot raised in flight, with my head turned in whichever way is farthest from them. Dee, though. She would always look anyone in the eye. Hesitation was no part of her nature.

"How do I look, Mama?" Maggie says, showing just enough of her thin body enveloped in pink skirt and red blouse for me to know she's there almost hidden by the door.

"Come out into the yard," I say.

Have you ever seen a lame animal, perhaps a dog run over by some careless person rich enough to own a car, sidle up to someone who is ignorant enough to be kind to him? That is the way my Maggie walks. She has been like this, chin on chest, eyes on ground, feet in shuffle, ever since the fire that burned the other house to the ground.

Dee is lighter than Maggie, with nicer hair and a fuller figure. She's a woman now, though sometimes I forget. How long ago was it that the other house burned? Ten, twelve years? Sometimes I can still hear the flames and feel Maggie's arms sticking to me, her hair smoking and her dress falling off her in little black papery flakes. Her eyes seemed stretched open, blazed open by the flames reflected in them. And Dee. I see her standing off under the sweetgum tree she used to dig gum out of; a look of concentration on her face as she watched the last dingy gray board of the house fall in toward the red-hot brick chimney. Why don't you do a dance around the ashes? I'd wanted to ask her. She had hated the house that much.

I used to think she hated Maggie too. But that was before we raised the money, the church and me, to send her to Augusta to school. She used to read to us without pity; forcing words, lies, other folks' habits, whole lives upon us two, sitting trapped and ignorant underneath her voice. She washed us in a river of make-believe, burned us with a lot of knowledge we didn't necessarily need to know. Pressed us to her with the serious way she read, to shove us away, like dimwits, at just the moment we seemed about to understand.

Dee wanted nice things. A yellow organdy dress to wear to her graduation from high school; black pumps to match a green suit she'd made from an old suit somebody gave me. She was determined to stare down any disaster in her efforts. Her eyelids would not flicker for minutes at a time. Often I fought off the temptation to shake her. At sixteen she had a style of her own: and knew what style was.

I never had an education myself. After second grade the school was closed down. Don't ask me why: in 1927 colored asked fewer questions than they do now. Sometimes Maggie reads to me. She stumbles along good-naturedly but can't see well. She knows she is not bright. Like good looks and money, quickness passed her by. She will marry John Thomas (who has mossy teeth in an earnest face), and then I'll be free to sit here and I guess just sing church songs to myself. Although I never was a good singer. Never could carry a tune. I was always better at a man's job. I used to love to milk till I was hooked in the side in '49. Cows are soothing and slow and don't bother you, unless you try to milk them the wrong way.

I have deliberately turned my back on the house. It is three rooms, just like the one that burned, except the roof is tin; they don't make shingle roofs anymore. There are no real windows, just some holes cut in the sides, like the portholes in a ship, but not round and not square, with rawhide holding the shutters up on the outside. This house is in a pasture too, like the other one. No doubt when Dee sees it she will want to tear it down. She wrote me once that no matter where we "choose" to live, she will manage to come see us. But she will never bring her friends. Maggie and I thought about this and Maggie asked me, "Mama, when did Dee ever *have* any friends?"

She had a few. Furtive boys in pink shirts hanging about on washday after school. Nervous girls who never laughed. Impressed with her they worshipped the well-turned phrase, the cute shape, the scalding humor that erupted like bubbles in lye. She read to them.

When she was courting Jimmy T she didn't have much time to pay to us, but turned all her fault-finding power on him. He *flew* to marry a cheap city girl from a family of ignorant flashy people. She hardly had time to recompose herself.

When she comes I will meet . . . but there they are!

Maggie attempts to make a dash for the house, in her shuffling way, but I stay her with my hand. "Come back here," I say. And she stops and tries to dig a well in the sand with her toe.

It is hard to see them clearly through the strong sun. But even the first glimpse of leg out of the car tells me it is Dee. Her feet were always neat looking, as if God himself had shaped them with a certain style. From the other side of the car comes a short, stocky man. Hair is all over his head a foot long and hanging from his chin like a kinky mule tail. I hear Maggie suck in her breath. "Uhnnnh," is what it sounds like. Like when you see the wriggling end of a snake just in front of your foot on a road. "Uhnnnh."

Dee, next. A dress down to the ground, in this hot weather. A dress so loud it hurts my eyes. There are yellows and oranges enough to throw back the light of the sun. I feel my whole face warming from the heat waves it throws out. Earrings gold too, and hanging down to her shoulders. Bracelets dangling and

making noises when she moves her arm up to shake the folds of the dress out of her armpits. The dress is loose and flows, and as she walks closer, I like it. I hear Maggie go "Uhnnnh" again. It is her sister's hair. It stands straight up like the wool on a sheep. It is black as night and around the edges are two long pigtails that rope about like small lizards disappearing behind her ears.

"Wa-su-zo-Tean-o!" she says, coming on in that gliding way the dress makes her move. The short stocky fellow with the hair to his navel is all grinning and he follows up with, "Asalamalakim, my mother and sister!" He moves to hug Maggie but she falls back, right up against the back of my chair. I feel her trembling there, and when I look up I see the perspiration falling off her skin.

"Don't get up," says Dee. Since I am stout it takes something of a push. You can see me trying to move a second or two before I make it. She turns, showing white heels through her sandals, and goes back to the car. Out she peeks next with a Polaroid. She stoops down quickly and snaps off picture after picture of me sitting there in front of the house with Maggie cowering behind me. She never takes a shot without making sure the house is included. When a cow comes nibbling around the edge of the yard she snaps it and me and Maggie *and* the house. Then she puts the Polaroid on the back seat of the car, and comes up and kisses me on the forehead.

Meanwhile Asalamalakim is going through motions with Maggie's hand. Maggie's hand is as limp as a fish, and probably as cold, despite the sweat, and she keeps trying to pull it back. It looks like Asalamalakim wants to shake hands but wants to do it fancy. Or maybe he don't know how people shake hands. Anyhow, he soon gives up on Maggie.

"Well," I say. "Dee."

"No, Mama," she says. "Not 'Dee,' Wangero Leewanika Kemanjo!"

"What happened to 'Dee'?" I wanted to know.

"She's dead," Wangero said. "I couldn't bear it any longer, being named after the people who oppress me."

"You know well as me you was named after your aunt Dicie," I said. Dicie is my sister. She named Dee. We called her "Big Dee" after Dee was born.

"But who was *she* named after?" asked Wangero.

"I guess after Grandma Dee," I said.

"And who was she named after?" asked Wangero.

"Her mother," I said, and saw Wangero was getting tired. "That's about as far back as I can trace it," I said. Though, in fact, I probably could have carried it back beyond the Civil War through the branches.

"Well," said Asalamalakim, "there you are."

"Uhnnnh," I heard Maggie say.

"There I was not," I said, "before 'Dicie' cropped up in our family, so why should I try to trace it that far back?"

He just stood there grinning, looking down on me like somebody inspecting a Model A car. Every once in a while he and Wangero sent eye signals over my head.

"How do you pronounce this name?" I asked.

"You don't have to call me by it if you don't want to," said Wangero.

"Why shouldn't I?" I asked. "If that's what you want us to call you, we'll call you."

"I know it might sound awkward at first," said Wangero.

"I'll get used to it," I said. "Ream it out again."

Well, soon we got the name out of the way. Asalamalakim had a name twice as long and three times as hard. After I tripped over it two or three times he told me to just call him Hakim-a-barber. I wanted to ask him was he a barber, but I didn't really think he was, so I didn't ask.

"You must belong to those beef cattle peoples down the road," I said. They said "Asalamalakim" when they met you too, but they didn't shake hands. Always too busy: feeding the cattle, fixing the fences, putting up salt-lick shelters, throwing down hay. When the white folks poisoned some of the herd, the men stayed up all night with rifles in their hands. I walked a mile and a half just to see the sight.

Hakim-a-barber said, "I accept some of their doctrines, but farming and raising cattle is not my style." They didn't tell me, and I didn't ask, whether Wangero (Dee) had really gone and married him.

We sat down to eat and right away he said he didn't eat collards and pork was unclean. Wangero, though, went on through the chitlins and corn bread, the greens and everything else. She

talked a blue streak over the sweet potatoes. Everything delighted her. Even the fact that we still used the benches her daddy made for the table when we couldn't afford to buy chairs.

"Oh, Mama!" she cried. Then turned to Hakim-a-barber. "I never knew how lovely these benches are. You can feel the rump prints," she said, running her hands underneath her and along the bench. Then she gave a sigh and her hand closed over Grandma Dee's butter dish. "That's it!" she said. "I knew there was something I wanted to ask you if I could have." She jumped up from the table and went over in the corner where the churn stood, the milk in it clabber by now. She looked at the churn and looked at it.

"This churn top is what I need," she said. "Didn't Uncle Buddy whittle it out of a tree you all used to have?"

"Yes," I said.

"Uh huh," she said happily. "And I want the dasher too."

"Uncle Buddy whittle that too?" asked the barber.

Dee (Wangero) looked up at me.

"Aunt Dee's first husband whittled the dash," said Maggie so low you almost couldn't hear her. "His name was Henry, but they called him Stash."

"Maggie's brain is like an elephant's," Wangero said, laughing. "I can use the churn top as a centerpiece for the alcove table," she said, sliding a plate over the churn, "and I'll think of something artistic to do with the dasher."

When she finished wrapping the dasher the handle stuck out. I took it for a moment in my hands. You didn't even have to look close to see where hands pushing the dasher up and down to make butter had left a kind of sink in the wood. In fact, there were a lot of small sinks; you could see where thumbs and fingers had sunk into the wood. It was beautiful light yellow wood, from a tree that grew in the yard where Big Dee and Stash had lived.

After dinner Dee (Wangero) went to the trunk at the foot of my bed and started rifling through it. Maggie hung back in the kitchen over the dishpan. Out came Wangero with two quilts. They had been pieced by Grandma Dee, and then Big Dee and me had hung them on the quilt frames on the front porch and

quilted them. One was in the Lone Star pattern. The other was Walk Around the Mountain. In both of them were scraps of dresses Grandma Dee had worn fifty and more years ago. Bits and pieces of Grandpa Jarrell's paisley shirts. And one teeny faded blue piece, about the size of a penny matchbox, that was from Great Grandpa Ezra's uniform that he wore in the Civil War.

"Mama," Wangero said sweet as a bird. "Can I have these old quilts?"

I heard something fall in the kitchen, and a minute later the kitchen door slammed.

"Why don't you take one or two of the others?" I asked. "These old things was just done by me and Big Dee from some tops your grandma pieced before she died."

"No," said Wangero. "I don't want those. They are stitched around the borders by machine."

"That'll make them last better," I said.

"That's not the point," said Wangero. "These are all pieces of dresses Grandma used to wear. She did all this stitching by hand. Imagine!" She held the quilts securely in her arms, stroking them.

"Some of the pieces, like those lavender ones, come from old clothes her mother handed down to her," I said, moving up to touch the quilts. Dee (Wangero) moved back just enough so that I couldn't reach the quilts. They already belonged to her.

"Imagine!" she breathed again, clutching them closely to her bosom.

"The truth is," I said, "I promised to give them quilts to Maggie, for when she marries John Thomas."

She gasped, like a bee had stung her.

"Maggie can't appreciate these quilts!" she said. "She'd probably be backward enough to put them to everyday use."

"I reckon she would," I said. "God knows I been saving'em for long enough with nobody using'em. I hope she will!" I didn't want to bring up how I had offered Dee (Wangero) a quilt when she went away to college. Then she had told me they were old-fashioned, out of style.

"But they're *priceless!*" she was saying now, furiously; for she has a temper. "Maggie would put them on the bed and in five years they'd be in rags. Less than that!"

"She can always make some more," I said. "Maggie knows how to quilt."

Dee (Wangero) looked at me with hatred. "You just will not understand. The point is these quilts, *these* quilts!"

"Well," I said, stumped, "what would *you* do with them?"

"Hang them," she said. As if that was the only thing you *could* do with quilts.

Maggie, by now, was standing in the door. I could almost hear the sound her feet made as they scraped over each other.

"She can have them, Mama," she said, like somebody used to never winning anything, of having anything reserved for her. "I can 'member Grandma Dee without the quilts."

I looked at her hard. She had filled her bottom lip with checkerberry snuff, and it gave her face a kind of dopey, hangdog look. It was Grandma Dee and Big Dee who taught her how to quilt herself. She stood there with her scarred hands hidden in the folds of her skirt. She looked at her sister with something like fear, but she wasn't mad at her. This was Maggie's portion. This was the way she knew God to work.

When I looked at her like that something hit me in the top of my head and ran down to the soles of my feet. Just like when I'm in church and the spirit of God touches me and I get happy and shout. I did something I never had done before: hugged Maggie to me, then dragged her on into the room, snatched the quilts out of Miss Wangero's hands and dumped them into Maggie's lap. Maggie just sat there on my bed with her mouth open.

"Take one or two of the others," I said to Dee.

But she turned without a word and went out to Hakim-a-barber.

"You just don't understand," she said, as Maggie and I came out to the car.

"What don't I understand?" I wanted to know.

"Your heritage," she said. And then she turned to Maggie, kissed her, and said, "You ought to try to make something of yourself too, Maggie. It's really a new day for us. But from the way you and Mama still live you'd never know it."

She put on some sunglasses that hid everything above the tip of her nose and her chin.

Maggie smiled; maybe at the sunglasses. But a real smile, not scared. After we watched the car dust settle I asked Maggie to bring me a dip of snuff. And then the two of us sat there just enjoying, until it was time to go in the house and go to bed.

FOR DISCUSSION

1. Read the fifth paragraph of the story again. What portrait of the mother does it paint? How is Maggie described? Why do you think the author chose to have Maggie scarred by burns?

2. Why does Dee (Wangero) want the quilts? Considering what you have already read here about culture, why is her idea of what to do with the quilts important?

3. Dee says that her mother does not understand her heritage. Do you agree? Does it limit the mother, as Dee suggests? Is Dee limited by *her* heritage? How?

4. The mother and Maggie have a celebration of sorts at the end of the story. Why? Does the author suggest that they have "won" something? What might it be?

Part Four

Changing Women

The women in this section are changing in many ways, expanding the possibilities for themselves and for others. Some overcome the usual cultural expectations for them by having the courage to say no to unacceptable choices. Some use great personal determination to create unique lives for themselves. Still others meet challenges with actions and ideas that clearly indicate their considerable abilities.

Regardless of the methods or reasons for the changes, all these women have their roots deep in the experiences of womanhood, from which they get much of their great strength.

INTRODUCTION

Harriette Arnow's novel *The Dollmaker* is the story of a
Kentucky hill family that moves to Detroit during World War II.
At the heart of the novel is Gertie Nevels, the wife and mother.
One label for her would be "housewife." As you read the fol-
lowing excerpt, you may wish to ask yourself how similar Gertie
is to other housewives you've read about to this point.

from The Dollmaker

Harriette Arnow

Dock's shoes on the rocks up the hill and his heavy
breathing had shut out all sound so that it seemed a long while
she had heard nothing, and Amos lay too still, not clawing at the
blanket as when they had started. They reached the ridge top
where the road ran through scrub pine in sand, and while the
mule's shoes were soft on the thick needles she bent her head
low over the long bundle across the saddle horn, listening. Al-
most at once she straightened, and kicked the already sweat-
soaked mule hard in the flanks until he broke into an awkward
gallop. "I know you're tired, but it ain't much furder," she said
in a low tight voice.

She rode on in silence, her big body hunched protectingly
over the bundle. Now and then she glanced worriedly up at the
sky, graying into the thick twilight of a rainy afternoon in Octo-
ber; but mostly her eyes, large, like the rest of her, and the
deep, unshining gray of the rain-wet pine trunks, were fixed
straight ahead of the mule's ears, as if by much looking she might
help the weary animal pull the road past her with her eyes.

They reached the highway, stretching empty between the
pines, silent, no sign of cars or people, as if it were not a road at
all, but some lost island of asphalt coming from no place, going
nowhere. The mule stopped, his ears flicking slowly back and

forth as he considered the road. She kicked him again, explaining, "It's a road fer automobiles; we'll have to ride it to stop a car, then you can git back home."

The mule tried to turn away from the strange black stuff, flung his head about, danced stiff-leggedly back into the familiar sanctuary of soft ground and pine trees. "No," the woman said, gripping his thin flanks with her long thighs, "no, you've got to git out in th middle so's we can stop a car goen toward th doctor's. You've got to." She kicked him again, turned him about. He tried one weary half-hearted bucking jump; but the woman only settled herself in the saddle, gripped with her thighs, her drawn-up knees, her heels. Her voice was half-pleading, half-scolding: "Now, Dock, you know you cain't buck me off, not even if you was fresh—an you ain't. So git on."

The great raw-boned mule argued with his ears, shook the bridle rein, side-stepped against a pine tree, but accepted soon the fact that the woman was master still, even on a strange road. He galloped again, down the middle of the asphalt that followed a high and narrow ridge and seemed at times like a road in the sky, the nothingness of fog-filled valleys far below on either side.

A car passed. Dock trembled at the sound, and side-stepped toward the edge, but the woman spoke gently, and held him still. "It won't hurt you none. It's a car like th coal truck; we ain't a stoppen it. It's a goen th wrong way."

The mule, in spite of all the woman's urging, was slow in getting through his fright from the passing of the car. He fought continually to stay on the edge of the road, which was beginning to curve sharply and down so that little of it could be seen in either direction. The woman's head was bent again, listening above the bundle, when the mule plunged wildly toward the pines. She jerked hard on the bridle, so swiftly, so fiercely, that he whirled about, reared, came down, then took a hard, stiff-legged jump that landed him for an instant crosswise in the road.

The roar of a car's coming grew louder. Terrified by the strange sound, the unfamiliar road, and the strangeness of the woman's ways, the mule fought back toward the pines. The woman gripped with her legs, pulled with her hand, so that they seemed to do some wild but well rehearsed dance, round and round in the road, the mule rearing, flinging his head about, fighting to get it down so that he could buck.

from The Dollmaker 181

She eased her hold an instant, jerked hard with all her strength. He reared but stayed in the road. Yellow fog lights, pale in the gray mists, washed over them, shone on the red sandy clay on one of the woman's shoes, a man's shoe with cleats holding leather thongs, pressed hard against the mule's lifted body as if it pointed to a place in the bridle mended with a piece of rawhide. It seemed a long time she sat so, the mule on his hind legs, the car lights washing over her, the child unshaken in the crook of her left arm while she talked to the mule in the same low urgent voice she had used to get him onto the highway: "Don't be afeared, Dock. They'll stop. We'll make em stop. They dasn't take these downhill curves too fast. They'll have to stop. We'll all go over the bluff together."

There was a loud, insistent honking; brakes squealed and rubber squeaked while the fingers of light swept away from the woman and out into the fog above the valley. Then, as the car skidded, the lights crossed the woman again, went into the pines on the other side of the road, swept back, as the car, now only a few feet behind her but on the other side of the road, came out of its skid. The woman's voice was low, pressed down by some terrible urgency as she begged under the screaming of the horn, "Crosswise, crosswise; it'll git by us on tother side."

She jerked, kicked the mule, until he, already crazed with fright, jumped almost directly in front of the car, forcing it to swerve again, this time so sharply that it went completely off the road. It plowed partway into a thicket of little pines, then stopped on the narrow sandy shoulder above the bluff edge. The woman looked once at the car, then away and past the trembling mule's ears; and though she looked down it was like searching the sky on a cloudy day. There was only fog, thickened in splotches, greenish above a pasture field, brownish over the corn far down in the valley below the tree tops by the bluff edge.

"You done good, real good," she whispered to the mule. Then all in one swift motion she swung one leg over the mule's back, looped the bridle over the saddle horn, turned the dazed mule southward, slapping him on the shoulder. "Git," she said, she did not look after him as he leaped away, broken ribbons of foam flying down his chin, and blood oozing from a cut on his left hind leg where the car had grazed him.

She hurried a few steps along the bluff edge to the car as if afraid it would be off again; but her hand was reaching for the front door handle before the door opened slowly, cautiously, and a soldier, his head almost to her chin, got out. He stared up at her and did not answer when she begged all in a breath: "I've got tu have a lift. My little boy he's . . ."

The soldier was no longer looking at her. His eyes, blue, and with the unremembering look of a very old man's eyes, were fixed on the poplar tops rising above the bluff edge. He looked past them down into the valley, then slowly taking his glance away he reached for the handle of the back door, but dropped his hand when he saw that the window in the door was opening.

The woman turned to the down-dropping window and watched impatiently while first a hard and shiny soldier's cap rose above it, then a man's face, straight and neat and hard-appearing as the cap, but flushed now with surprise and anger. The mouth was hardly showing before it spoke, quickly, but with a flat, careful pronunciation of the words. "You realize you've run me off the road. If you can't manage a horse, don't ride one on the highway. Don't you know there's a war and this road carries . . ."

The woman had listened intently, watching the man's lips, her brows drawn somewhat together like one listening to a language only partly understood. "I know they's a war," she said, reaching for the door handle. "That's why th doctor closest home is gone. It was a mule," she went on. "I managed him. I had to make you stop. I've got to git my little boy to a doctor—quick." She had one foot inside the door, the child held now in her two hands as she prepared to lay him on the seat.

The man, plainly irritated because he had neglected to hold the door shut, continued to sit by it, his legs outspread, barring her way. His hand moved slowly, as if he wanted her to see it touch the pistol in a polished holster by his side, let the pistol speak to her more than his toneless, unruffled words when he said, "You must use other means of getting your child to the doctor." He reached swiftly, jerked the door so that she, bent as she was, and with the heavy bundle in her two hands, staggered. Her head flopped downward to his knees, but she righted herself and kept one foot in the door.

"If my business were not so urgent," he said, not taking his

hand from the door, "I would have you arrested for sabotage. I travel from"—he hesitated—"an important place on urgent business." The voice still was not a man's voice, but the shiny cap, the bright leather, the pistol. It sharpened a little when he said, turning from her to the driver, "Get back into the car and drive on." He looked once at the bundle where one small sunburned but blue-nailed hand waved aimlessly out of the blanket folds. Then, letting the door swing wide, he jerked it swiftly so that it struck hard against the woman's back, bent again as she searched for his eyes.

She straightened, put the hand under the blanket, but continued to stand between door and car. "I'm sorry you're th army; frum Oak Ridge, I reckon, but I'd a stopped you enyhow." Her voice was quiet as the voice below the cap. "You can shoot me now er give me an this youngen a lift to the closest doctor." And even in the man's work shoes, the long and shapeless coat, green-tinged with age, open, giving glimpses of a blue apron faded in strange squares as if it might have at one time been something else—a man's denim trousers or overall jumper—she held herself proudly, saying: "You want my name; I'm Gertie Nevels frum Ballew, Kentucky. Now, let me lay my little boy down. You can't go . . ."

The officer had flung the door suddenly outward again. Still she did not fall when he banged it back against her, though in her attempts to keep from falling forward into the car and onto the child she dropped to her knees, her feet sliding through the gravel to the bluff edge. The officer gripped the pistol butt, and his voice shrilled a little as he said to the young soldier who had stood stiff and silent, staring at the woman: "Get in and drive on. She'll have to drop off then."

The other took his eyes from the blanket, still now. He saluted, said, "Yes, sir," but continued to stand, his body pressed against the car, his glance going again to the treetops below his feet.

"Back up on the road and drive on," the other repeated, his face reddening, his eyes determinedly fixed straight in front of him.

"Yes, sir?" the other said again, unmoving. There was in his questioning acceptance of the command some slight note of

pleasure. He looked up at the tall woman as if he would share it with her. Their glances crossed, but the trouble, the urgency of her need would let nothing else come into her eyes.

She looked again at the other. "You want him to go over th bluff?" And her voice was weary to breaking, like an overwrought mother speaking to a stubborn child.

The older man for the first time looked past the woman and realized that what he had taken for a continuation of the brush and scrub pine was the tops of tall-growing trees below a bluff. He looked quickly away and began rapid edging along the seat to the opposite door. It was only when he was out of the car and a few feet from the bluff edge that he was able to speak with the voice of polished leather and pistol handle, and command the other to back out.

The woman, as soon as the officer moved, had laid the child on the seat, then stood a moment by the door, watching the driver, shaking her head slowly, frowning as he raced the motor until the car shivered and the smoking rear wheels dug great holes in the sandy shoulder. "That'll do no good," she said, then more loudly, her voice lifted above the roaring motor, "Have you got a ax?"

He shook his head, smiling a little, then his eyes were blank, prim like his mouth when the other told him to turn off the motor. The woman picked up a large sandrock, dropped it behind one of the deeply sunken rear wheels. "Have you got a jack?" she asked the officer. "You could heist it up with a jack, git rocks under them wheels, an back up on the road."

"Take your child out of the car and get on," he said, his voice no longer smooth. "We may be stuck here until I can get a tow truck. You'll be arrested."

She glanced at him briefly, smoothed back her straight dark brown hair with a bended arm, then drawing the bottom of her apron into one hand to form kind of a sack, she began gathering rocks with the other hand, going in a quick squatting run, never straightening in her haste, never looking up.

The young soldier had by now got out of the car and stood by it, his back and shoulders very straight, his hands dropped by his sides so that a band of colored ribbon was bright on his dull uniform. The woman glanced curiously at it as she dumped a

load of rocks by a wheel. The officer looked at him, and his voice was shrill, akin to an angry woman's. "Hatcher, you're not on the parade ground."

"Yes, sir," the other said, drawing himself up still more rigidly.

"Get out the jack," the officer said, after frowning a moment at the woman as if loath to repeat her suggestion.

"Yes, hurry, please," the woman begged, not pausing in her rock gathering, but looking toward the child on the back seat. It had struggled until the blanket had fallen away from its head, showing dark hair above a face that through the window shone yellowish white, contorted with some terrible effort to cry or vomit or speak. Like the woman as she ran squatting through the mud, the struggling child seemed animal-like and unhuman compared to the two neatly dressed men.

The woman hurried up again with another apronful of rocks, dumped them, then went at her darting, stooping run along the bluff edge searching for more. The young soldier in the awkward, fumbling way of a man, neither liking nor knowing his business, got out the jack and set it in the sandy mud under the rear bumper. "That's no good," the woman said, coming up with more rocks; and with one hand still holding the apron she picked up the jack, put a flat rock where it had been, reset it, gave it a quick, critical glance. "That'll hold now," she said. She dumped her rocks by the wheel, but continued to squat, studying now the pines caught under the front of the car.

The officer stood at the edge of the asphalt, silent. Sometimes he looked up and down the road, and often he glanced at his wrist watch, but mostly his frowning glance was fixed on the car. He watched the woman now. Her hands had been busied with rocks and apron when she bent by the wheel; now one hand was still holding her emptied apron as she straightened, but in the other was a long knife, bright, thin, sharply pointed. The man, watching, took a quick step backward while his hand went again to the pistol butt. The woman, without looking at either man, knelt by the front of the car, reaching far under with the knife, slashed rapidly at the entangled pine saplings while with the other hand she jerked them free and flung them behind her.

Finished with the pines, she went quickly along the bluff

edge by the car, her glance searching through the window toward the child, still now, with the hand of one down-hanging arm brushing the floor. She watched only an instant and did not bend to listen, for clearly in the silence came the child's short choking gasps. She hurried on around the back of the car, and bent above the soldier, only now getting the jack into working position. "Hurry," she begged in the same tight, urgent voice she had used on the mule. "Please, cain't you hurry—he's a choken so," and in her haste to get a wheel on solid rock she began clawing at the muddy earth with her hands, pushing rocks under the tire as it slowly lifted.

In a moment the officer called, "That's enough; try backing out now."

Some of the woman's need for haste seemed to have entered the soldier. He straightened, glanced quickly toward the child, struggling with its head dangling over the edge of the seat, its eyes rolled back but unseeing. He turned quickly and hurried into the driver's seat without taking time to salute or say, "Yes, sir." The woman ran to the back wheel that had dug such a rut in the mud, and watched anxiously while the driver started the motor, raced it as he backed an inch or so. The car stopped, the motor roaring, the wheels spinning, smoking, flinging mud, rocks, and pine brush into the woman's face bent close above them in her frantic efforts with hands and feet to keep the brush and rocks under the wheel.

"Try rocking out," the officer said. "Pull up, then shift, quick, into reverse."

The soldier was silent, looking at the emptiness in front of him. With the bent young pines cut away, the bumper seemed to hang above the valley. He moved at last, a few inches forward, but slowly, while the woman pushed rocks behind the rear wheels, jumping from first one to the other as she tried to force the rocks into the earth with her heavy shoes. The car stopped. The driver shifted again into reverse. The woman stood waiting between the side of the car and the bluff, her long arms a little lifted, the big jointed fingers of her great hands wide spread, her eyes on the back fender, her shoulders hunched like those of an animal gathering itself for a spring.

The motor roared again, the back wheels bit an inch or so

into the rocks and mud, then spun. The woman plunged, flinging her two hard palms against the fender. Her body arched with the push like a too tightly strung bow; her eyes bulged; the muscles of her neck and face writhed under the thin brown skin; her big shoes dug holes in the mud in their efforts to keep still against the power of the pushing hands. The car hung trembling, shivering, and one of the woman's feet began to slide toward the bluff edge.

Then her body seemed slowly to lengthen, for the car had moved. The woman's hands stayed with the fender until it pulled away from them. She fell sideways by the bluff edge so that the front wheel scraped her hip and the bumper touched strands of the dark hair tumbled from the thick knob worn high on her head. She stayed a moment in the mud, her knees doubled under her, her hands dropped flat on the earth, her drooping head between her arms, her whole body heaving with great gasping breaths.

She lifted her head, shook it as if to clear some dimness from her eyes, smoothed back her hair, then got slowly to her feet. Still gasping and staggering a little, she hurried to the car, stopped again but ready to start with its wheel on the hard-packed gravel by the road.

She jerked the door open and started in, but with the awkwardness of one unused to cars she bumped her head against the door-frame. She was just getting her wide shoulders through, her eyes on the child's face, when the officer, much smaller and more accustomed to cars than she, opened the door on his side, stepped partway in, and tried to pick up the child. It seemed heavier than he had thought, and instead of lifting it he jerked it quickly, a hand on either shoulder, across the seat and through the door, keeping it always at arm's length as if it had been some vile and dirty animal.

The woman snatched at the child but caught only the blanket. She tried to jump into the car, but her long loose coat-tail got under her feet and she squatted an instant, unable to rise, trapped by the coattail. Her long, mud-streaked hair had fallen over her face, and through it her eyes were big, unbelieving, as the man said, straightening from pulling the child into the road a few feet from the car, "You've helped undo a little of the damage

you've done, but"—he drew a sharp quick breath—"I've no time for giving rides. I'm a part of the Army, traveling on important business. If you must go with me you'll leave your child in the road. He isn't so sick," he went on, putting his foot through the door, even though the woman, still crouching, struggled through the other door. "He seemed quite active, kicking around," and then to the driver, quietly now, with no trace of shrillness, "Go on."

The woman gave the driver a swift measuring glance, saw his stiff shoulders, his face turned straight ahead as if he were a part of the car to be stopped or started at the will of the other. The car moved slowly; the officer was in now, one hand on the back of the front seat, the other closing the door. She gave an awkward squatting lunge across the car, her hand flung palm outward as when she had flung herself against the fender. One hand caught the small man's wrist above his pistol, the other caught his shoulder, high up, close to the neck, pushing, grasping more than striking, for she was still entangled in her coat.

He half sat, half fell in the road, one foot across the child. She did not look at him, but reached from the doorway of the car for the child, and her voice came, a low breathless crying: "Cain't you see my youngen's choken tu death? I've got to git him to a doctor."

One of the child's hands moved aimlessly, weakly knocking the blanket from its face. She gave a gasping cry, her voice shrilling, breaking, as if all the tightness and calmness that had carried her through the ride on the mule and the stopping and the starting of the car were worn away.

"Amos, Amos. It's Mommie. Amos, honey, Amos?" She was whispering now, a questioning whisper, while the child's head dangled over her arm. His unseeing eyes were rolled far back; the whites bulged out of his dark, purplish face, while mucus and saliva dribbled from his blue-lipped swollen mouth. She ran her finger down his throat, bringing up yellow-tinged mucus and ill-smelling vomit. He gave a short whispering breath that seemed to go no deeper than his choked-up throat. She blew in his mouth, shook him, turned him over, repeating the questioning whisper, "Amos, oh Amos?"

The driver, who had leaped from his seat when she pushed

the other through the car, was still, staring at the child, his hands under the older man's elbows, though the latter was already up and straightening his cap. For the first time he really looked at the child. "Shake him by the heels—slap him on the back," the young soldier said.

"Yes, take him by the heels," the other repeated. "Whatever is choking him might come loose." And now he seemed more man than soldier, at once troubled and repelled by the sick child.

The woman was looking about her, shaking the child cradled in her arms with quick jerky motions. "It's a disease," she said. "They's no shaken it out." She saw what she had apparently been hunting. A few feet up the road was a smooth wide shelf of sandstone, like a little porch hung above the valley. She ran there, laid the child on the stone, begging of the men, "Help me; help me," meanwhile unbuttoning the little boy's blue cotton jumper and under it his shirt, straightening him on the stone as one would straighten the dead. "Bring me a rock," she said over her shoulder, "flat like fer a piller."

The young soldier gaped at her, looked around him, and at last picked up a smooth piece of sandrock. She slipped it high up under the child's shoulders so that the swollen neck arched upward, stretched with the weight of the head, which had fallen backward.

"Help me," she repeated to the young soldier. "You'll have to hold his head, tight." She looked up at the other, who had stopped a few feet away, and now stared at her, wondering, but no longer afraid. "You hold his hands and keep his feet down." She looked down at the blue swollen face, smoothed back the dark brown hair from a forehead high and full like her own. "He cain't fight it much—I think—I guess he's past feelen anything," and there was a hopefulness in her voice that made the officer give her a sharp appraising glance as if he were thinking she could be crazy.

"Wouldn't it be better," he said, "to go quickly to the nearest doctor? He's not—he still has a pulse, hasn't he?"

She considered, nodding her head a little like one who understood such things. "I kept a tryen to feel it back there—I couldn't on the mule—but his heart right now—it's not good."

She looked at him, and said in a low voice: "I've seen youngens die. He ain't hardly breathen," then looked down again at the child. "Hold his hands an keep his feet down; they's no use a talken a gitten to th doctor; th war got th closest; th next is better'n fifteen miles down th road—an mebbe out a his office."

"Oh," the officer said, and hesitantly drew closer and stooped above the child, but made no move to touch him.

"Hold him," the woman repeated, "his hands," her voice low again and tight, but with a shiver through it as if she were very cold. Her face looked cold, bluish like the child's, with all the color drained away, leaving the tanned, weather-beaten skin of her high cheekbones and jutting nose and chin like a brown freckled mask painted on a cold and frightened face with wide, frightened eyes. She looked again at the child, struggling feebly now with a sharp hoarse breath, all her eyes and her thoughts for him so that she seemed alone by the sloping sandrock with the mists below her in the valley and the little fog-darkened pines a wall between her and the road. She touched his forehead, whispering, "Amos, I cain't let th war git you too." Then her eyes were on his neck bowed up above the rock pillow, and they stayed there as she repeated, "Hold him tight now."

The older man, with the air of one humoring a forlorn and helpless creature, took the child's hands in one of his and put the other about its ankles. The young soldier, gripping the child's head, drew a sharp, surprised breath, but the other, staring down at patched overall knees, saw nothing until when he looked up there was the long bright knife drawing swiftly away from the swollen neck, leaving behind it a thin line that for an instant seemed no cut at all, hardly a mark, until the blood seeped out, thickening the line, distorting it.

The woman did not look away from the reddening line, but was still like a stone woman, not breathing, her face frozen, the lips bloodless, gripped together, the large drops of sweat on her forehead unmoving, hanging as she squatted head bent above the child. The officer cried: "You can't do that! You're—you're killing. You can't do that!"

He might have been wind stirring fog in the valley for all she heard. The fingers of her left hand moved quickly over the cut skin, feeling, pulling the skin apart, holding it, thumb on one

side, finger on the other, shaping a red bowed mouth grinning up from the child's neck. "Please," the man was begging, his voice choked as if from nausea.

The knife moved again, and in the silence there came a little hissing. A red filmed bubble streaked with pus grew on the red dripping wound, rose higher, burst; the child struggled, gave a hoarse, inhuman whistling cry. The woman wiped the knife blade on her shoe top with one hand while with the other she lifted the child's neck higher, and then swiftly, using only the one hand, closed the knife, dropped it into her pocket, and drew out a clean folded handkerchief.

She gently but quickly wiped the blood and pus from the gaping hole, whispering to the child as it struggled, giving its little hoarse, inhuman cries. "Save yer breath, honey; thet little ole cut ain't nothen fer a big boy like you nigh four years old." She spoke in a low jerky voice like one who has run a long way or lifted a heavy weight and has no breath to speak. She lay down the handkerchief, hunted with her free hand an instant in her back hair, brought out a hairpin, wiped it on the handkerchief, inserted the bent end in the cut, and then slowly, watching the hole carefully, drew her hand from under the child's neck, all the while holding the hole open with the hairpin.

The young soldier, who had never loosened his grip on the child's head, drew a long shivering breath and looked with admiration at the woman, searching for her eyes; but finding them still on the child, he looked toward the officer, and at once gave an angry, whispering, "Jee-*sus.*"

The woman looked around and saw the officer who had collapsed all in a heap, his head on Amos's feet, one hand still clutching the child's hands. "He's chicken-hearted," she said, turning back to the child, saying over her shoulder, "You'd better stretch him out. Loosen his collar—he's too tight in his clothes enyhow. Go on, I can manage."

The young soldier got up, smiling a secret, pleased sort of smile, and the woman, glancing quickly away from the child, gave him an uneasy glance. "Don't you be a letten him roll off the bluff edge."

"No?" the other said, smiling down at Amos, breathing hoarsely and quickly, but breathing, his face less darkly blue.

The soldier looked past the officer crumpled on the stone down to the wide valley, then up and across to the rows of hills breaking at times through shreds and banks of the low-hanging fog, at other places hidden so that the low hills, seen through the fog, seemed vast and mysterious, like mountains rising into the clouds. He waved his hand toward the hills. "I'll bet hunting there is good."

The woman nodded without looking up. "Mighty good—now. They ain't hardly left us a man able to carry a gun er listen to a hound dog."

"Where is—" the soldier began, then stopped, for the officer's head was slowly lifting, and at once it was as if the other had never looked at the hills or spoken to her. He straightened his shoulders, pulled down his coat, watched an instant longer. As the head continued to lift, he stepped closer, and after a moment's hesitation, and with a swift glance at Gertie, put his hands under the other's arms, standing in front of him so that the officer was between him and the bluff.

The woman gave the two a quick, worried glance. "It's high there; watch out."

"I'm quite all right," the officer said, shaking the other's hands away. He lifted a greenish, watery-eyed face that seemed no soldier's face at all, only an old man's face. "How's the little one?" he asked, getting slowly to his feet.

"Breathen," the woman said.

"You've done a thing many doctors would be afraid to do without an operating room or anything," he said, all his need for haste somehow dropped away. The other had handed him his cap, but he stood holding it, looking at the woman as if there were something he would like to say but could not.

The woman dabbed at the blood and mucus and pus bubbling through the hole. "If that stuff runs down his windpipe an into his lungs, it'll be bad," she said, as if talking to herself more than to the men. "You can give a sheep pneumonie if when you're a drenchen it water gits down into its lungs."

She looked about her: at the little pine trees, at the tops of the black gum and poplar rising by the bluff, then away across the road as if searching for something. "Once I saved a cow that was choked—an in her windpipe I put a piece a cane."

"What is it?" he asked, careful not to look at the child. "It doesn't seem like plain choking."

"It's—" She rubbed her bent arm up her forehead, back across her stringing hair. "I disremember what they call it now; used to be they said membranous croup. I thought it was just plain croup, bad hard croup like he's had afore, till Aunt Sue Annie come. She told me word come in th mail last night Mealie Sexton's baby was dead. We thought it had th croup when she come a visiten my mother when she come in frum Cincinnati—her baby an him, they was together." She looked toward the young soldier, who stood in respectful silence a few feet behind the other. "Could you hold this open and watch him; I'll have to git somethin to put in it. It'll jist take a minnit. They's a little poplar right across th road."

He glanced as if for permission at the officer, but the other had turned away, looking greenish and sick again; and after a moment's hesitation the young one came with a fresh clean handkerchief of his own and took the hairpin and the woman's place by the child. She hurried across the road to a little poplar, and with one swift stroke cut a bough about the thickness of her middle finger, cut again; the bough with its yellow leaves unflecked with red or brown dropped away. Then, working as she walked back across the road, she stripped the gray bark from the short length of limb, glancing between each knife stroke at the child. She had crossed the road, when she stopped, knife lifted, to look at a red card lettered in black, tacked to a fair-sized pine tree. Most of the print was small, but large enough for men in passing cars to read were the words: MEN, WOMEN, WILLOW RUN, UNCLE SAM, LIVING QUARTERS. Her knife lifted, came down in one long thrust against the card. It fell and she walked on, the knife working now with swift, twisting cuts, forming a hole in one end of the wood.

"You shouldn't have done that," the older man said, nodding toward the card at the foot of the pine. "They need workers badly—as much as soldiers almost."

She nodded, glancing again toward the child. "But in our settlement they ain't nobody else they can git," she said.

"Is your husband in the armed forces?" he asked.

She shook her head. "His examinen date is still about three weeks off."

"Does he work in a factory?"

"He hauls coal in his own truck—when he can git gas—an th miners can git dynamite an caps an stuff to work in th coal."

"The big mines are more efficient," he said. "They need materials worse."

"Th only miners they left us is two cripples an one real old."

"But a good miner back here in these little mines—I've seen them by the road—would be a waste of man power, working without machinery," he said.

She studied the cut in the child's neck, listened, frowning to his short whistling breaths. She nodded to the man's words at last, but grudgingly, as if she had heard the words many times but could not or would not understand, and her face was expressionless, watching now the knife in the soft wood, now glancing at the child.

"It's like the farmers," the officer went on, his voice slightly apologetic as he glanced toward the child, struggling again so that the soldier must lay down the handkerchief and hold his hands while the strain of holding the hairpin steady in the windpipe was bringing sweat to his forehead. "They can't exempt every little onehorse farmer who has little to sell. A man has to produce a lot of what the country needs."

She did not nod, but her lips tightened so that, as when she had cut the child's neck, her mouth was a pale straight slit below the long straight upper lip and the jutting nose. "They warn't a farmer in all our settlement big enough," she said, and her voice was low and sullen.

"Have you any relatives in the armed forces?" he asked, his voice somehow critical.

"Jist cousins an in-laws an sich—now."

"Now?"

"Since yesterday mornen—I had a brother till then."

"Oh." His voice had changed, filled with a kind of proper sadness. "Let us hope he is only missing and that—"

"Jesse—that's my man's brother—he's th one that's missen. Fer my brother the telegram said, 'Kilt in action.'" The knife was still, and she sat a moment staring out across the hills, repeating slowly, tonelessly, "Kilt in action." Then, still in the toneless talking-to-herself voice: "These same leaves was green

from The Dollmaker 195

when they took him—an he'd planted his corn. Some of it he saw come up."

"He was a farmer?" the man asked.

The knife moved in the wood again as she said, "One a them little ones." The knife fought the wood with sharp swift jabs, forming a hole the length of the short piece of poplar. The man, watching stiffly, uncomfortably, trying not to look at the child or the woman's face, said, "You are very skillful with a knife."

"I've allus whittled."

"What?"

"Oh, handles."

"Handles?"

She looked down at the hand that held the poplar wood, the back brown and wrinkled, fingernails black and ragged, then at the palm, smooth with the look of yellowed leather. It was as if the hand were a page engraved with names while she, looking now at the poplar wood, repeated: "Hoe handles, saw handles, ax handles, corn-knife handles, broom handles, plow handles, grubben-hoe handles, churn-dasher handles, hammer handles, all kinds a handles—it takes a heap a handles. Sometimes I make em fer th neighbors."

He was silent, his glance fixed on her hands. "Handles," he said at last. "There wouldn't be much fun in handles."

Her face for an instant softened, and as she looked up something that might have been hatred was gone from her eyes. "I've never had much time fer whittlen foolishness. Oh, a few dolls. Cassie—that's my least girl—she's crazy over th dolls I whittle, but when I git all settled I'm aimen to work up a piece a wild cherry wood I've got. It's big enough fer th head an shoulders uv a fair-sized man if"—her voice was low again, wandering as if she talked to herself—"if I can ever hit on th right face." She glanced at the soldier struggling to keep the child's hands from clawing at his neck. "Hold out a little minute longer. I've about got this hole through."

The older man stood so that if he looked straight in front of him he could see the woman but not the child. "What kind of face?" he asked.

She shook the shavings out of the rapidly deepening hole,

began on the other end. "I don't know. I've thought on Christ—but somehow his face ain't never clear er somethen. Maybe some other—old Amos, I liked, or Ecclesiastes or Judas."

"Judas?" And he gave her a sharp, suspicious-seeming glance.

She looked again at the child, then nodded, her eyes on the knife blade as she talked. "Not Judas with his mouth all drooly, his hand held out fer th silver, but Judas given th thirty pieces away. I figger," she went on after blowing the shavings out of the hole, "they's many a one does meanness fer money—like Judas." Her eyes were on the poplar as she spoke, "But they's not many like him gives th money away an feels sorry onct they've got it."

She looked toward the child and met the eyes of the young soldier—there was a head nod in his eyes—but he was silent, for the other was saying, "You seem to be quite a student of the Bible."

She shook her head. "Th Bible's about th only thing I've ever read—when I was a growen up my mother was sick a heap an my father hurt his leg in th log woods. I had to help him, an never got much schoolen but what he give me."

"And he had you study the Bible."

"He had me git things by heart th way they used to do in th old days—poetry an th Constitution an a heap a th Bible." She rose, and still whittling walked toward the child. She stood above him, working swiftly until the hole in the tiny wooden pipe was to her liking, and then with the same gentle skill with which she had whittled she put the tube into the child's neck. She then wrapped him swiftly in the blanket, and with no glance at either man walked quickly to the car.

The officer pushed himself into a corner as far from the woman and child as possible. He sat stiffly, trying not to show his distaste for the big woman cluttering his speckless car, just as he tried not to look at the child or show that the inhuman gurgling cries it gave or the whispering bubbles of its breath nauseated him like the sight of the wooden tube beaded at times with pus and bloody mucus.

The woman sensed this and sat, trying to make herself as small as possible, her muddy feet unmoving by the door, her

great shoulders hunched over the child, and slightly sideways. The driver stared straight ahead at the road. The woman mostly watched the wooden pipe. The officer looked first at one side of the road then the other, unable to keep his glance from the child.

The road left the high pine ridges and followed the twisting course of a creek down into the valley of the Cumberland. Above them on the shoulder of the ridge lay a steep little clearing; stumpy first-year new ground it looked to be, not half tended. Even in the rainy twilight Gertie could see the leafless sprouts encircling the white oak stumps and the smallness of the fodder shocks—a woman's fodder shocks. Held up against the hillside on long front legs like stilts was a little plank house with a tarpaper roof. Chickens were going to roost in a crooked dogwood tree near the door, and a white-headed child came around the house, stumbling under the sticks of stovewood hugged in its arms, while on the high porch steps two other children, one too small to walk, played with a spotted hound.

Though it lay on the woman's side of the road, both glanced at it—the first house after miles of Cumberland National Forest. Then both saw the service flag with one star—blue—in the one front window by the door.

"What crops do they raise in this country?" the officer asked, as if he didn't much care but wanted to make some sound above the child's breathing.

"A little uv everthing."

"But what is their main crop?" he insisted.

"Youngens," she said, holding the child's hands that were continually wandering toward the hole in his neck. "Youngens fer th wars an them factories."

He turned his head sharply away, as if he wished to hear no more, but almost at once his unwilling glance was flicking the child's face where the blueness was thinning, and the eyes, less bulging now, showed their dark coloring through the half open lids. "Your child needs a hospital," he said, looking past her through the window. "You'd better go with us until we reach one."

"Th closest that ud take him with a disease like this is mebbe Lexington—an that's nigh a hunnert miles away." She wiped a trickle of yellowish saliva from one corner of his mouth.

"He needs some drugs, like they give fer this, right now—he oughtn't to wait."

"He needs oxygen," the man said. They were silent again, and once more the sounds of the child's battle for breath filled the quiet car. "Do you farm?" the officer asked in the same aimless, desperate, sound-making voice.

"A little."

"I guess every family back in these hills has a little patch of land and keeps a cow or so and a few sheep."

The woman turned and looked at him, her quiet gray eyes questioning. She gave a slow headshake. "Not everybody has got a little piece a land."

"I suppose you have."

She shook her head again with a slowness that might have been weariness. "We're renten," she said, "on Old John Ballew's place; he gits half—we git half." She hesitated, then added slowly, in a low voice, as if not quite certain of her words. "Now, that is; but—we're aimen—we're buyen us a place—all our own."

"How nice," he said, still making sound, giving a quick glance at the child. "A place for you and your children to live while your husband is in service."

"Yes," she said. A warm look came into her troubled eyes as when she had spoken of the block of wood. "Silas Tipton's went off to Muncie to work in a factory. He wanted his wife an youngens with him, so he sold his place. It's a good place—old, a log house—big an built good like they built in th old days. He sold it to Old John Ballew fer to git money to move on. Old John don't want th place. His boys is all gone."

He nodded. "So you'll buy it; farm it while your husband's gone."

"Yes," she said, speaking with more certainty than before, as if her words had made the land her own. "My biggest boy, Reuben, he's twelve," and her eyes were warm again. "He likes farm work an he's a good hand."

"You like to farm," he said, not asking, glancing at her wide shoulders and muscle-corded wrists showing beneath the too short coat sleeves.

She nodded. "I've allus farmed. My father had a big

farm—I hepped him when I was growen up. My brother is—"
She stopped, went on again, but the words were a thick mumble.
"Way younger than me."

After a little space of level road, they were going down
again, and the rainy autumn dark came swiftly down like a set-
tling bird. There were sharp steep curves where the dripping
limestone cliffs above gave back the sound of the car's horn, and
below them lay a narrow black plain pricked with lights. A train
blew high above them somewhere in the limestone walls. The
child started at the strange sound, and the woman whispered,
"Nothen's goen tu hurt you, honey."

On the low road in the village by the Cumberland, the
lighted windows of homes were squares of brightness behind the
shadows of the leafless, dripping trees. Then came sidewalks
with store windows bright above them, and the driver went more
slowly, looking first this way and that. The woman looked at the
windows filled with many different things, and on them all were
pasted white or red or blue or yellow sheets of paper that bore
pictures of Uncle Sam, of soldiers, of sailors, of airmen, of pretty
girl soldiers with neat hair; but all held big black words like the
red sign on the pine tree: "GIVE, RED CROSS—JOIN THE
WACS—GIVE BLOOD—WORK AT WILLOW RUN."

The car stopped in a wash of light from a broad window,
while high above the road more lights made a brightness on the
wet leaf-plastered sidewalks that lay on either side of the street.
The woman, as if unaccustomed to so much brightness,
squinched her eyes and twisted her head about as she drew the
blanket more closely about the child.

"Wait," the officer said. "Hatcher, make certain there is a
doctor's office close by and that he is in."

The woman watched the soldier go across the street, then
glanced at the officer, who was looking out his window as he
rolled it down. A door had opened on the street, and through it
came a burst of juke-box music. The woman looked toward the
sound, a shadow of girlish interest on her troubled eyes, then her
glance went swiftly back to the officer's head, and not taking her
eyes from him, she lifted the child on one arm, and with a quick
and furtive movement reached into her coat pocket, her hand

going down into the lining, searching. The man turned a little, glancing at her in his quick, impatient way, and her hand at once became still, and did not search again until he had turned away.

The hand was still again when the young soldier opened the door, saying, "The doctor's in his office right across the street."

The woman hesitated, moving toward the opened door, but looking at the officer, her hand, folded into a fist coming slowly out of the bottom of her coat. She flushed, opening the fist, showing a worn and limp bill. "I want tu pay you fer th ride," she said, "but I can't find th right change."

The officer looked at the outstretched five-dollar bill, surprise and disgust reddening his face. "I wouldn't think of charging," he said, staring at the bill, so worn, so wrinkled, the five was hardly legible.

"But I aimed tu pay," she said, touching his hand with the money.

He reached quickly for the money like one suddenly changing his mind. "I can change it," he said, and turning away from her drew out a wallet; but it was only after she was out of the car that he put bills, folded closely together, into her hand, saying, "A dollar's fair enough, I guess." And then, "Good luck. Help her across the street, Hatcher."

"I can manage," she said, dropping the money into her apron pocket.

The young soldier stooped quickly and picked up a small bright thing fallen from the folds of the child's blanket. He handed it to her as they walked across the highway. "Keep it for the baby," he said. "Stars like that are kind of scarce."

"Oh," she said, "th man's star—I didn't mean to tear it off. You'd better give it back to him; somebody'ull git him fer losen it. I've heared they're mighty hard on soldiers if their clothes don't look right."

"Not on the likes of him," the other said. They had gone a little distance down the sidewalk when the man pointed to a lighted doorway a few steps back from the street. "There's the doctor's," he said.

She glanced timidly toward the door. "I ain't never been

to a doctor before. Clovis, my husband, he's allus took th youngens th few times it was somethen Sue Annie couldn't cure."

His flat, absent-minded eyes opened wide in astonishment. "Lady, you can't be afraid of nothing. Just walk in."

FOR DISCUSSION

1. Gertie Nevels is a housewife. How is she like and unlike other housewives you have read about in this text?
2. Does Gertie Nevels remind you of anyone in your own experience—a grandmother perhaps? Is Gertie a "modern" person in any sense?
3. This excerpt is the first chapter from the novel. Why do you think the novelist chose to begin her book with a situation like this? What human qualities are revealed? Which of these qualities are usually used to describe men? What qualities do the men here have?
4. Women have been important figures in situations involving life and death—birthing and dying. If they can be as competent in these areas as Gertie seems to be, why haven't we seen more examples of this kind of behavior in the popular media? Can you think of any people like Gertie in current TV shows?
5. Have you known women who have redefined your expectations of them? How have they done it? Are they like Gertie?

INTRODUCTION

If women have been important in the birthing and dying processes, they have been no less important in shaping our idea of "home." Most of us have memories of a home cared for by Mother. It is difficult for us to separate the two in our minds. But this role that we have *expected* women to play can be limiting. Aren't there other ways to think about women and the idea of "home"? Gertie Nevels would probably say so. Margaret Mead thinks so, too.

from Blackberry Winter
Home and Travel

Margaret Mead

For many people moving is one kind of thing and travel is something very different. Travel means going away from home and staying away from home; it is an antidote to the humdrum activities of everyday life, a prelude to a holiday one is entitled to enjoy after months of dullness. Moving means breaking up a home, sadly or joyfully breaking with the past; a happy venture or a hardship, something to be endured with good or ill grace.

For me, moving and staying at home, traveling and arriving, are all of a piece. The world is full of homes in which I have lived for a day, a month, a year, or much longer. How much I care about a home is not measured by the length of time I have lived there. One night in a room with a leaping fire may mean more to me than many months in a room without a fireplace, a room in which my life has been paced less excitingly.

From the time I can first remember, I knew that we had not always lived where we were living then—in Hammonton, New Jersey, where we had moved so that Mother could work on her

doctoral thesis. I knew that I had spent my first summer at a resort called Lavallette, a place I did not visit again until I was seventeen, there to have the only authentic attack of homesickness I have ever had, brought on by the sound of the pounding surf. I knew also that we had lived on St. Marks Square, Philadelphia, because the next winter we lived near St. Marks Square and still knew people who lived there.

Every winter we went to live in or near Philadelphia so that Father would not have to travel too far or stay in the city on the nights that he lectured at the University. From the time I was seven years old, we went somewhere for the summer, too. So we moved four times a year, because for the fall and spring we returned to the house in Hammonton.

All the other houses were strange—houses that had to be made our own as quickly as possible so that they no longer would be strange. This did not mean that they were frightening, but only that we had to learn about every nook and corner, for otherwise it was hard to play hide-and-go-seek. As soon as we arrived, I ran ahead to find a room for myself as far away as possible from everyone else, preferably at the top of the house where I would always be warned by footsteps that someone was coming. After that, until we were settled in, I was busy exploring, making my own the new domain. Later, when I was about fourteen, I was in charge of unpacking, getting beds made, food in the icebox, and the lamps filled and lit before nightfall.

The next step was to explore the neighborhood. I had to find out what other children lived nearby and whether there were woods, wild flowers, tangles, or jungles—any hidden spot that could be turned into a miniature primeval forest where life could be quickly shaped to an imaginary world.

In Hammonton we had five whole acres, a good part of which was second-growth bush, studded with blueberries, which the little Italian children who were our neighbors picked and sold back to us. In Lansdowne and Swarthmore there were bits of woodlot. But in Philadelphia there was nothing, only stone walls of different heights on which to walk. Nothing, except for the winter when we lived at the edge of the park near the zoo.

However far away we moved and however often, we always came home again to Hammonton and the familiar and loved things that were too fragile to take with us—although Mother was very permissive about allowing us to carry along all the objects each of us wanted. In Hammonton there was the same blueberry thicket in which to wander along old paths and make new ones, the same surrey, which we hired from the livery stable, and the same door which was never opened—a second door on the front porch which was used only on one occasion, on the night the neighbors pounded on it to tell us that our chimney had caught fire.

There was the great tree from which a hornets' nest blew down in a storm. I had been dancing in the wind when it blew down and, still dancing, I plunged my hands into it. I can still remember the wind but not the stings with which I was said to have been covered. There were the tall evergreen arborvitae that divided the lawn into little squares, where Grandma played games with us until one day she put her hand to her heart and then she did not play running games anymore. And outside the mock-orange hedge we once found faeces, and Mother said, in a tone of disgust close to horror, that they were human faeces.

There was the well with a pump that we used to prime with hot water, until one day my five-year-old brother and a desperado friend a year younger threw everything detachable down the well, and then it was never used again. There was an old dinghy in which we grew flowers until the boys tore it up. And once, when the barn had been reshingled and the old shingles had been piled in the barn for the winter, the two little boys threw all of them out. Grandma said it just showed how two children, each one quite good by himself, could get into mischief. You never could tell, when you put two children together, what the outcome would be. This enlarged my picture of what boys were like.

It was contrapuntal to an engraving in a homemade copper frame that stood on the mantelpiece. This showed a pair of children, a little girl diligently sewing a fine seam and a boy, beautiful and remote, simply sitting and looking out at the world. Long years later, the same picture provided the central image in

a bitter little verse of feminine protest that I wrote when Edward Sapir told me I would do better to stay at home and have children than to go off to the South Seas to study adolescent girls:

> *Measure your thread and cut it*
> *To suit your little seam,*
> *Stitch the garment tightly, tightly,*
> *And leave no room for dream.*
>
> *. . .*
>
> *Head down, be not caught looking*
> *Where the restless wild geese fly.*

There were treasures on Mother's dressing table, too—a Wedgwood pin dish, a little porcelain Mary and her lamb, the pale green, flowered top of a rose bowl that had broken, and Mother's pearl backed comb and brush and mirror. All these things held meaning for me. Each was—and still is—capable of evoking a rush of memories.

Taken altogether, the things that mattered a great deal to me when I was a child are very few when I compare them to the overloaded tables and overcrowded shelves through which children today have to thread their way. Only if they are very fortunate will they be able to weave together into memories the ill-assorted mass of gadgets, toys, and easily forgotten objects, objects without a past or a future, and piles of snapshots that will be replaced by new, brightly colored snapshots next year.

The difficulty, it seems to me, is not—as so many older people claim—that in the past life was simpler and there were fewer things, and so people were somehow better, as well as more frugal. It is, rather, that today's children have to find new ways of anchoring the changing moments of their lives, and they have to try to do this with very little help from their elders, who grew up in an extraordinarily different world. How many of the young people who are rebelling against the tyranny of things, who want to strip their lives down to the contents of a rucksack, can remember and name the things that lay on their mother's dressing table or can describe every toy and book they had as a child?

It has been found that when desperate, unhappy youngsters are preparing to break away from a disordered, drug-ridden commune in which they have been living for months, they first gather together in one spot their few possessions and introduce a semblance of order among them. The need to define who you are by the place in which you live remains intact, even when that place is defined by a single object, like the small blue vase that used to mean home to one of my friends, the daughter of a widowed trained nurse who continually moved from one place to another. The Bushmen of the Kalahari Desert often build no walls when they camp in the desert. They simply hollow out a small space in the sand. But then they bend a slender sapling into an arch to make a doorway, an entrance to a dwelling as sacrosanct from invasion as the walled estates of the wealthy are or as Makati, in Manila, is, where watchmen guard the rich against the poor.

I realized how few things are needed to make a "home" when I took my seven-year-old daughter on her first sea voyage. The ship—the *Marine Jumper,* an unrenovated troopship with iron decks—was crowded with over a thousand students. They were bunked below where the troops had slept, while Cathy and I shared one cabin with six other members of the staff. Cathy climbed into her upper berth, opened the little packages that had been given to her as going-away presents, and arranged them in a circle around her. Then she leaned over the side of the berth and said, "Now I am ready to see the ship."

Home, I learned, can be anywhere you make it. Home is also the place to which you come back again and again. The really poignant parting is the parting that may be forever. It is this sense that every sailing may be a point of no return that haunts the peoples of the Pacific islands. On the very day I arrived in Samoa, people began to ask, "When will you leave?" When I replied, "In a year," they sighed, "Alas, *talofai*"—our love to you—with the sadness of a thousand partings in their voices. Their islands were peopled by voyagers who set off on a short known journey and whose canoes were blown hundreds of miles off course. But even when a fishing canoe goes out there is a chance that it will upset on the dangerous reef and that someone will be drowned. The smallest journey may be forever.

from Blackberry Winter 207

I have seen something similar on the seacoast of Portugal, where every year for four hundred years fishermen set out in their frail boats for the fishing banks across the treacherous Atlantic and no one could tell when—or whether—they would return. Portugal is still a widow's walk. The old women, dressed in black, still seem to be looking out to sea for the men who disappeared into the distance and an unknown fate.

In all my years of field work, each place where I have lived has become home. Each small object I have brought with me, each arrangement on a shelf of tin cans holding beads or salt for trade or crayons for the children to draw with becomes the mark of home. When it is dismantled on the last morning—a morning that is marked by the greed of those who have little and hope for a share of whatever is left behind, as well as by the grief of feeling that someone is leaving forever—on that morning, I weep. I, too, know that this departure, unlike my forays from home as a child, is likely to be forever.

In Manus, in 1928, the men beat the death drums as our canoe pulled out of the village. In 1953, when I made my first return visit to Manus and was leaving again, old Pokanau bade me a formal farewell: "Now, like an old turtle, you are going out into the sea to die and we will never see you again." Then Kilipak, a much younger man, remarked insightfully, "He is really talking about himself!"

Going away, knowing I shall return to the same place and the same people—this is the way my life has always been. When I set off for Samoa, for my first field trip in 1925, we had a last dinner in the dining room of the farm, the farm in Holicong, Bucks County, to which we moved when I was ten, after we had sold the house in Hammonton. Father and Mother and Grandma were there, and my brother and sisters, Richard, Elizabeth and Priscilla, and my student husband, Luther Cressman. Father and Richard sang, partly to tease me and partly to cover their own feelings, alternating "The smoke goes up the chimney just the same"—a song that had become a family joke when we moved to the farm and all the chimneys smoked—and "We shall meet but we shall miss her."

After dinner we drove to Philadelphia to the old Baltimore

and Ohio station, which I had never seen before. I kissed them all good-bye and walked through the gate. Afterward my father said, "She never looked back!" This was a next step in life. I was going to the field and Luther had a fellowship to travel in Europe, the thing he wanted very much to do. No one was permanently bereft. I would be coming back to the farm when the hollyhocks were in bloom again.

I have never been without a home to return to. First there was Hammonton and then the farm, which was not sold until 1928. Then, in 1926, after my return from Samoa, I came to the American Museum of Natural History in New York City, where I was given as my office an attic room under the eaves up in the west tower of the old Seventy-seventh Street building. It was just like the room I had at the farm and the kind of room I had always chosen in each rented house we lived in. Among other advantages, there were two stairways leading up to the tower, just as there had been in all the better houses we had rented; this meant that one could creep down one stairway while someone whom one did not want to meet—in my childhood, my mother or the person who was It in a game, or later, a too solicitous elderly curator—was coming up the other.

Perhaps it was because I was given that little attic room with a view out over the city roofs that I decided within a few months that I was going to stay at the Museum all my life. I saw the elderly men, retired curators—one of whom was even named Mead—puttering among their books and specimens. Far from being repelled, I felt secure. Evidently the Museum did not evict its curators as universities evicted their professors when they were too old to rearrange their papers in some other place so that they could find them again. I would manage to stay there, always.

Only a few years before I came to the Museum, that office had been the bedroom of the building superintendent's apartment in which he had lived with his family. He used to stand in the doorway and tell me how all his children had been born in that room. There was also a bathroom large enough for a massive sink in which to wash specimens and, in the room across the little hall, a tiled fireplace that later held a gas jet. For those of

us who worked in the tower, there was no endless hall lined with storage cases to walk along and no limits like those set by the large handsome offices downstairs, each one reserved for a curator and anyone he happened to have to help him.

After the superintendent and his family moved out, my attic had become a cataloguing room presided over by Mr. Sabine, formerly the Museum president's butler, who had become an assistant in the Department. He had a fine eye for detail and spotted at once in my Manus collection the anomalous javelin that was hurled by a twisted cord in the same manner as a Roman javelin. When I arrived, Mr. Sabine was moved out in order to give me a place to work, at least temporarily, until one of the big offices downstairs would be free.

At first my office seemed large and bare. The only furnishings were a few half-size metal cabinets, a bookcase, and an old rolltop golden oak desk that had been banished from some office down below. I hung tapa-patterned cotton curtains at the window, spread Samoan mats on the floor, and on the wall hung a map of the world on which the archeologist Erich Schmidt and I used to plot our future field trips.

Slowly through the years, after I had been offered a proper office and had refused it, I increased my attic domain. First I acquired the inside room of the old apartment, which, during Mr. Sabine's regime, had been labeled "Unidentified Specimens" and had a secret cabinet in which the Peruvian gold was stored. This is where my staff work, for I have kept as my own the outer office. In one sense, this has been my most permanent home for many years.

Since the late 1920's, I have had no permanent house to go back to, only a series of rented apartments between field trips or part of the brownstone houses belonging to friends, in which I have lived, which I have cherished, but without a householder's responsibilities. After my parents sold the old farm in the Buckingham Valley, they bought another one which burned down soon after. So the office in the Museum became the successor to the rooms in which I had grown up.

When the farm was gone, my parents also lived in rented houses, at first a very large one which my brother and younger

sisters left to get married, and then, after Father retired, a tiny house, about which Mother complained that the rooms were too small for committee meetings. Now my brother owns a house, but it is far away in California. My daughter also has a house in New Hampshire, but no country house today is safe from rodents, vandals, and arson.

The office at the top of the Museum is where all my valuable things—notes, manuscripts, photographs, and films—are stored and where, over time, I have had to find additional space for the notes and manuscripts and films of my collaborators—in the room across the hall, which was once the superintendent's kitchen, and in the window alcoves of the tower next to high racks of stored specimens.

"The Museum is a very safe place," the Department chairman, Dr. Wissler, used to say. "Once when we were going away for the summer, I brought all our silver down and we didn't find it again for eleven years. Mrs. Wissler wasn't very pleased. But we did find it."

That sense of total safety has diminished over the past thirty years. During World War II, when I used to practice imagining the Empire State Building bend and crash under bombs, we packed away some of our most valuable specimens and notes. So thoroughly were they put away that the carbon copies of our Balinese notes have not turned up yet. There have been occasional robberies, too. One thief, an ingenious and interested student of native materials, altered ethnological specimens to suit his fancy, which made it much harder to locate them in the city's pawnshops. There was also the well-publicized robbery of the Star of India from the Museum's gem collection. And there have been bomb scares and telephoned false alarms, one of them during the period when the man known as the Mad Bomber was still at large in New York.

As in wartime, now in this troubled peacetime no place is wholly safe. Still, up in the tower, with two flights of stairs between me and the milling crowds below, I feel as safe from intrusion and loss as once I did at home in my third-floor room where the night wind whistled through the closed shutters and the sparrows racketed in the ivy outside my windows every

dawn. For all my years of traveling, I have always had somewhere to return to, somewhere where everything is just where I put it away twenty, thirty, or forty years ago.

It was a little hard, a few years ago, to find on my desk, accompanied by a rather curt letter of obviously unwilling apology, a skit written by a member of another department, which he labeled something like "The Department of Unimportant Information." In the skit the writer reported that although he constantly encountered me in print and on the radio and on television, he had not seen me in the Museum for many years. Finally, he penetrated the west tower to find my office deep in dust. (My hard-working, harried young student assistants particularly resented this bit.) Eventually he made his way into the big corner tower room. There he did find live files. These revealed that I had been dead for years, but that ample funds were still being provided by a series of impersonators, each of whom was murdered when she asked for a larger share of the take, and was replaced by another.

It was a cruel little piece. But I must admit there was a germ of truth in it. I always did—and still do—come into the Museum at very odd hours, so that I seldom have a chance to greet my colleagues in the elevator, and I have underwritten most of the expense of my own research with my own earnings.

As my activities have grown and as I have found room under the eaves and in the alcoves for my associates, the style of decoration of my office has changed with the interests of the young people who work with me. For a long time two reproductions of le Douanier Rousseau hung on the wall of the inner office. Then for a time Japanese lanterns hung from the ceiling lights, and the wastebaskets and stepladders were painted bright nursery colors. Later the students put up a picture of Martin Luther King. At present a huge beautiful portrait of an American Indian covers most of the slanting ceiling of the inner office.

My personal possessions can all be contained in part of the colleague's apartment, which we share. But the accumulation of research materials continues to grow as the years go by. We still need attics for those pieces of the past we find it hard to discard altogether, for someday, finding them, grandchildren may puzzle over them like old buried treasure.

FOR DISCUSSION

1. How does Margaret Mead define "home"? Is her idea different from any of your own ideas of home?

2. Margaret Mead is an expert on culture. How is she or isn't she herself a product of a particular culture? Do you think she has overcome others' ideas of what she should be? How is she like or unlike other women you have read about in this text?

INTRODUCTION

In the following poem Mary Lou Espinosa speaks clearly and strongly about change in traditional ideas of Chicanas' roles. She feels that women must fully believe in their own abilities and worth before they can convince others of it. She also speaks of the conflict between the Spanish and Indian heritages of the Chicana woman.

La Madre de Aztlan

Mary Lou Espinosa

Equality respects the function of
man as father
woman as mother
and both as an independent
human capable of change. 5

A Chicana woman springs out of her
Indian and Spanish cultural and
historical heritage.
From Indian comes strong mother figure.
From Spanish comes dominant father figure. 10

True woman's liberation must happen first
in the mind of the woman.
No woman can expect nor demand
to be thoroughly accepted as equal
in a man's eyes, nor be given equal recognition, 15
if she first does not believe that
her potential and the man's potential
are equally realizable given the
opportunity.

Man cannot change his attitude 20
toward woman until the woman
perceives her deep psychological
self as independent and asserted
from man.

Socio-economic and political 25
conditions can help
the process of woman's full
assertion in the movement and
in society, but the woman has first
to want to make herself free. 30

Woman's contribution is essential.
A woman, a mother, knows life
from within because of her function.
Our society is sadly masculine oriented;
it does not know life from within 35
because men alone make it.

Creative solution to social change
comes with people who have
creative life within themselves,
a free woman can creatively 40
contribute with radical solutions
because she knows life from within.

FOR DISCUSSION

How "poetic" is Espinosa's poem? Why do you think she
chose to put these ideas in poetry rather than in another
medium? What is the effect of presenting her message
this way?

INTRODUCTION

Although I am young and a woman, I feel that I cannot remain silent and see my people manipulated and put down. Many men do not speak up for fear of losing their jobs, and so the hardest workers for Inuit rights seem to be young women.

Jeela Alilkatuktuk is angry. She is an Inuit woman living in the Northwest Territories of Canada. She is angry because she is watching a culture disintegrate.

Canada: Stranger in My Own Land

Jeela Alilkatuktuk

My people call themselves "Inuit," which means "The People," rather than *Eskimo*, which is a Cree Indian word meaning "raw-meat eaters." I am an Inuit woman and live in a small settlement (population: 350), north of the Arctic Circle. I live with my husband, Tony, and daughter, Pitseolalaq. We live here in Broughton Island, Northwest Territories, Canada, because my parents and grandparents live here, and because being Inuit is more important than anything else to me. Our identity is our culture, our language, and our land, and we watch helplessly as we see each part slipping away.

I was born 21 years ago in a small, happy camp of 50 people called Padloping. I started school there when I was 11. When I was 12, and my brother was 10, we went hunting alone by dog team in the spring. We were gone for more than 36 hours. My father had taught us both how to handle a gun, how to hunt, how to beware of the dangers on the ice, and how to travel safely over it with the dog team—our only means of transportation.

216

Then, when I was 13, my family was told by the white governing officials that it would be best for me if I were sent away "to get an education." The Inuit love their children, and, wanting to do what was "best" for me, my parents sent me away. I went 2,000 miles south to a vocational school at Churchill, Manitoba to spend the next three years living in a hostel and coming home only during the summer months.

To me, the three years I spent pursuing "education" in the south seemed like 10. I had come from a place with 50 people, and I had never seen a store. Instead of our dog teams, suddenly there were planes and cars; there were also big buildings, thousands of people, and the overwhelming rush and bustle of the city.

I missed my home and the Inuit way of doing things. The hostel supervisors were white, and the teachers were white. They seemed to be trying to make me a brown carbon copy of a white person. The white people made all the decisions, and because I did not know English, and they did not speak the Inuit language, we had little communication. But eventually, I learned English. Given the choice between being a nurse's aide or a secretary, I chose to be a secretary, not knowing there were other things a woman could do.

When I tell people this, they think that it is marvelous that the government helped me so much to take "Giant Steps Forward." One of my teachers said proudly, "Jeela arrived in Churchill in skins and left wearing a miniskirt."

While I was away, the government had decided that since there could be no settlement without a white-run school, and since our tiny camp was obviously too isolated for any white teacher to live in, the camp must be closed. And so in 1967 our people were forced to move south to Broughton.

In the meantime, I left Churchill for Winnipeg and took a one-and-a-half-year secretarial course, and then worked for a few months in Frobisher Bay—the administrative center for Baffin Island, 300 miles south of home. Tony Moss-Davies (now my husband) was principal of the adult education center there, and I was his secretary. He was beginning to respect the Inuit way of

Canada: Stranger in My Own Land 217

doing things, and he was developing programs which would help us gather information to combat the pressures of white society.

I became involved in community affairs and was elected to the Frobisher Bay Hamlet Council at the age of 19. The Council is supposed to try to run the community for the people in it. The formal council structure is alien to Inuit members, whose heritage is informal communal decision-making, and in reality the territorial government controls all the money and all the personnel. For the most part, the councils are powerless. I knew I wanted to help my people and knew I couldn't do that as a secretary. After Tony and I were married, we decided to come to Broughton, and Tony applied for a transfer in the school system. Not only was he denied, he was fired, for reasons that were never made clear. We came anyway, and although Tony has no steady job, we're glad we came to Broughton.

I am just beginning to learn again those things that an Inuit girl learned by merely being in her own settlement during adolescence—sewing and cleaning and making clothes out of skins. Different skins require different stitches and are treated differently: when sealskin boots are made, the sole must be wet and the stitches made so that the boot becomes waterproof when dried; boots with fur have to be worked so that the stitches do not show; caribou has to be held in such a way that you don't stretch it or shrink it with your stitches. If these and other skills are lost by our people, they can never be regained. They are part of a culture that is preserved only in an Inuit home.

My income from various jobs is about $200 a month for the family. It is strange to be supporting a white man, especially when I used to work for him, and it is hard to live on so little money when we used to have an income of $18,000 a year.

Our house is rented in my name because we live in "Eskimo" low-rental housing. It has no running water and is heated by an oil stove which is used for cooking as well. It is quite different from "white" housing. I am told that I am lucky to be able to have a house, since I am not an "Eskimo" because I am married to a white man. I am also told that our children will be regarded as white. This is silly. I am Inuit, and my children are Inuit. They will be brought up to speak Inuit in a settlement

that is 94 percent Inuit. I have been told that they will have to register at school as white people. If this happens, I will not send them to school. We shall teach our children the Inuit language even though we know that this will hinder their education in the white man's school. We have no books in our language and the teachers in the school use English except for the first two years. (And this is a concession to help children "adapt" better to school and be more easily assimilated.) The Alberta, Canada, curriculum is used by the teaching staff (90 percent of which is white), so the children learn about the farms and the trees of *southern* Canada instead of their own land.

There are no high schools in the Inuit settlements: the government says it costs too much. So our youth must be sent away to continue their studies. The assistant director of education told me that the aim of education is to enable us to move anywhere across Canada and *compete*. We don't want to compete; we don't want to move. We want to stay here and retain our identity.

The question of land ownership is centered on the white man's legal system. We are forced to prove before the Canadian courts that we have legal title (in white man's terms) to the specific land areas on which our communities have been built, and which have been our homes for thousands of years. The official stance of the government is that all the Northwest Territories (except for a few pieces given to some Indians) is government Crown land. The Inuit have no legal status and are regarded as "squatters." We have no land according to the government and no decision-making power on what shall be done with this land which is, and always has been, ours.

This year the Canadian government is sending a ship along our coast which will make explosions in the water to search for minerals. They have sent a letter to us asking for comments. But, by now, it is almost too late to stop the project, and we have no power to stop it, anyway. No research has been done to see what effect the blasts will have on the seals our hunters depend on for the long, hard winter months.

Our values are being violated by the intrusion of large oil companies which take our resources, and by governmental decisions to make national parks of our land without consulting us.

The white people come with their Almighty Dollar and their Work Ethic. The whites take the best jobs, and feel that the only good Innuk (singular of Inuit) is the one who *works*, at a job defined by white culture. There is a very skilled carver here. Because there is little demand for his carvings, he now works as a sewage worker, carrying plastic bags of feces out of houses.

To an Innuk, white people seem so powerful. The power in our settlement is in the hands of white people: the settlement manager, store manager, and 12 teachers. It is not strange that our young people look down on their parents and try to copy these strangers who live in the largest houses and have the best things.

With the introduction of technological advances and material objects which make life easier, the woman has become less important. In the old days, the man and the woman were equally necessary to each other and to the family: the man hunted and without him, the woman would starve; the woman sewed and without her, the man would freeze. Men often died before the women because their lives were more often in danger. The oldest and the most respected persons were the old women. There were no formal councils and women had equal influence over camp matters. The white men who brought with them modern material objects also brought a different sexual attitude toward women.

We are monogamous, but our children are not raised with the taboo against sex that white people have. The small huts threw everyone together and made nakedness natural and not a matter for shame. Most white men who come up north take advantage of this and use the girls sexually without any intention of marrying them or providing for the many children which result. The Inuit parents do not know how to handle this situation. In the past, a child born as a result of a mating that did not result in an Inuit marriage was easily adopted by someone else if the mother could not raise it. This system is breaking down as people lose the old closeness and interdependency. One of our greatest losses is that our young Inuit men are copying the white people in their attitude. Where a white woman can walk without fear an Inuit woman is harassed and propositioned.

Although I am young and a woman, I feel that I cannot re-

main silent and see my people manipulated and put down. Many men do not speak up for fear of losing their jobs, and so the hardest workers for Inuit rights seem to be young women.

We speak up because the Inuit have been asked to speak, but soon find that we face a lot of hostility if we do not say what the white people want us to say. Some of our own people have been upset at what we say because they are afraid of the white government.

What makes me most angry is when people say I do not speak for myself—that my husband is telling me what to say. It seems inconceivable to them that an "Eskimo" woman could have a mind of her own. They would be more comfortable believing it is a white man who is behind what I say.

As far as I know, I am the only Inuit woman broadcaster working for the Canadian Broadcasting Corporation. I started with a program for women in the Inuit language when we lived in Frobisher. I was able to change the program from just giving recipes to discussions about the issues which face the Inuit: issues such as land and aboriginal rights; the communication problems; the effects of alcohol (which came with the white man); the history of the Inuit; the syllabic system of writing and the new roman orthography that is being forced on us; legal rights and the Royal Canadian Mounted Police; court procedure; welfare rules; unemployment insurance; the Canada pension plan and health care.

I sometimes do programs in English because I want to tell the white people in the south what their government is doing to us. Some of my programs have been refused because the producers do not want to hear that the "Eskimos" are not happy, smiling people.

I am translating a book on the law for my people—necessary because the Inuit do not know the white man's laws.

I keep very busy and am lucky that I do not have too much time to think about what is happening to my people. Some say that it will be a good thing when the culture is forgotten and everyone is just like the white people. Some Inuit think they want this, but many of us do not, and the world should know that the Inuit are being pressured into joining white Canada without any idea of what they are getting into and what they will lose.

The future looks very bleak to me, and I often despair when I think of the power of the government and the oil companies and the competition and the aggression of the white culture. But my people are getting lost, and I must say what I believe is right.

FOR DISCUSSION

1. How does the tone of this article differ from others that you've read here? How does the article make you feel? Why?

2. Compare and contrast Jeela Alilkatuktuk with other women that you have read about in this section. How does she qualify as a "changing woman"?

Women
Stereotyped

CHAPTER THREE

To deal more easily with our complex world, we often group things according to their similarities. We tend to ignore differences and oversimplify what we see. By doing this we form general and incomplete impressions called "stereotypes." Stereotypes describe *types* of people and things; for example, the young people, the women, the athletes. Both men and women have had to cope with stereotypes about them. But women, in particular, have been damaged by these overgeneralizations which present a limited and false image of women.

The first two chapters of this book contain portraits of women with a wide range of interests, attitudes, skills, experience, and humanity. These portraits contrast sharply with the popular beliefs that women are merely fragile, home-bound creatures chiefly interested in their appearance. Even though some women may think of themselves as fragile or home-bound or attractive, these are not their *only* qualities and interests, or even their most important ones.

When people respond to one of the many stereotypes of women, they are reacting to an idea rather than to the real person. Therefore, their impressions are often wrong, and their behavior is often inappropriate. For example, if people think a woman is a soft and delicate creature incapable of reason, they may treat her as the woman in "Albatross" is treated. They may defend, protect, and think for her. They may substitute their reality for hers and deny her own experience its validity.

But worse than having her individuality denied by others, is the way she herself may identify totally with the stereotypes, treating herself as less than a person. The article "Sexual Stereotypes Start Early" tells us that females learn at an early age the faulty generalizations of society in a process we call "acculturation." The person harmed by the stereotypes is the one who accepts them unchallenged. She will find her hopes and dreams belittled and mocked in the popular media, where, for the most part, her life is shown as limited to kitchens, beauty care, and

laundry tasks. She may fulfill the roles expected of her and then find herself cut off from her real feelings and wishes. Such is the situation of the woman in the story "The Sink."

Women have traditionally had their roles and their worth defined for them by their usefulness in the family. The woman who pours great energy and talent into the task of rearing children and making a home for her family fulfills a role which is vital to society's survival. However, she is unlikely to be paid or given any positive public recognition. Instead, she is known as "just a housewife," a label which belittles all her dedication and effort as well as the vital role she performs.

Although traditional roles for women are undervalued, they may nevertheless be very attractive. For one reason, these roles are systematically taught. For another, they deal with women's potential ability to create and shape human life and are thus a symbol of creative power. As a result, the woman who becomes a wife and mother is often responded to on the symbolic level alone. And the woman who does not attain or seek these roles is mistakenly thought of as incomplete and useless. Too often she may believe this herself and fail to discover the many ways in which she can gain satisfaction by shaping other parts of the world.

We must also remember that there are women who seem not to be uncomfortable with stereotypes. Perhaps they understand that they, themselves, are not identical to these roles they fill, like the young woman in "Who Cares." Perhaps they are able to choose those parts of the stereotypes that help them form a comfortable public image. Or, perhaps they are simply oblivious to these stereotypes and feel no confining or demeaning aspects in their lives. Like Ma in "A Basket of Apples," these women are very happy fulfilling the role their culture and background have prepared them for. Thus, while some women may accept and even identify with certain aspects of the stereotypes, they may not necessarily be equating themselves with or limiting themselves to those stereotypes. Still other women derive great personal satisfaction from performing traditional roles well.

The writers in this chapter show two ways of seeing these female stereotypes. On the one hand they can be rigid role defi-

nitions which ignore many aspects of human identity. As such, they limit the lives they define. On the other hand, if these stereotypes are properly understood, they can be symbols which give force and direction to a woman's life. These writers see the stereotype as something that can be reacted to, used, and even played with. They do not confuse the stereotype with the person, for they realize that a similarity is not an identity.

INTRODUCTION

Sex stereotyping, which begins in infancy, is widespread in our culture. This article, written in 1971, explains the author's view of how our culture puts boys in the active roles and girls in the passive roles. This is done through the readers and texts students use in school and through the extracurricular activities they are offered. The author feels that girls are given a false picture of women. She also points out that typically feminine personality characteristics are completely different from the characteristics of mentally healthy adults. Typically masculine characteristics are, however, the same as those of mentally healthy adults. The author believes that ignorance, not ill will, is the cause of this injustice done to children. And she further believes that reeducation of parents and teachers is the key to change.

Sexual Stereotypes
Start Early

Florence Howe

"I remember quite clearly a day in sixth grade," a college freshman told me a year ago, "when the class was discussing an article from a weekly supplementary reader. The story was about a chef, and someone in the class ventured the opinion that cooking was women's work, that a man was a 'sissy' to work in the kitchen. The teacher's response surprised us all. She informed us calmly that men make the best cooks, just as they make the best dress designers, singers, and laundry workers. 'Yes,' she said, 'anything a woman can do a man can do better.' There were no male students present; my teacher was a woman."

Children learn about sex roles very early in their lives, probably before they are eighteen months old, certainly long be-

fore they enter school. They learn these roles through relatively simple patterns that most of us take for granted. We throw boy-babies up in the air and roughhouse with them. We coo over girl-babies and handle them delicately. We choose sex-related colors and toys for our children from their earliest days. We encourage the energy and physical activity of our sons, just as we expect girls to be quieter and more docile. We love both our sons and daughters with equal fervor, we protest, and yet we are disappointed when there is no male child to carry on the family name.

A hundred fifty years ago, Elizabeth Cady Stanton learned to master a horse and the Greek language in an attempt to comfort her father, who had lost his only son and heir. No matter what evidence of brilliance Cady Stanton displayed, her father could only shake his head and murmur, "If only you were a boy, Elizabeth," much to the bafflement of the girl who had discerned that riding horses and studying Greek were the activities that had distinguished her dead brother from her living sisters. Only thirty years ago, at family gatherings, I remember hearing whispers directed at my brother and me: "Isn't it a pity that he has all the looks while she has all the brains." Others could contribute similar anecdotes today.

The truth of it is that while we in the West have professed to believe in "liberty, equality, and fraternity," we have also taken quite literally the term "fraternity." We have continued to maintain, relatively undisturbed, all the ancient edicts about the superiority of males, the inferiority of females. Assumptions current today about woman's alleged "nature" are disguised psychological versions of physiological premises in the Old Testament, in the doctrines of the early church fathers, and in the thinking of male philosophers, writers, educators—including some who founded women's colleges or opened men's colleges to women. In short, what we today call the "women's liberation movement" is only the most recent aspect of the struggle that began with Mary Wollstonecraft's *Vindication of the Rights of Women* in 1795—a piece of theory that drew for courage and example on the fathers of the French and American revolutions. It is, of course, only one hundred years since higher education was really opened up to women in this country, and many people

know how dismal is the record of progress for professional women, especially during the past fifty years.

How much blame should be placed on public education? A substantial portion, although it is true that schools reflect the society they serve. Indeed, schools function to reinforce the sexual stereotypes that children have been taught by their parents, friends, and the mass culture we live in. It is also perfectly understandable that sexual stereotypes demeaning to women are also perpetuated by women—mothers in the first place, and teachers in the second—as well as by men—fathers, the few male teachers in elementary schools, high school teachers, and many male administrators and educators at the top of the school's hierarchy.

Sexual stereotypes are not to be identified with sexual or innate differences, for we know nothing about these matters. John Stuart Mill was the first man (since Plato) to affirm that we could know nothing about innate sexual differences, since we have never known of a society in which either men or women lived wholly separately. Therefore, he reasoned, we can't "know" what the pure "nature" of either sex might be: What we see as female behavior, he maintained, is the result of what he called the education of "willing slaves." There is still no "hard" scientific evidence of innate sexual differences, though there are new experiments in progress on male hormones of mice and monkeys. Other hormonal experiments, especially those using adrenaline, have indicated that, for human beings at least, social factors and pressures are more important than physiological ones.

Sexual stereotypes are assumed differences, social conventions or norms, learned behavior, attitudes, and expectations. Most stereotypes are well known to all of us, for they are simple—not to say simple-minded. Men are smart, women are dumb but beautiful, etc. A recent annotated catalogue of children's books (distributed by the National Council of Teachers of English to thousands of teachers and used for ordering books with federal funds) lists titles under the headings "Especially for Girls" and "Especially for Boys." Verbs and adjectives are remarkably predictable through the listings. Boys "decipher and discover," "earn and train," or "foil" someone; girls "struggle,"

230

"overcome difficulties," "feel lost," "help solve," or "help [someone] out." One boy's story has "strange power," another moves "from truancy to triumph." A girl, on the other hand, "learns to face the real world" or makes a "difficult adjustment." Late or early, in catalogues or on shelves, the boys of children's books are active and capable, the girls passive and in trouble. All studies of children's literature—and there have been many besides my own—support this conclusion.

Ask yourself whether you would be surprised to find the following social contexts in a fifth-grade arithmetic textbook:

1) girls playing marbles; boys sewing;
2) girls earning money, building things, and going places; boys buying ribbons for a sewing project;
3) girls working at physical activities; boys babysitting and, you guessed it, sewing.

Of course you would be surprised—so would I. What I have done here is to reverse the sexes as found in a fifth-grade arithmetic text. I was not surprised, since several years ago an intrepid freshman offered to report on third-grade arithmetic texts for me and found similar types of sexual roles prescribed: Boys were generally making things or earning money; girls were cooking or spending money on such things as sewing equipment.

The verification of sexual stereotypes is a special area of interest to psychologists and sociologists. An important series of studies was done in 1968 by Inge K. Broverman and others at Worcester State Hospital in Massachusetts. These scientists established a "sex-stereotype questionnaire" consisting of "122 bipolar items"—characteristics socially known or socially tested as male or female. Studies by these scientists and others established what common sense will verify: that those traits "stereotypically masculine . . . are more often perceived as socially desirable" than those known to be feminine. Here are some "male-valued items" as listed on the questionnaire:

very aggressive
very independent
not at all emotional

very logical
very direct
very adventurous
very self-confident
very ambitious

These and other characteristics describe the stereotypic male. To describe the female, you need only reverse those traits and add "female-valued" ones, some of which follow:

very talkative
very tactful
very gentle
very aware of feelings of others
very religious
very quiet
very strong need for security

and the one I am particularly fond of citing to men who control my field—"enjoys art and literature very much."

The Worcester scientists used their 122 items to test the assumptions of clinical psychologists about mental health. Three matched groups of male and female clinical psychologists were given three identical lists of the 122 items unlabeled and printed in random order. Each group was given a different set of instructions: One was told to choose those traits that characterize the healthy adult male; another to choose those of the healthy adult female; the third, to choose those of the healthy adult—a person. The result: The clinically healthy male and the clinically healthy adult were identical—and totally divergent from the clinically healthy female. The authors of the study concluded that "a double standard of health exists for men and women." That is, the general standard of health applies only to men. Women are perceived as "less healthy" by those standards called "adult." At the same time, however, if a woman deviates from the sexual stereotypes prescribed for her—if she grows more "active" or "aggressive," for example—she doesn't grow healthier; she may, in fact, if her psychiatrist is a Freudian, be perceived as "sicker." Either way, therefore, women lose or fail, and so it is not surprising to find psychologist Phyllis

Chesler reporting that proportionately many more women than men are declared "sick" by psychologists and psychiatrists.

The idea of a "double standard" for men and women is a familiar one and helps to clarify how severely sexual stereotypes constrict the personal and social development of women. Studies by child psychologists reveal that while boys of all ages clearly identify with male figures and activities, girls are less likely to make the same sort of identification with female stereotypes. With whom do girls and women identify? My guess is that there is a good deal of confusion in their heads and hearts in this respect, and that what develops is a pattern that might be compared to schizophrenia: The schoolgirl knows that, for her, life is one thing, learning another. This is like the Worcester study's "double standard"—the schoolgirl cannot find herself in history texts or as she would like to see herself in literature; yet she knows she is not a male. Many women may ultimately discount the question of female identity as unimportant, claiming other descriptions preferable—as a parent, for example, or a black person, or a college professor.

Children learn sexual stereotypes at an early age, and, by the time they get to fifth grade, it may be terribly difficult, perhaps hardly possible by traditional means, to change their attitudes about sex roles—whether they are male or female. For more than a decade, Paul Torrance, a psychologist particularly interested in creativity, has been conducting interesting and useful experiments with young children. Using a Products Improvement Test, for example, Torrance asked first-grade boys and girls to "make toys more fun to play with." Many six-year-old boys refused to try the nurse's kit, "protesting," Torrance reports, "I'm a boy! I don't play with things like that." Several creative boys turned the nurse's kit into a doctor's kit and were then "quite free to think of improvements." By the third grade, however, "boys excelled girls even on the nurse's kit, probably because," Torrance explains, "girls have been conditioned by this time to accept toys as they are and not to manipulate or change them."

Later experiments with third, fourth, and fifth-graders using science toys further verify what Torrance calls "the inhibiting effects of sex-role conditioning." "Girls were quite reluctant," he

reports, "to work with these science toys and frequently protested: 'I'm a girl; I'm not supposed to know anything about things like that!'" Boys, even in these early grades, were about twice as good as girls at explaining ideas about toys. In 1959, Torrance reported his findings to parents and teachers in one school and asked for their cooperation in attempting to change the attitudes of the girls. In 1960, when he retested them, using similar science toys, the girls participated willingly and even with apparent enjoyment. And they performed as well as the boys. But in one significant respect nothing had changed: The boys' contributions were more highly valued—both by other boys and by girls—than the girls' contributions, regardless of the fact that, in terms of sex, boys and girls had scored equally. "Apparently," Torrance writes, "the school climate has helped to make it more acceptable for girls to play around with science things, but boys' ideas about science things are still supposed to be better than those of girls."

Torrance's experiments tell us both how useful and how limited education may be for women in a culture in which assumptions about their inferiority run deep in their own consciousness as well as in the consciousness of men. While it is encouraging to note that a year's effort had changed behavior patterns significantly, it is also clear that attitudes of nine-, ten-, and eleven-year-olds are not so easily modifiable, at least not through the means Torrance used.

Torrance's experiments also make clear that, whatever most of us have hitherto assumed, boys and girls are *not* treated alike in elementary school. If we consider those non-curricular aspects of the school environment that the late anthropologist Jules Henry labeled the "noise" of schools, chief among them is the general attitude of teachers, whatever their sex, that girls are likely to "love" reading and to "hate" mathematics and science. As we know from the Rosenthal study of teacher expectations, *Pygmalion in the Classroom,* such expectations significantly determine student behavior and attitudes. Girls are not expected to think logically or to understand scientific principles; they accept that estimate internally and give up on mathematics and science relatively early. And what encouragement awaits the interested few in high school? For example, in six high school science texts published since 1966 and used in the Baltimore city

public schools—all of the books rich in illustrations—I found photographs of one female lab assistant, one woman doctor, one woman scientist, and Rachel Carson. It is no wonder that the percentage of women doctors and engineers in the United States has remained constant at 6 percent and 1 percent respectively for the past fifty years.

Though there is no evidence that their early physical needs are different from or less than boys', girls are offered fewer activities even in kindergarten. They may sit and watch while boys, at the request of the female teacher, change the seating arrangement in the room. Of course, it's not simply a matter of physical exercise or ability: Boys are learning how to behave as males, and girls are learning to be "ladies" who enjoy being "waited on." If there are student-organized activities to be arranged, boys are typically in charge, with girls assisting, perhaps in the stereotyped role of secretary. Boys are allowed and expected to be noisy and aggressive, even on occasion to express anger; girls must learn "to control themselves" and behave like "young ladies." On the other hand, boys are expected not to cry, though there are perfectly good reasons why children of both sexes ought to be allowed that avenue of expression. Surprisingly early, boys and girls are separated for physical education and hygiene, and all the reports now being published indicate preferential treatment for boys and nearly total neglect of girls.

In junior high schools, sexual stereotyping becomes, if anything, more overt. Curricular sex-typing continues and is extended to such "shop" subjects as cooking and sewing, on the one hand, and metal- and woodworking, printing, ceramics, on the other. In vocational high schools, the stereotyping becomes outright channeling, and here the legal battles have begun for equality of opportunity. Recently, the testimony of junior high and high school girls in New York has become available in a pamphlet prepared by the New York City chapter of NOW (*Report on Sex Bias in the Public Schools*, available from Anne Grant West, 453 Seventh St., Brooklyn, N.Y. 11215). Here are a few items:

Well, within my physics class last year, our teacher asked if there was anybody interested in being a lab assistant, in the physics lab, and when I raised my hand, he told all the

*girls to put their hands down because he was only inter-
ested in working with boys.*

*There is an Honor Guard . . . students who, instead of
participating in gym for the term, are monitors in the hall,
and I asked my gym teacher if I could be on the Honor
Guard Squad. She said it was only open to boys. I then
went to the head of the Honor Guard . . . who said that he
thought girls were much too nasty to be Honor Guards. He
thought they would be too mean in working on the job, and I
left it at that.*

*We asked for basketball. They said there wasn't enough
equipment. The boys prefer to have it first. Then we will
have what is left over. We haven't really gotten anywhere.*

Finally, I quote more extensively from one case:

MOTHER: *I asked Miss Jonas if my daughter could
take metalworking or mechanics, and she said there is no
freedom of choice. That is what she said.*
THE COURT: *That is it?*
ANSWER: *I also asked her whose decision this was,
that there was no freedom of choice. And she told me it
was the decision of the board of education. I didn't ask
her anything else because she clearly showed me that it was
against the school policy for girls to be in the class. She
said it was a board of education decision.*
QUESTION: *Did she use that phrase, "no freedom of
choice"?*
ANSWER: *Exactly that phrase—no freedom of choice.
That is what made me so angry that I wanted to start this
whole thing.*

THE COURT: *Now, after this lawsuit was filed, they
then permitted you to take the course; is that correct?*
DAUGHTER: *No, we had to fight about it for quite a
while.*
QUESTION: *But eventually they did let you in the
second semester?*
ANSWER: *They only let me in there.*

236

Q: *You are the only girl?*
A: *Yes.*
Q: *How did you do in the course?*
A: *I got the medal for it from all the boys there.*
Q: *Will you show the court?*
A: *Yes (indicating).*
Q: *And what does the medal say?*
A: *Metal 1970 Van Wyck.*
Q: *And why did they give you that medal?*
A: *Because I was the best one out of all the boys.*
THE COURT: *I do not want any giggling or noises in the courtroom. Just do the best you can to control yourself or else I will have to ask you to leave the courtroom. This is no picnic, you know. These are serious lawsuits.*

Such "serious lawsuits" will, no doubt, continue, but they are not the only routes to change. There are others to be initiated by school systems themselves.

One route lies through the analysis of texts and attitudes. So long as those responsible for the education of children believe in the stereotypes as givens, rather than as hypothetical constructs that a patriarchal society has established as desired norms—so long as the belief continues, so will the condition. These beliefs are transmitted in the forms we call literature and history, either on the printed page or in other media.

Elementary school readers are meant for both sexes. Primers used in the first three grades offer children a view of a "typical" American family: a mother who does not work, a father who does, two children—a brother who is always older than a sister—and two pets—a dog and sometimes a cat—whose sexes and ages mirror those of the brother and sister. In these books, boys build or paint things; they also pull girls in wagons and push merry-go-rounds. Girls carry purses when they go shopping; they help mother cook or pretend that they are cooking; and they play with their dolls. When they are not making messes, they are cleaning up their rooms or other people's messes. Plots in which girls are involved usually depend on their inability to do something—to manage their own roller skates or to ride a pony. Or in another typical role, a girl named Sue admires a parachute

jumper: "What a jump!" said Sue. "What a jump for a man to make!" When her brother puts on a show for the rest of the neighborhood, Sue, whose name appears as the title of the chapter, is part of his admiring audience.

The absence of adventurous heroines may shock the innocent; the absence of even a few stories about women doctors, lawyers, or professors thwarts reality; but the consistent presence of one female stereotype is the most troublesome matter:

> *Primrose was playing house. Just as she finished pouring tea for her dolls she began to think. She thought and thought and she thought some more: "Whom shall I marry? Whomever shall I marry?*
>
> *"I think I shall marry a mailman. Then I could go over to everybody's house and give them their mail.*
>
> *"Or I might marry a policeman. I could help him take the children across the street."*

Primrose thinks her way through ten more categories of employment and concludes, "But now that I think it over, maybe I'll just marry somebody I love." Love is the opiate designated to help Primrose forget to think about what she would like to do or be. With love as reinforcer, she can imagine herself helping some man in his work. In another children's book, Johnny says, "I think I will be a dentist when I grow up," and later, to Betsy, he offers generously, "You can be a dentist's nurse." And, of course, Betsy accepts gratefully, since girls are not expected to have work identity other than as servants or helpers. In short, the books that schoolgirls read prepare them early for the goal of marriage, hardly ever for work, and never for independence.

If a child's reader can be pardoned for stereotyping because it is "only" fiction, a social studies text has no excuse for denying reality to its readers. After all, social studies texts ought to describe "what is," if not "what should be." And yet, such texts for the youngest grades are no different from readers. They focus on families and hence on sex roles and work. Sisters are still younger than brothers; brothers remain the doers, questioners, and knowers who explain things to their poor, timid sisters. In a study of five widely used texts, Jamie Kelem Frisof finds that

energetic boys think about "working on a train or in a broom factory" or about being President. They grow up to be doctors or factory workers or (in five texts combined) to do some hundred different jobs, as opposed to thirty for women.

Consider for a moment the real work world of women. Most women (at least for some portion of their lives) work, and if we include "token" women—the occasional engineer, for instance—they probably do as many different kinds of work as men. Even without improving the status of working women, the reality is distinctly different from the content of school texts and literature written for children. Schools usually at least reflect the society they serve; but the treatment of working women is one clear instance in which the reflection is distorted by a patriarchal attitude about who *should* work and the maleness of work. For example, there are women doctors—there have been women doctors in this country, in fact, for a hundred years or so. And yet, until the publication this month of two new children's books by the Feminist Press (Box 334, Old Westbury, N.Y. 11568), there were no children's books about women doctors.

In a novel experiment conducted recently by an undergraduate at Towson State College in Maryland, fourth-grade students answered "yes" or "no" to a series of twenty questions, eight of which asked, in various ways, whether "girls were smarter than boys" or whether "daddies were smarter than mommies." The results indicated that boys and girls were agreed that 1) boys were not smarter than girls, nor girls smarter than boys; but 2) that daddies were indeed smarter than mommies! One possible explanation of this finding depends on the knowledge that daddies, in school texts and on television (as well as in real life), work, and that people who work know things. Mommies, on the other hand, in books and on television, rarely stir out of the house except to go to the store—and how can someone like that know anything? Of course, *we* know that half of all mothers in the United States work at some kind of job, but children whose mommies do work can only assume—on the basis of evidence offered in school books and on television—that their mommies must be "different," perhaps even not quite "real" mommies.

If children's readers deny the reality of working women, high school history texts deny women their full historical role. A

recent study by Janice Law Trecker of thirteen popular texts concludes with what by now must seem a refrain: Women in such texts are "passive, incapable of sustained organization or work, satisfied with [their] role in society, and well supplied with material blessings." Women, in the grip of economic and political forces, rarely fighting for anything, occasionally receive some "rights," especially suffrage in 1920, which, of course, solves all *their* problems. There is no discussion of the struggle by women to gain entrance into higher education, of their efforts to organize or join labor unions, of other battles for working rights, or of the many different aspects of the hundred-year-long multi-issue effort that ended, temporarily, in the suffrage act of 1920. Here is Dr. Trecker's summary of the history and contributions of American women as garnered from the thirteen texts combined:

> *Women arrived in 1619 (a curious choice if meant to be their first acquaintance with the New World). They held the Seneca Falls Convention on Women's Rights in 1848. During the rest of the nineteenth century, they participated in reform movements, chiefly temperance, and were exploited in factories. In 1920, they were given the vote. They joined the armed forces for the first time during the Second World War and thereafter have enjoyed the good life in America. Add the names of the women who are invariably mentioned: Harriet Beecher Stowe, Jane Addams, Dorothea Dix, and Frances Perkins, with perhaps Susan B. Anthony, Elizabeth Cady Stanton . . . [and you have the story].*

Where efforts have been made in recent years to incorporate black history, again it is without attention to black women, either with respect to their role in abolitionist or civil rights movements, for example, or with respect to intellectual or cultural achievements.

Just as high school history texts rely on male spokesmen and rarely quote female leaders of the feminist movement—even when they were also articulate writers such as Charlotte Perkins Gilman, or speakers such as Sojourner Truth—so, too, literary

240

anthologies will include Henry James or Stephen Crane rather than Edith Wharton or Kate Chopin. Students are offered James Joyce's *Portrait of the Artist as a Young Man* or the *Autobiography of Malcolm X*, rather than Doris Lessing's *Martha Quest* or Anne Moody's *Coming of Age in Mississippi*. As a number of studies have indicated, the literary curriculum, both in high school and college, is a male-centered one. That is, either male authors dominate the syllabus or the central characters of the books are consistently male. There is also usually no compensating effort to test the fictional portraits—of women and men—against the reality of life experience. Allegedly "relevant" textbooks for senior high school or freshman college composition courses continue to appear, such as Macmillan's *Representative Men: Heroes of Our Time*. There are two women featured in this book: Elizabeth Taylor, the actress, and Jacqueline Onassis, the Existential Heroine. Thirty-five or forty men—representing a range of racial, political, occupational, and intellectual interests—fill the bulk of a book meant, of course, for both men and women. And some teachers are still ordering such texts.

It's not a question of malice, I assume, but of thoughtlessness or ignorance. Six or seven years ago I too was teaching from a standard male-dominated curriculum—and at a women's college at that. But I speak from more than my own experience. Last fall at this time I knew of some fifty college courses in what has come to be known as women's studies. This fall, I know of more than 500, about half of which are in literature and history. I know also of many high school teachers who have already begun to invent comparable courses.

School systems can and should begin to encourage new curricular developments, especially in literature and social studies, and at the elementary as well as the high school level. Such changes, of course, must include the education and re-education of teachers, and I know of no better way to re-educate them than to ask for analyses of the texts they use, as well as of their assumptions and attitudes. The images we pick up, consciously or unconsciously, from literature and history significantly control our sense of identity, and our identity—our sense of ourselves as powerful or powerless, for example—controls our behavior. As

teachers read new materials and organize and teach new courses, they will change their views. That is the story of most of the women I know who, like me, have become involved in women's studies. The images we have in our heads about ourselves come out of literature and history; before we can change those images, we must see them clearly enough to exorcise them and, in the process, to raise others from the past we are learning to see.

That is why black educators have grown insistent upon their students' learning black history—slave history, in fact. That is also why some religious groups, Jews for example, emphasize their history as a people, even though part of that history is also slave history. For slave history has two virtues: Not only does it offer a picture of servitude against which one can measure the present; it offers also a vision of struggle and courage. When I asked a group of young women at the University of Pittsburgh last year whether they were depressed by the early nineteenth-century women's history they were studying, their replies were instructive: "Certainly not," one woman said, "we're angry that we had to wait until now—after so many years of U.S. history in high school—to learn the truth about some things." And another added, "But it makes you feel good to read about those tremendous women way back then. They felt some of the same things we do now."

Will public education begin to change the images of women in texts and the lives of women students in schools? There will probably be some movement in this direction, at least in response to the pressures from students, parents, and individual teachers. I expect that parents, for example, will continue to win legal battles for their daughters' equal rights and opportunities. I expect that individual teachers will alter their courses and texts and grow more sensitive to stereotypic expectations and behavior in the classroom. But so far there are no signs of larger, more inclusive reforms: no remedial program for counselors, no major effort to destereotype vocational programs or kindergarten classrooms, no centers for curricular reform. Frankly, I don't expect this to happen without a struggle. I don't expect that public school systems will take the initiative here. There is too much at stake in a society as patriarchal as this one. And schools, after all, tend to follow society, not lead it.

242

FOR DISCUSSION

1. What is stereotyping? Where have you personally seen it in areas other than sex roles? How does it feel to be stereotyped?
2. When you read books as a child, did you find the boys active and capable, the girls passive and in trouble? Were there any exceptions? Did you read the Nancy Drew books? What was she like? (You will find some articles about this series in fairly recent magazines.)

ACTIVITIES

1. Do a study of the children's textbooks your school system uses. Keep track of the number of boys and the number of girls doing active, interesting things. Count the number of mothers with aprons on.
2. What evidence can you find in the names for different activities and professions that women are an afterthought? For example, look at "doctor," "driver," and "poet." Make a list of such words, ones that need a suffix or the word "woman" to indicate female.
3. Make a list of the names for professions which end in the word "man." Is there evidence that nonsexist terms are beginning to replace these sexist ones? Can you give some examples?
4. Where do women get their last names? Why and how did this custom start? Do you think married women should be allowed to use their maiden name as well as their married name? Why?
5. Make a list of personality characteristics, such as *assertive* and *naive*. Are any of these terms sex linked? Why? Do you think they should be? Explain.
6. Look through some Mother Goose rhymes and find images of women as foolish, mean, timid, and never quiet. What other stereotypes do you find? How do these images compare to the male images in the rhymes?

INTRODUCTION

In the essay that begins this section, Florence Howe suggests that women are programmed into learning traits that are different from those of mentally healthy adults. The confusion felt by a woman as she tries to fulfill both her inner self and a specific role might contribute to mental illness. Women have been expected to tolerate stresses, sometimes beyond their ability to do so. The obsession of the woman in the following story shows her inability to cope with being known not for herself, but for her roles as mother, wife, and house cleaner.

The Sink

Susan Griffin

It was dark out; she was forty years old, and she was sitting under the sink. Forty. Married twenty years. She dreamt the marriage, and it happened that way, down to the color of the dresses of her bridesmaids, the color of her husband's hair, and their children's. Red. Red like carrots. Like carrots before they are cooked. Like the carrots she cut into four pieces every evening at eight o'clock and wrapped in cellophane to go in their lunch bags. Three lunch bags. Folded over with a name on each bag. And then she would close the refrigerator and clear the drain, clear the sink and the drain of carrot peelings, because they stick in the pipes and clog the sink if they are not removed, the same as coffee grounds. She had lost interest in coffee, though. That's what he said, the man she had married, with red hair. Just like a woman, he said, flighty. You have an interest, like soap or coffee, and then one day you just let it drop.

She had started with Italian coffee, the time he took her to an Italian restaurant and the waiter insisted they drink after-dinner coffee and the cups were small and the coffee very sweet and thick. She bought an espresso pot. She had to send away.

She looked every day in the mail. It came packed in confetti with instructions in Italian, and she put the water where the coffee grounds were supposed to be. But she finally mastered it, and open-pot coffee, and drip and steam and Turkish coffee. Finally she even bought her own grinder. And she learned that the coffee shrub grew wild in Abyssinia, that the Dutch drank Java in the eighteenth century.

But she lost interest. Pots gathered dust on the shelf. She finally took to buying preground percolator coffee in huge tins in the supermarket.

The same thing had happened to her as a young girl with soap. Her favorite aunt went on a trip around the world and sent a bar of soap from every country. Myrurgia soap from Spain. Sandalwood from India. Lilac from England. She began to take long baths. She stored bars of soap with her sweaters and her lingerie so they would be perfumed. And once, on a date with her husband, the man she finally married, a bar of soap fell out of the sleeve of her sweater.

But that was twenty years ago. And now it was pipes. The house was old. The pipes were no good. She started with crystals of drain cleaner every week. The pipes were cleared, but a small amount of water always floated at the bottom of the sink, taking five or ten minutes to gurgle itself downward. So she could never keep the sink clean. The cycle got interrupted. The cycle of rinsing and draining after washing the dishes, because there was always this last bit of water sitting in the sink, preventing her from laying her hand on a clean dry sink at the end of a day in the kitchen.

She found a book on plumbing. She took the pipes apart and discovered the catch in the first joint, filled with collected refuse. So she cleared it out. And the sink worked perfectly. Every last drop of water flowed down and out the drain, so smoothly she never even saw it collect.

But the catch jammed up again. Within a week it was full and she did not know why. The trouble might be under the house; she might have to dig up the foundations.

Her husband did not understand the importance of the drainpipe. He mentioned the large cost of major plumbing and the disruption it might cause in their lives, and so they did nothing.

She began to clean the catch out every week. And it was then that she noticed the catch would start to get full in the middle of the week, and water would start to collect in the sink. A small amount of water, but it angered her, so she began to clean the catch twice a week.

Now she heard footsteps. Perhaps the man she had married was coming to the kitchen. He might eat. He might wash the remains of his plate down the drain. She waited.

She wondered if there might be a leak in the drain. She could feel the pipe on the back of her neck. Water might drip on her hair. But she did not want to wash her hair that night. She began to pick at her nails. She calculated when it was that she had last washed her hair, because she liked to wash her hair twice a week, not more often or it would get dry—and not less, because her hair got stringy. It got dirty in three or four days. And when her hair got stringy her face looked pasty. So she liked to plan the washings for days when she went out, only she never knew when she might go out. She was worried. She had just washed her hair yesterday, so she put her hands on top of her head and held them there, even though her back began to ache.

In fact it all began to ache. There was not much room for her under the sink. She was doubled up; her feet under her had gone to sleep. Her chin was bent into her chest and had begun to feel as if it were growing longer. She folded her hands over her breasts and felt each movement of her ribs as she breathed. She perspired.

But it was not his footsteps she heard. No one came to dump their uneaten breadcrumbs, or their bits of lettuce with mayonnaise down the pipe. She waited, as she had waited the night before, and the night before, and every night since she first realized that someone had been putting garbage in the drain in the middle of the night.

At first she lay awake night after night listening for any sound in the kitchen. But at close to five in the morning she would somehow fall asleep. By ten o'clock, when she usually wakened, they had all gone, the man she was married to and the two children, and their lunch bags were gone from the refrigerator. She would go and stare at the sink, where she found bits of cold cereal, egg and banana floating in a pool of coffee, the remains of their morning.

Now the house was retired. She could visualize its order from her hiding place. Everything was smoothed out. All the wrinkles were out of all the clothes that hung empty in closets. Everything was in its place. The lumps beneath the blankets breathed in and out. And the wet was wet and the dry was dry. All the dust was outside the windows with the earth. Food was cool and glistening behind the white door of the refrigerator; and garbage was wrapped in black plastic in cans by the backyard fence, or was on its way through the floor of the house, through the floor of the earth, by pipes and rivers, out to the sea.

Everything save the catch in the drain was ready. She longed sometimes, staring at it all, thinking of the order and the multitude of ways she kept it, she longed to join the garbage in the waste can and become part of the air—the way that objects slowly carbonize, turn into compost, or bits of particles, vapors.

Or she longed, when everyone had gone off to sleep, to put on her coat and leave as if she had never been there. To go some place under a different name and make messes. Some place where she could make the dry wet and the wet dry. Where she could wrinkle her clothes, where she could spread the contents of the refrigerator over the furniture, like cheese over crackers.

And afterwards she dreamt that she would throw herself down some drain and plummet out to the sea and swim along with the waste and the garbage in one great bath.

Tears rolled over her face. She didn't move to clean them off. She sighed and she had a great urge to let her head rest against the drainpipe, but she didn't. She held on. The house waited for her. Her head began to hurt listening for the sound of the drain.

Everything she knew was ready, except the drain. When that was clear, her life could begin.

FOR DISCUSSION

1. Why has the sink become so important to the woman? What is it a symbol of? How would you react to the story if she were a man? Can you think of a situation involving a man that would be similar to this one?

INTRODUCTION

In the following story the Indian woman Janaki fits the typical feminine stereotypes of the perfect housekeeper and the totally submissive woman. Her acceptance of these roles is a conscious and deliberate one, however. She knows that her culture expects her to fill these roles if she wants to obtain what is important to her—a husband, a family, and a home. However, Janaki also seems to understand that she has a personal identity beyond these roles, and, for this reason, she can fulfill them happily.

Who Cares?

Santha Rama Rau

The only thing, really, that Anand and I had in common was that both of us had been to college in America. Not that we saw much of each other during those four years abroad—he was studying business management or some such thing in Boston and I was taking the usual liberal arts course at Wellesley, and on the rare occasions we met, we hadn't much to say—but when we got back to Bombay, the sense of dislocation we shared was a bond. In our parents' generation that whole malaise was covered by the comprehensive phrase "England-returned," which held good even if you had been studying in Munich or Edinburgh, both popular with Indian students in those days. The term was used as a qualification (for jobs and marriages) and as an explanation of the familiar problems of readjustment. Even after the war, in a particular kind of newspaper, you could find, in the personal columns, advertisements like this: "Wanted: young, fair, educated girl, high caste essential, for England-returned boy. Send photograph." The point is that she would have to prove herself—or rather, her family would have to demonstrate her desirability—but "England-returned" would tell her just about everything she needed to know about the boy: that his family

was rich enough to send him abroad for his education, that his chances for a government job or a good job in business were better than most, that his wife could probably expect an unorthodox household in which she might be asked to serve meat at meals, entertain foreigners, speak English, and even have liquor on the premises. She would also know that it would be a "good" (desirable, that is) marriage.

"England-returned," like that other much-quoted phrase, "Failed B.A.," was the kind of Indianism that used to amuse the British very much when it turned up on a job application. To Indians, naturally, it had a serious and precise meaning. Even "Failed B.A.," after all, meant to us not that a young man had flunked one examination, but that he had been through all the years of school and college that led to a degree—an important consideration in a country where illiteracy is the norm and education a luxury.

In the course of a generation that became increasingly sensitive to ridicule, those useful phrases had fallen out of fashion, and by the time Anand and I returned to Bombay we had to find our own descriptions for our uneasy state. We usually picked rather fancy ones, about how our ideas were too advanced for Bombay, or how enterprise could never flourish in India within the deadly grip of the family system, or we made ill-digested psychological comments on the effects of acceptance as a way of life. What we meant, of course, was that we were suffering from the England-returned blues. Mine was a milder case than Anand's, partly because my parents were "liberal"—not orthodox Hindus, that is—and, after fifteen years of wandering about the world in the diplomatic service, were prepared to accept with equanimity and even a certain doubtful approval the idea of my getting a job on a magazine in Bombay. Partly, things were easier for me because I had been through the worst of my readjustments six years before, when I had returned from ten years in English boarding schools.

Anand's England-returned misery was more virulent, because his family was orthodox, his mother spoke no English and distrusted foreign ways, he had been educated entirely in Bombay until he had gone to America for postgraduate courses, and, worst of all, his father, an impressively successful contractor

in Bombay, insisted that Anand, as the only son, enter the family business and work under the supervision not only of the father but of various uncles.

Our families lived on the same street, not more than half a dozen houses from each other, but led very different lives. Among the members of our generation, however, the differences were fading, and Anand and I belonged to the same set, although we had never particularly liked each other. It was a moment of boredom, of feeling at a loose end, and a fragmentary reminder that both of us had been in America that brought Anand and me together in Bombay.

It was during the monsoon, I remember, and the rain had pelted down all morning. About noon it cleared up, and I decided to spend my lunch hour shopping instead of having something sent up to eat at my desk. I started down the street toward Flora Fountain, the hideous monument that is the center of downtown Bombay, and had gone about halfway when I realized I had guessed wrong about the weather. The rain began, ominously gentle at first, then quickly changing into a typical monsoon downpour. I ducked into the first doorway I saw, and ran slap into Anand, a rather short, slender young man, dressed with a certain nattiness. It was the building in which his father's firm had its offices, and Anand stood there staring glumly at the streaming street and scurrying pedestrians. We greeted each other with reserve. Neither was in the mood for a cheery exchange of news. We continued to gaze at the rain, at the tangle of traffic, the wet and shiny cars moving slowly through the dirty water on the road.

At last, with an obvious effort and without much interest, Anand said, "And what are you up to these days?"

"I *was* going to go shopping," I said coolly, "but I don't see how I can, in this."

"Damn rain," he muttered. I could hardly hear him over the sound of the water rushing along the gutters.

I said, "Mm," and, as a return of politeness, added, "And you? What are you doing?"

"Heaven knows," he said, with a world of depression in his voice. "Working, I suppose." After another long pause, he said, "Well, look, since you can't shop and I can't get to the

garage for my car, suppose we nip around the corner for a bite of lunch."

"Okay," I said, not knowing quite how to refuse.

Anand looked full at me for the first time and began to smile.

"'Okay,'" he repeated. "Haven't heard *that* in some time."

We raced recklessly down the street, splashing through puddles and dodging people's umbrellas, until we arrived, soaked and laughing, at the nearest restaurant. It was no more than a snack bar, really, with a counter and stools on one side of the small room and a few tables on the other. We stood between them, breathless, mopping our faces ineffectually with handkerchiefs and slicking back wet hair, still laughing with the silly exhilaration such moments produce. We decided to sit at a table, because Anand said the hard little cakes with pink icing, neatly piled on the counter, looked too unappetizing to be faced all through lunch.

Our explosive entrance had made the other customers turn to stare; but as we settled down at our table, the four or five young men at the counter—clerks, probably, from nearby offices, self-effacing and pathetically tidy in their white drill trousers and white shirts (the inescapable look of Indian clerks)—turned their attention back to their cups of milky coffee and their curry puffs. The Sikhs at the next table, brightly turbaned and expansive of manner, resumed their cheerful conversation. The two Anglo-Indian typists in flowered dresses returned to their whispers and giggles and soda pop.

When the waiter brought us the menu, we discovered that the restaurant was called the Laxmi and Gold Medal Café. This sent Anand into a fresh spasm of laughter, and while we waited for our sandwiches and coffee, he entertained himself by inventing equally unlikely combinations for restaurant names— the Venus and Sun Yat-sen Coffee Shoppe, the Cadillac and Red Devil Ice-Cream Parlor, and so on—not very clever, but by that time we were in a good mood and prepared to be amused by almost anything.

At some point, I remember, one of us said, "Well, how do you *really* feel about Bombay?" and the other replied, "Let's

face it. Bombay *is* utter hell," and we were launched on the first of our interminable conversations about ourselves, our surroundings, our families, our gloomy predictions for the future. We had a lovely time.

Before we left, Anand had taken down the number of my office telephone, and only a couple of days later he called to invite me to lunch again. "I'll make up for the horrors of the Laxmi and Gold Medal," he said. "We'll go to the Taj, which is at least air-conditioned, even if it isn't the Pavillon."

He had reserved a table by the windows in the dining room of the Taj Mahal Hotel, where we could sit and look out over the gray, forbidding water of the harbor and watch the massed monsoon clouds above the scattered islands. Cool against the steamy rain outside, we drank a bottle of wine, ate the local *pâté de foie gras*, and felt sorry for ourselves.

Anand said, "I can't think why my father bothered to send me to America, since he doesn't seem interested in anything I learned there."

"Oh, I know, I know," I said, longing to talk about my own concerns.

"Can you believe it, the whole business is run *exactly* the way it was fifty years ago?"

"Of course I can. I mean, take the magazine—"

"I mean, everything done by vague verbal arrangements. Nothing properly filed and accounted for. And such enormous reliance on pull, and influence, and knowing someone in the government who will arrange licenses and import permits and whatever."

"For a consideration, naturally?"

"Or for old friendship or past favors exchanged or—"

"Well, it's a miracle to me that we ever get an issue of the magazine out, considering that none of the typesetters speaks English, and they have to make up the forms in a language they don't know, mirrorwise and by hand."

"Oh, it's all hopelessly behind the times."

"You can see that what we really need is an enormous staff of proofreaders and only a *tiny* editorial—"

"But at least you don't have to deal with the family as well. The amount of deadwood in the form of aged great-uncles, dim-witted second cousins, who *have* to be employed!"

"Can't you suggest they be pensioned off?"

"Don't think I haven't. My father just smiles and says I'll settle down soon. Oh, what's the use?"

Our discussions nearly always ended with one or the other of us saying, with exaggerated weariness, "Well, so it goes. Back to the salt mines now, I suppose?" I never added that I enjoyed my job.

That day we didn't realize until we were on the point of leaving the Taj how many people were lunching in the big dining room whom we knew or who knew one or the other of our families. On our way out, we smiled and nodded to a number of people and stopped at several tables to exchange greetings. With rising irritation, both of us were aware of the speculative glances, the carefully unexpressed curiosity behind the pleasant formalities of speech. Anand and I sauntered in silence down the wide, shallow staircase of the hotel. I think he was trying to seem unconcerned.

It was only when we reached the road that he exploded into angry speech. "Damn them," he said. "The prying old cats! What business is it of theirs, anyway?"

"It was the wine," I suggested. "Even people who have been abroad a lot don't drink wine at lunchtime."

"So? What's it to them?"

"Well, Dissolute Foreign Ways, and besides—"

"And besides, they have nothing to do but gossip."

"That, of course, but besides, you're what they call a catch, so it's only natural that they wonder."

Anand frowned as we crossed the road to where his car was parked against the sea wall. He opened the door for me and then climbed in behind the steering wheel. He didn't start the car for a moment or two, but sat with his hands on the wheel and his head turned away from me, looking at the threatening light of the early afternoon, which would darken into rain any minute. I thought he was about to tell me something—about a disappointment or a love affair—but instead, he clenched his fingers suddenly and said, "Well, the devil with them. Let them talk, if they have nothing better to do."

"Yes. Anyway, who cares?" I said, hoping it didn't sound as though I did.

He smiled at me. "That's the spirit. We'll show them."

We lunched at the Taj several times after that, but on each occasion a bit more defiantly, a bit more conscious of the appraising looks, always knowing we were the only "unattacheds" lunching together. The others were businessmen, or married couples doing duty entertaining, which, for some reason, they couldn't do at home, or ladies in groups, or foreigners.

As we stood inside the doors of the dining room, Anand would pause for a second, and then grip my elbow and say something like, "Well, come along. Let's strike a blow for freedom," or, "Throw away the blindfold. I'll face the firing squad like a man." He didn't deceive me—or, I suppose, anyone else.

Bombay is a big city—something over two million people—but in its life it is more like a conglomeration of villages. In our set, for instance, everyone knew everyone else at least by sight. At any of the hotels or restaurants we normally went to we were certain to meet a friend, a relative, an acquaintance. We all went to the same sort of party, belonged to the same clubs. People knew even each other's cars, and a quick glance at a row of parked cars would tell you that Mrs. Something was shopping for jewelry for her daughter's wedding, or that Mr. Somethingelse was attending a Willingdon Club committee meeting. So, of course, everyone knew that Anand and I lunched together a couple of times a week, and certainly our families must have been told we had been seen together.

My parents never mentioned the matter to me, though there was a certain wariness in their manner whenever Anand's name came up in conversation. (It's a sad moment, really, when parents first become a bit frightened of their child.) Privately, they must have put up with a good deal of questioning and comment from friends and relatives. Even to me people would sometimes say, "Can you come to a party on Saturday? Anand will be there." If Anand's mother ever lectured him on getting talked about, he evidently didn't think it worth repeating. Of them all, I daresay she was the most troubled, being orthodox, wanting a good, conservative marriage for her only son, being bewildered by what must have appeared to her—it seems astonishing in retrospect—as sophistication.

Occasionally Anand would take me home to tea after our offices had closed. I think he did this out of an unadmitted consid-

eration for his mother, to set her mind at rest about the company he was keeping, to show her that I was not a Fast Girl even if I did work on a magazine. I don't know how much I reassured her, with my short hair and lipstick, no *tika* in the middle of my forehead. But she always greeted me politely, bringing her hands together in a *namaskar,* and gave me canny looks when she thought I wasn't noticing. We couldn't even speak to each other, since we came from different communities and she spoke only Gujarati, while my language was Hindi. She would always wait with us in the drawing room until one of the servants brought the tea; then she would lift her comfortable figure out of her chair, nod to me, and leave us alone. We were always conscious of her presence in the next room beyond the curtained archway, and every now and then we would hear her teacup clink on the saucer. Our conversation, even if she didn't understand it, was bound to be pretty stilted.

Perhaps it was this silent pressure, perhaps it was only a sort of restlessness that made Anand and me leave the usual haunts of our set and look for more obscure restaurants for our lunch dates. Liberal as we considered ourselves, we still couldn't help being affected by the knowing curiosity. There's no point in denying it (predictably, I always *did* deny it to Anand); I was concerned about public opinion. I suppose I was beginning to lose my England-returned brashness and intractability: I was not, however, prepared to stop meeting Anand for lunch. I liked him and waited with some impatience for his telephone calls, the rather pleasant voice saying things like "Hello? Is this the career girl?" (This was one of Anand's favorite phrases of defiance—a career girl was still something of a peculiarity in Bombay in those days. If you came from a respectable family that could support you, you weren't supposed to work for money. Social work would have been all right, but not something as shady as journalism.) Sometimes he would say, "This is underground agent 507. Are you a fellow resistance fighter?" or, "Am I speaking to Miss Emancipation?"

In any case, I would laugh and say, "Yes," and he would suggest that we try some Chinese food, or eat dry curried chicken at a certain Irani shop, or, if it was one of the steamy, rainless days near the end of the monsoon, go to Chowpatty beach and eat

odds and ends of the delicious, highly spiced mixtures the vendors there concoct. By tacit agreement, he no longer picked me up at the office. Instead, we either met at the corner taxi rank (leaving Anand's car parked in the alley behind his office building) or arrived separately at our rendezvous.

Once, when we were driving to Colaba, the southernmost point of the island, Anand suddenly leaned forward and asked the taxi driver to stop. On an otherwise uninspired-looking street, lined with dingy middle-class houses, he had seen a sign that said "Joe's Place." Anand was entranced, and certainly the sign did look exotic among the bungalows and hibiscus. Joe's Place—named by some homesick American soldier, who had found his way there during the war—quickly became our favorite restaurant. We felt it was our discovery, for one thing, and then it had a Goan cook, which meant that, unlike at some of the other Indian restaurants, you could order beef. Most Hindus will not eat beef, cook it, or allow it on the premises; it is, as a result, the cheapest meat in Bombay. We ate a lot of beef at Joe's Place, and I often thought that Anand, at home in the evening, probably got rather a kick out of imagining how horrified his mother would be if she knew he had a rare steak inside him.

The proprietor, whom Anand insisted on calling Joe, even though he was a fat and jolly Indian, soon got used to seeing us almost every other day. We couldn't imagine how he made any money, since there never seemed to be anyone there besides Anand and me. Joe waited on table, so there weren't even waiters. Anand said that it was probably a front for black market activities and that you could expect anything of a man who ran a Joe's Place in Bombay. More likely, the real, prosaic reason was that most of Joe's business was in cooking meals to send out.

We came to feel so much at home at Joe's that we bought him a checkered tablecloth, to lend the place a bit of class, and he would spread it ceremoniously over the corner table, invariably pointing out that it had been laundered since our last meal. We kept a bottle of gin at Joe's and taught him to make fresh-lime gimlets with it, so that we could have a cocktail before lunch. He hadn't a license to sell liquor, so he always shook our cocktails in an opaque bottle labeled Stone Ginger, in case any-

one came in. He probably watered the gin; but we didn't much care, because it was the idea that pleased us.

We would sit at our table between the windows, glancing out occasionally at the patch of straggly garden, the jasmine bush, the desultory traffic, and talk. How we talked! On and on and on. Sometimes it was "In the States, did you ever—" or "Do you remember—" kind of talk. Sometimes it was about incidents at home or in our offices. We talked a lot about Them—a flexible term, including any relatives or friends we considered old-fashioned, interfering, lacking in understanding. We often discussed Their iniquities, and many of our conversations began, "Do you know what They've gone and done *now?*" All through the sticky postmonsoon months, into the cooler, brilliant days of early winter, we talked. It seems a miracle to me now that we could have found so much to say about the details of our reasonably pedestrian lives.

If we'd been a bit older or more observant, we would certainly have known that this state of affairs couldn't last much longer. I was dimly aware that every day of life in Bombay relaxed our antagonism a tiny bit and blurred the outlines of our American years. However, I never guessed what Anand's family's counterattack to his England-returned discontent would be. Anand's mother was a direct, uncomplicated woman, and in her view there was one obvious and effective way to cure the whole disease without waiting for the slower methods of time.

It was at Joe's Place that Anand announced the arrival of Janaki. I had got there early, I remember, and was sitting at our table when Anand came in. He always had a certain tension in his walk, but that day it seemed more pronounced. He held his narrow shoulders stiffly and carried an air of trouble, so I asked him at once whether anything was the matter.

"Matter?" he asked sharply, as though it were an archaic word. "Why should anything be the matter?"

"Well, I don't know. You just look funny."

"Well, I don't feel funny," he said, deliberately misunderstanding.

Joe brought him his gimlet and inquired rather despairingly if we wanted steak *again.*

Anand waved a hand at him impatiently and said, "Later. We'll decide later." Then he looked at me in silence, with a portentous frown. At last he said, "Do you *know* what They've gone and done *now?* They've invited a cousin—a *distant* cousin—to stay."

This didn't seem to me any great disaster. Cousins, invited or not, were eternally coming to visit. Any relatives had the right to turn up whenever it was convenient for them and stay as long as they liked. His announcement came as an anticlimax; but since he did seem so distressed, I asked carefully, "And I suppose you'll be expected to fit him into the firm in some capacity?"

"Her," Anand said. "It's a girl."

"A *girl?* Is *she* going to work in the business?" This was really cataclysmic news.

"Oh, of *course* not. Can't you see what They're up to?"

"Well, no, I can't."

"Don't you *see?*" he said, looking helpless before such stupidity. "They're trying to arrange a marriage for me."

I could think of nothing to say except an unconvincing "Surely not."

He went on without paying any attention. "I dare say They think They're being subtle. Throwing us together, you know, so that my incomprehensible, *foreign*—" he emphasized the word bitterly—"preference for making up my own mind about these things will not be offended. We are to grow imperceptibly fond of each other. Oh, I see the whole plot."

"You must be imagining it all."

"She arrived last night. They didn't even tell me she was coming."

"But people are forever dropping in."

"I know. But she was *invited*. She told me so."

"Poor Anand." I was sorry for him, and angry on his behalf. There had never been any romantic exchanges between Anand and me, so the girl didn't represent any personal threat; but I honestly thought that a matter of principle was involved and that one should stand by the principle. We had so often agreed that the system of arranged marriages was the ultimate insult to one's rights as a human being, the final, insupportable

interference of domineering families. I tried to think of something comforting to say, but could only produce, feebly, "Well, all you have to do is sit it out."

"And watch her doing little chores around the house? Making herself quietly indispensable?" He added with a sour smile, "As the years roll by. Do you suppose we will grow old gracefully together?"

"Oh, don't be such a fool," I said, laughing. "She'll have to go, sooner or later."

"But will I live that long?" He seemed to be cheering up.

"It's rather unfair to the poor thing," I said, thinking for the first time of the girl. "I mean, if they've got her hopes up."

"Now, don't start sympathizing with *her*. The only way to finish the thing once and for all—to make my position clear—is to marry someone else immediately. I suppose you wouldn't consider marrying me, would you?"

"Heavens, no," I said, startled. "I don't think you need to be as drastic as that."

"Well, perhaps not. We'll see."

At last I thought to ask, "What's she called?"

"Janaki."

"Pretty name."

"It makes me vomit."

I could hardly wait for our next lunch date, and when we met a couple of days later at Joe's Place I started questioning Anand eagerly. "Well, how are things? How are you making out with Janaki?"

Anand seemed remote, a bit bored with the subject. "Joe!" he called. "More ice, for Pete's sake. Gimlets aren't supposed to be *mulled*." He tapped his fingers on the table in a familiar, nervous movement. "He'll never learn," he said resignedly. Then, after a pause, "Janaki? Oh, she's all right, I suppose. A minor pest."

"Is she being *terribly* sweet to you?"

"Oh, you know. I will say this for her, she manages to be pretty unobtrusive."

"Oh." I was obscurely disappointed.

"It's just knowing she's always *there* that's so infuriating."

"It would drive me crazy."

In a voice that was suddenly cross, he said, "She's so *womanly*."

"Hovers about, you mean?"

"Not that so much, but I can see her *hoping* I'll eat a good dinner or have had a good day at the office, or some damn thing."

"It sounds rather flattering."

"I dare say that's the strategy. It's pathetic, really, how little They know me if They think she's the sort of girl I'd want to marry."

"What sort of girl *would* you want to marry?"

"Heaven knows," Anand said in a hopeless voice. "Someone quite different, anyway. I knew one once."

"Was there a girl in America?" I asked with interest.

"Isn't there always a girl in America? A sort of tradition. In our fathers' time, it used to be the daughter of the landlady somewhere in Earl's Court. Usually blonde, always accommodating."

"And yours?"

"Accommodating. But several cuts above the landlady's daughter. She was a senior in college. And she had quite a nice family, if you can stand families, rather timid, but determined to believe that a Good Home Environment was a girl's best protection. I don't think they would have raised many objections if we'd got married."

"Why didn't you marry her, then?"

"Oh, I don't know. Do those things work? I really don't know."

"I expect your parents would have raised the devil."

"Before—if I'd told them. Not after. By then the particular alchemy that turns a girl into a daughter-in-law would have done its work. That was really the trouble. I couldn't see her being an Indian daughter-in-law living in a Bombay family—and what a mess that would have made. Hurt feelings and recriminations and disappointment all around. I'm not sentimental about her," he said earnestly, as if it were an important point. "I mean, I know she wasn't particularly good-looking or anything,

but I had a separate identity in her mind. I wasn't just some-body's son, or someone to marry, or someone with good business connections."

"And all that is what you are to Janaki?"

"I suppose so. What else could I be?"

As we left Joe's Place after lunch, he said, "I think you'd better come to tea to meet her. Would you like to?"

"I was hoping you'd ask me."

"Okay, then. Tomorrow?"

Full of excitement, the next day, I met Anand after work and drove home with him. "Is your mother going to be cross about your asking me?"

"Why should she be cross? You've been to tea with us before."

"But that was different."

"I can't see why," he said, refusing to accept the situation.

"Oh, don't be so dense," I said, thinking, poor girl, it's going to be very frustrating for her if he insists on treating her as a casual cousin come for a holiday. "Does your mother tactfully leave you alone with her for tea?"

"Never. The two of them chatter about domestic details. It's really very boring."

To me it was far from boring. For one thing, Anand's mother was far more cordial to me than she had been on previous visits, and I wondered whether she could already be so sure of the success of her plan that I was no longer a danger. And then there was the suspense of waiting to see what Janaki would be like.

She came in with the servant who carried the tea tray, hold-ing back the curtain of the dining room archway so that he could manage more easily. A plump, graceful girl with a very pretty face and a tentative, vulnerable smile, which she seemed ready to cancel at once if you weren't going to smile with her. I saw, instantly, that she was any mother-in-law's ideal—quiet, obe-dient, helpful. Her hair was drawn back into the conventional knot at the nape of her neck; she had a *tika* on her forehead, wore no make-up except for the faintest touch of lipstick, and even that, I decided, was probably a new experiment for her, a conces-sion to Anand's Westernized tastes.

She spoke mostly to Anand's mother, in Gujarati, and I noticed that she had already assumed some of the duties of a hostess. She poured the tea and asked, in clear, lilting English, whether I took milk and sugar, handed around the plates of Indian savories and sweets.

After the first mouthful, I remarked formally, "This is delicious."

Anand's mother caught the tone, even if she didn't understand the words, and said something in Gujarati to Anand.

He translated, without much interest, "Janaki made them."

Janaki, in embarrassment, wiped her mouth on her napkin with the thorough gesture that someone unused to wearing lipstick makes, and then gazed in surprise and alarm at the pink smear on the linen. She saw me watching and gave me one of her diffident smiles.

I quickly said the first thing that came into my head, "How clever you are. I wish I could cook."

"It is very easy to learn," she replied.

"There never seems to be any time for it."

Entirely without sarcasm or envy she said, "That is true for someone like you who leads such a busy and interesting life."

I felt ashamed of myself, for no reason I could quite put my finger on.

We continued to talk banalities, and Janaki kept up her end admirably, managing to seem interested in the most ordinary comments and still keeping a watchful eye out to see that cups and plates were filled. The conversation gradually fell entirely to Janaki and me, because Anand retreated into a sulky silence. I remember thinking that one couldn't really blame him. It must have been maddening to have to face this sweet and vapid politeness every day after work. At last he jumped up, said abruptly that he had some papers to go through and left the room. I left soon after.

Janaki saw me to the front door and, with an unexpected spontaneity, put her hand on my arm. "Please come to tea again," she said. "I mean, if you are not too occupied. I should so much like it. I have no friends in Bombay."

"I'd be delighted, and you must come to tea with me."

"Oh, no, thank you very much. Perhaps later on, but I must learn the ways of this house first. You see that, don't you?"

I walked home, wondering at her mixture of nervousness and confidence, at the fact that she already felt certain she had a permanent place in that house.

At our next lunch date, it was Anand who asked the eager questions. "Well? What did you think of her?"

And I replied noncommittally, "She seemed very pleasant."

"Quite the little housewife, do you mean?"

"No. Sweet and anxious to please, I meant."

"You sound like my mother. She says, 'A good-natured girl. You should count yourself fortunate.' I suppose she asked you to be her friend?"

"How did you know?"

"She's not as stupid as she looks. She said the same to me. 'Will you not allow us to be friendly, Anand?'" He attempted a saccharine, unconvincing falsetto. He frowned. "The thin end of the wedge, don't you see? It would be funny if it weren't so sad."

"Well, at least she's very good-looking," I said defensively.

"She's too fat."

"I think it rather suits her."

"A strong point in her favor, my mother says, to make up for my puniness." Anand was sensitive about his height. He said, in a touchy voice, daring one to sympathize with him, "Eugenically very sound. Strong, healthy girl like Janaki married to a weakling like me, and we have a chance of strong, healthy children that take after her. The children, you see, are the whole point of this stratagem. I'm an only son and must produce some. My mother has a rather simple approach to these things."

"You must admit," I said rather uncomfortably, "that she'd make a very good mother."

"Not a doubt in the world. She's a natural for the part of the Great Earth Mother. But I rather resent being viewed in such an agricultural light."

In the weeks that followed, Janaki dominated our conversation at lunchtime, and I had tea with them quite frequently. Sometimes, if Anand was kept late at his office or had to attend a board meeting, Janaki and I would have tea alone, and she would ask hundreds of questions about America, trying, I thought, to build up a picture of Anand's life there and the background that

seemed to influence him so much. She claimed to be uniformly enthusiastic about everything American, and for me it was rather fun, because it made me feel so superior in experience. Once she asked me to teach her to dance, and I was unexpectedly disconcerted. There was something very refreshing about her lack of Westernization, and I didn't want to see her lose it.

"I will if you really want me to, but—"

"Anand likes dancing, doesn't he?"

"Yes, but wouldn't it be better if he taught you himself, after you—I mean, when he—what I mean is, a little later on?"

"You think that would be best?" She meant, of course, the best way of handling Anand.

"Yes, I do," I said, meaning, "You don't want to seem too eager."

"Very well." She nodded, accepting my opinion as final. On this level of unspoken frankness we understood each other perfectly.

She would question me, sometimes openly and sometimes indirectly, about Anand's tastes and preferences. We had a long session, I remember, about her looks. Should she wear make-up? Should she cut her hair? What about her clothes? I told her she was fine the way she was, but she insisted, "Has he *never* said anything? He must have made *some* remark?"

"Well," I said reluctantly, "he did once mention that he thought you were just a fraction on the chubby side."

Without a trace of rancor, Janaki said, "I will quickly become thin."

"Heavens! Don't take the remark so seriously."

"It is nothing," Janaki assured me. "One need only avoid rice and *ghi.*" She did, too. I noticed the difference in a couple of weeks.

When Anand was there, the atmosphere was much more strained. From the frigid politeness of his early days with Janaki, his manner gradually changed to irritation, which expressed itself in angry silence and later in a kind of undercover teasing sometimes laced with malice. For instance, he would greet her with something like, "What have you been up to today? Hemstitching the sheets? Crocheting for the hope chest?" and Janaki would look puzzled and smile, as though she had missed

264

the point of a clever joke. Actually, she was a beautiful nee-
dlewoman and did a good deal of exquisitely neat embroidery on
all kinds of things—antimacassars, doilies, face towels—infal-
libly choosing hideous designs of women, in enormous crino-
lines, watering the flowers in an English garden, or bunches of
roses with ribbons streaming from them. Once Janaki answered
Anand's inquiry quite seriously with an account of her day, the
household jobs she had done, the women who had called on his
mother in the morning and had been served coffee, and even
produced the embroidery she had been working on.

"Wonderfully appropriate for India, don't you think?"
Anand remarked to me with rather labored irony.

"I think it's lovely," I said unconvincingly.

Janaki seemed unruffled. "Men do not appreciate embroi-
dery," she said quietly.

Anand leaned back in his chair, stared at the ceiling, and
gave an exaggerated sigh.

One couldn't help disliking him in this role of tormentor.
The fact was, of course, that, in Anand's phrase, *I* was getting im-
perceptibly fonder of Janaki as his impatience with her grew
more overt. There was, to me, both gallantry and an appealing
innocence in her undaunted conviction that everything would
turn out all right. What I didn't recognize was the solid realism
behind her attitude. I started to suspect the calculation in her
nature one day when Anand had been particularly difficult. He
had insisted on talking about books she hadn't read and, with
apparent courtesy, addressing remarks to her he knew she
couldn't answer.

Janaki said nothing for a long time and then admitted, with
a becoming lack of pretension, "I'm afraid I read only the stories
in the *Illustrated Weekly*. But, Anand, if you would bring me
some books you think good, I would read them."

"I'll see if I can find the time," he replied in a surly voice.

When Janaki showed me to the door that evening, I said in
considerable exasperation, "Why do you put up with it? He
needn't be so disagreeable when he talks to you."

"It is natural that there should be difficulties at first. After
his life in America, there are bound to be resentments here."

"Well, I think you are altogether too forbearing. I wouldn't

stand it for a second." Privately, I had begun to think she must, after all, be stupid.

Then Janaki said, "What would you do?"

"Leave, of course. Go back." And at that moment I realized what she meant. Go back to what? To another betrothal arranged by her elders? Learning to please some other man? Here, at least, she liked her future mother-in-law.

"And besides," she said, "I know that really he is kind."

In the end, Janaki turned out to be the wisest of us all, and I have often thought how lucky it was that she didn't follow my advice then. Not that Anand capitulated all at once, or that one extraordinary morning he suddenly saw her with new eyes, or anything like that. He remained irritable and carping; but gradually he became enmeshed in that most satisfactory of roles, a reluctant Pygmalion.

I noticed it first one day when he finished his lunch rather hurriedly and said, as we were going back to our offices, "That girl's conversation is driving me nuts. I think I really had better buy her some books. As long as I'm stuck with her company," he added awkwardly.

We parted at the bookshop, and in later conversations I learned that Janaki was doing her homework with diligence and pleasure.

From then on things moved fairly rapidly. I began to anticipate Anand's frequent suggestions that we spend part of the lunch hour shopping—usually rather ungraciously expressed: "We've got to get that girl into some less provincial-looking saris." "That girl listens to nothing but film music. I really must get her some decent classical stuff. What do you suggest as a beginning? Kesarbai? Subbaluxmi?"

"No Western music?" I asked pointedly.

"She wouldn't understand it," Anand replied.

All the same, at home he continued to be offhand or overbearing with her. She remained calm and accepting, a willing pupil who knew that her stupidity was a great trial to her teacher. Still, there wasn't a doubt in my mind about the change of attitude going on in Anand. I wanted a lived-happily-ever-after conclusion for Janaki; but mostly I was certain that the Pygmalion story could have only one ending, whatever the minor variations might be.

Anand's parents were evidently equally confident of the outcome, for one day at tea he announced, with an exuberance no amount of careful casualness could disguise, that his father was going to send him to New York on a business trip. He was pleased, he insisted, largely because it meant that at last he was to be trusted with some real responsibility.

I said, "And it will be such wonderful fun to be back in America."

"Oh, yes. That, too, naturally. But I don't know how much time I'll have for the bright lights and parties." He had moved so smoothly into the correct businessman's viewpoint that I wanted to laugh.

We were absorbed in discussing the details of the trip, and besides, by then Janaki had become such an accepted—and pleasing—part of the scenery of the house that we assumed she was listening with her usual attention and, as always, trying to fit in with Anand's mood.

So it came as quite a shock when she suddenly spoke in a flat, decisive voice. "I, too, am leaving. I am going back to my home." Dead silence for a moment. "Tomorrow," she said.

"But *why*—" I began.

"It is my decision," she said, and wouldn't look at either of us.

Anand didn't say anything, just stood up, all his bright, important planning gone, and walked out of the room. We waited to hear his study door slam.

Then my affection for Janaki (and, of course, curiosity) made me ask, "But why *now*, just when things are going so well?"

"It was your advice, don't you remember?"

"But things were different then."

"Yes." She nodded as though we both recognized some particular truth.

At the time I thought she believed herself defeated. I was surprised and concerned that what seemed so plain to me should remain obscure to her. "Listen," I said cautiously, "don't you see that he—that in spite of everything, he has fallen in love with you?"

I don't know quite what I had expected her response to be—a radiant smile, perhaps, or even a sense of triumph. I

hadn't expected her to glare at me as though I were an enemy and say, "Oh, love. I don't want him to *love* me. I want him to marry me."

"It's different for him," I said, as persuasively as I could. "For him it is important."

She looked at me shrewdly, making up her mind about something. "You are sure?" she asked.

"Absolutely sure."

Her voice was hard and impatient. "Love, what books you read, whether you like music, your 'taste'—whatever that may mean. As if all that has anything to do with marriage."

"Well," I said ineffectually.

How can one make the idea of romantic love attractive to someone who wants only a home, a husband, and children? Even if nothing could be done about that, I thought I knew the reason for her sudden despair. The renewing of Anand's American experiences must have seemed to her an overwhelming menace. I tried to reassure her, reminded her that Anand would be gone only a matter of weeks, that he would miss her, that America would look quite different to him now, that he had changed a lot in the past year—more than a year, actually.

But she wouldn't listen, and she kept repeating, "I must pack my things and leave the house tomorrow."

I thought, Poor Janaki. I can see that the tedious business of starting all over again on the unraveling of Anand's England-returned tangles might well seem to be too much to face. It didn't occur to me that I might equally have thought, Clever Janaki, the only one of us who knows exactly what she wants. Leave the house? She would have slit her throat first.

When I think of it, I can't help wondering at the extent of my naïveté then. The fact is that women—or perhaps I mean just the women of a certain kind of world, Janaki's world—have inherited, through bitter centuries, a ruthless sense of self-preservation. It still seems to me ghastly that they should need it; but it would be silly to deny that, in most places on earth, they still do. That cool, subtle determination to find her security and hang on to it, that all's-fair attitude—not in love, which she discounted, but in war, for it *was* war, the gaining or losing of a kingdom—was really no more than the world deserved from

Janaki. As in war, victory, conquest, success, call it what you will, was the only virtue. And, of course, the really absurd thing was that nobody would have been more appalled than Janaki if you had called her a feminist.

As it was, I heard with anxiety Anand on the phone the next day, saying, "Let's lunch. I want to talk to you. Joe's Place? One o'clock?"

I was certain that Janaki had gone home, with only the indignities of a few new clothes and a lot of tiresome talk to remember.

As soon as I saw him, I knew I was wrong. He had the conventionally sheepish look that makes the announcing of good news quite pointless. He said, "An eventful evening, wasn't it?"

"Yes, it was, rather."

Then there was a long pause while he looked embarrassed and I could think of no way to help him out. At last he said, all in a rush, "Look, this is going to seem ridiculous. I mean—well, Janaki and I are going to be married."

"You couldn't do a more sensible thing," I said, much relieved.

He looked startled. "Sensible? Perhaps it seems that way to you. Actually, we're in love with each other."

"With *each other?*" I echoed incredulously, and regretted it immediately.

"I knew it would seem peculiar to you. I daresay you've thought I hated her all this time." He smiled at me in a rather superior way. "I thought so myself for a while. And Janaki, as you well imagine, had every reason to think so. And I must say it certainly took a lot of courage on her part. I mean, when you think—"

"You'd better start at the beginning," I said, suddenly feeling depressed.

"Okay. I heard you leave yesterday, and then I heard Janaki come into the hall—you know that timid way she has of walking—and stand outside my study door. I was in quite a state; but I daresay that I wouldn't have done anything about anything if she hadn't—I mean, if someone hadn't taken the initiative."

"Yes," I said, knowing what was coming but unable to

shake off my gloom. "She came to explain why she was going home."

"She said—you see, she isn't the passive, orthodox girl you think—she told me that quite against her plans or anything she'd expected, she'd—I know this will seem silly—but she'd fallen in love with me."

"I see. And that accounted for her behavior. Trying all the time to please you, I mean."

"Well, yes. Then I realized that—"

"All your resentment and bad manners were just that—" I wanted to hurry him through the story.

"Well, yes."

"Well, yes," I repeated, and couldn't look at him. We were silent for a while. "Well, congratulations," I said uneasily.

"It's funny, isn't it," he said in a confident voice, "that Their plans should have worked out—but so differently. I don't suppose They'll ever understand."

"It wouldn't be worth trying to explain."

"Heavens, no. Look, I'm taking Janaki out to lunch tomorrow. Will you join us?"

"Oh, no, surely—"

"She asked particularly that you come. She likes you very much, you know, and besides, she doesn't feel quite comfortable going out without a chaperon."

"In *that* case—" I said, with a nastiness lost on Anand. And all the time I was thinking, Have we all been made use of? A sympathetic mother-in-law, a man you can flatter, a gullible friend from whom you can learn background and fighting conditions, with whom you can check tactics and their effects. Now that she has won, she must have nothing but contempt for all of us. But simultaneously I was wondering, Is she, after all, really in love? It was a state she didn't know how to cope with, and she could hope only to use the weapon she knew, an ability to please or try to please. Why should she, or how could she, tell me all that herself—a realm of which she was so unsure, which was so far out of her experience?

Now that I have met so many Janakis of the world, I think I know which explanation was right.

"So we'll meet," Anand was saying, "at the Taj, if that's all right with you?"

He had reserved a table by the windows. Janaki was a bit late, to be sure—she explained breathlessly—that we would be there before her, because it would have been agony to sit alone.

We ordered from the Indian menu, and Anand said, with only a fleeting, questioning glance at me, "No wine, I think. There really isn't any wine at all that goes with Indian food, is there?"

FOR DISCUSSION

1. Why do the narrator's education and background make her an especially good person to tell this story?
2. Why do you think Anand chooses to marry Janaki? Has Janaki planned this? How and why?
3. Why is the story titled "Who Cares?"
4. Do you find any similarities between the marriage in the story and other marriages you know of?

INTRODUCTION

In the following story, Ma fits the typical female stereotype of the submissive wife, totally dependent on a dominant husband and living only for him. All the reward she desires is a kind word from him. But Ma is supremely content. She has performed well the only role her culture and background have prepared her for and is totally oblivious to the confining or demeaning aspects of her role.

A Basket of Apples

Shirley Faessler

This morning Pa had his operation. He said I was not to come for at least two or three days, but I slipped in anyway and took a look at him. He was asleep, and I was there only a minute before I was hustled out by a nurse.

"He looks terrible, nurse. Is he all right?"

She said he was fine. The operation was successful, there were no secondaries, instead of a bowel he would have a colostomy, and with care should last another——

Colostomy. The word had set up such a drumming in my ears that I can't be sure now whether she said another few years or another five years. Let's say she said five years. If I go home and report this to Ma she'll fall down in a dead faint. She doesn't even know he's had an operation. She thinks he's in the hospital for a rest, a checkup. Nor did we know—my brother, my sister, and I—that he'd been having a series of X rays.

"It looks like an obstruction in the lower bowel," he told us privately, "and I'll have to go in the hospital for a few days to find out what it's all about. Don't say anything to Ma."

"I have to go in the hospital," he announced to Ma the morning he was going in.

She screamed.

272

"Just for a little rest, a checkup," he went on, patient with her for once.

He's always hollering at her. He scolds her for a meal that isn't to his taste, finds fault with her housekeeping, yells at her because her hair isn't combed in the morning and sends her back to the bedroom to tidy herself.

But Ma loves the old man. "Sooner a harsh word from Pa than a kind one from anyone else," she says.

"You're not to come and see me, you hear?" he cautioned her the morning he left for the hospital. "I'll phone you when I'm coming out."

I don't want to make out that my pa's a beast. He's not. True, he never speaks an endearing word to her, never praises her. He loses patience with her, flies off the handle and shouts. But Ma's content. "Poor man works like a horse," she says, "and what pleasures does he have. So he hollers at me once in a while, I don't mind. God give him the strength to keep hollering at me, I won't repine."

Night after night he joins his buddies in the back room of an ice-cream parlor on Augusta Avenue for a glass of wine, a game of klaberjass, pinochle, dominoes: she's happy he's enjoying himself. She blesses him on his way out. "God keep you in good health and return you in good health."

But when he is home of an evening reading the newspaper and comes across an item that engages his interest, he lets her in on it too. He shows her a picture of the Dionne quintuplets and explains exactly what happened out there in Callander, Ontario. This is a golden moment for her—she and Pa sitting over a newspaper discussing world events. Another time he shows her a picture of the Irish Sweepstakes winner. He won 150,000, he tells her. She's entranced. *Mmm-mm-mm!* What she couldn't do with that money. They'd fix up the bathroom, paint the kitchen, clean out the backyard. *Mmm-mm-mm!* Pa says if we had that kind of money we could afford to put a match to a hundred-dollar bill, set fire to the house, and buy a new one. She laughs at his wit. He's so clever, Pa. Christmas morning King George VI is speaking on the radio. She's rattling around in the kitchen, Pa calls her to come and hear the King of England. She doesn't understand a word of English, but pulls up a chair

and sits listening. "He stutters," says Pa. This she won't believe. A king? Stutters? But if Pa says so, it must be true. She bends an ear to the radio. Next day she has something to report to Mrs. Oxenberg, our next-door neighbor.

I speak of Pa's impatience with her; I get impatient with her too. I'm always at her about one thing and another, chiefly about the weight she's putting on. Why doesn't she cut down on the bread, does she have to drink twenty glasses of tea a day? No wonder her feet are sore, carrying all that weight. (My ma's a short woman a little over five feet and weighs almost two hundred pounds.) "Go ahead, keep getting fatter," I tell her. "The way you're going you'll never be able to get into a decent dress again."

But it's Pa who finds a dress to fit her, a Martha Washington Cotton, size fifty-two, which, but for the length, is perfect for her. He finds a shoe she can wear, Romeo Slippers with elasticized sides. And it's Pa who gets her to soak her feet, then sits with them in his lap scraping away with a razor blade at the calluses and corns.

Ma is my father's second wife, and our stepmother. My father, now sixty-three, was widowed thirty years ago. My sister was six at the time, I was five, and my brother four when our mother died giving birth to a fourth child who lived only a few days. We were shunted around from one family to another who took us in out of compassion, till finally my father went to a marriage broker and put his case before him. He wanted a woman to make a home for his three orphans. An honest woman with a good heart; these were the two and only requirements. The marriage broker consulted his lists and said he thought he had two or three people who might fill the bill. Specifically, he had in mind a young woman from Russia, thirty years old, who was working without pay for relatives who had brought her over. She wasn't exactly an educated woman; in fact, she couldn't even read or write. As for honesty and heart, this he could vouch for. She was an orphan herself and as a child had been brought up in servitude.

Of the three women the marriage broker trotted out for him, my father chose Ma, and shortly afterward they were married.

A colostomy. So it is cancer . . .

As of the second day Pa was in hospital I had taken to dropping in on him on my way home from work. "Nothing yet," he kept saying, "maybe tomorrow they'll find out."

After each of these visits, four in all, I reported to Ma that I had seen Pa. "He looks fine. Best thing in the world for him, a rest in the hospital."

"Pa's not lonesome for me?" she asked me once, and laughing, turned her head aside to hide her foolishness from me.

Yesterday Pa said to me, "It looks a little more serious than I thought. I have to have an operation tomorrow. Don't say anything to Ma. And don't come here for at least two or three days."

I take my time getting home. I'm not too anxious to face Ma—grinning like a monkey and lying to her the way I have been doing the last four days. I step into a hospital telephone booth to call my married sister. She moans. "What are you going to say to Ma?" she asks.

I get home about half-past six, and Ma's in the kitchen making a special treat for supper. A recipe given her by a neighbor and which she's recently put in her culinary inventory—pieces of cauliflower dipped in batter and fried in butter.

"I'm not hungry, Ma. I had something in the hospital cafeteria." (We speak in Yiddish; as I mentioned before, Ma can't speak English.)

She continues scraping away at the cauliflower stuck to the bottom of the pan. (Anything she puts in a pan sticks.) "You saw Pa?" she asks without looking up. Suddenly she thrusts the pan aside. "The devil take it, I put in too much flour." She makes a pot of tea, and we sit at the kitchen table drinking it. To keep from facing her I drink mine leafing through a magazine. I can hear her sipping hers through a cube of sugar in her mouth. I can feel her eyes on me. Why doesn't she ask me, "How's Pa?" Why doesn't she speak? She never stops questioning me when I come from hospital, drives me crazy with the same questions again and again. I keep turning pages, she's still sucking away at that cube of sugar—a maddening habit of hers. I look up. Of course her eyes are fixed on me, probing, searching.

I lash out at her. "Why are you looking at me like that!"

Without answer she takes her tea and dashes it in the sink. She spits the cube of sugar from her mouth. (Thank God for that; she generally puts it back in the sugar bowl.) She resumes her place, puts her hands in her lap, and starts twirling her thumbs. No one in the world can twirl his thumbs as fast as Ma. When she gets them going they look like miniature windmills whirring around.

"She asks me why I'm looking at her like that," she says, addressing herself to the twirling thumbs in her lap. "I'm looking at her like that because I'm trying to read the expression in her face. She tells me Pa's fine, but my heart tells me different."

Suddenly she looks up, and thrusting her head forward, splays her hands out flat on the table. She has a dark-complexioned strong face, masculine almost, and eyes so black the pupil is indistinguishable from the iris.

"Do you know who Pa is!" she says. "Do you know who's lying in the hospital? I'll tell you who. The captain of our ship is lying in the hospital. The emperor of our domain. If the captain goes down, the ship goes with him. If the emperor leaves his throne, we can say good-by to our domain. That's who's lying in the hospital. Now ask me why do I look at you like that."

She breaks my heart. I want to put my arms around her, but I can't do it. We're not a demonstrative family, we never kiss, we seldom show affection. We're always hollering at each other. Less than a month ago, I hollered at Pa. He had taken to dosing himself. He was forever mixing something in a glass, and I became irritated at the powders, pills, and potions lying around in every corner of the house like mouse droppings.

"You're getting to be a hypochondriac!" I hollered at him, not knowing what trouble he was in.

I reach out and put my hand over hers. "I wouldn't lie to you, Ma. Pa's fine, honest to God."

She holds her hand still a few seconds, then eases it from under and puts it over mine. I can feel the weight of her hand pinioning mine to the table, and in an unaccustomed gesture of tenderness we sit a moment with locked hands.

"You know I had a dream about Pa last night?" she says. "I

dreamt he came home with a basket of apples. I think that's a good dream?"

Ma's immigration to Canada had been sponsored by her Uncle Yankev. Yankev, at the time he sent for his niece, was in his mid forties and had been settled a number of years in Toronto with his wife, Danyeh, and their six children. They made an odd pair, Yankev and Danyeh. He was a tall, two-hundred-fifty-pound handsome man, and Danyeh, whom he detested, was a lackluster little woman with a pock-marked face, maybe weighing ninety pounds. Yankev was constantly abusing her. "Old Devil," he called her, to her face and in the presence of company.

Ma stayed three years with Yankev and his family, working like a skivvy for them and without pay. Why would Yankev pay his niece like a common servant? She was one of the family, she sat at table with them and ate as much as she wanted. She had a bed and even a room to herself, which she'd never had before. When Yankev took his family for a ride in the car to Sunnyside, she was included. When he bought ice-cream cones, he bought for all.

She came to Pa without a dime in her pocket.

Ma has a slew of relatives, most of them émigrés from a remote little village somewhere in the depths of Russia. They're a crude lot, loudmouthed and coarse, and my father (but for a few exceptions) had no use for any of them. The "Russian hordes," he called them. He was never rude; anytime they came around to visit he simply made himself scarce.

One night I remember in particular; I must have been about seven. Ma was washing up after supper and Pa was reading a newspaper when Yankev arrived, with Danyeh trailing him. Pa folded his paper, excused himself, and was gone. The minute Pa was gone, Yankev went to the stove and lifted the lids from the two pots. Just as he thought—*mamaliga* in one pot, in the other one beans, and in the frying pan a piece of meat their cat would turn its nose up at. He sat himself in the rocking chair he had given Ma as a wedding present, and rocking, proceeded to lecture her. He had warned her against the marriage, but if she was satisfied, he was content. One question and that's all. How

had she bettered her lot? True, she was no longer an old maid. True, she was now mistress of her own home. He looked around him and snorted. A hovel. "*And* three snot-nose kids," he said, pointing to us.

Danyeh, hunched over in a kitchen chair, her feet barely reaching the floor, said something to him in Russian, cautioning him, I think. He told her to shut up, and in Yiddish continued his tirade against Ma. He had one word to say to her. To *watch* herself. Against his advice she had married this no-good Romanian twister, this murderer. The story of how he had kept his first wife pregnant all the time was now well known. Also well known was the story of how she had died in her ninth month with a fourth child. Over an ironing board. Ironing his shirts while he was out playing cards with his Romanian cronies and drinking wine. He had buried one wife, and now was after burying a second. So Ma had better *watch* herself, that's all.

Ma left her dishwashing and with dripping wet hands took hold of a chair and seated herself facing Yankev. She begged him not to say another word. "Not another word, Uncle Yankev, I beg you. Till the day I die I'll be grateful to you for bringing me over. I don't know how much money you laid out for my passage, but I tried my best to make up for it the three years I stayed with you, by helping out in the house. But maybe I'm still in your debt? Is this what gives you the right to talk against my husband?"

Yankev, rocking, turned up his eyes and groaned. "*You* speak to her," he said to Danyeh. "It's impossible for a *human being* to get through to her."

Danyeh knew better than to open her mouth.

"Uncle Yankev," Ma continued, "every word you speak against my husband is like a knife stab in my heart." She leaned forward, thumbs whirring away. "*Mamaliga?* Beans? A piece of meat your cat wouldn't eat? A crust of *bread* at his board, and I will still thank God every day of my life that he chose me from the other two the *shadchan* showed him."

In the beginning my father gave her a hard time. I remember his bursts of temper at her rough ways in the kitchen. She never opened a kitchen drawer without wrestling it—

wrenching it open, slamming it shut. She never put a kettle on the stove without its running over at the boil. A pot never came to stove without its lid being inverted, and this for some reason maddened him. He'd right the lid, sometimes scalding his fingers—and all hell would break loose. We never sat down to a set or laid table. As she had been used to doing, so she continued; slamming a pot down on the table, scattering a handful of cutlery, dealing out assorted-size plates. More than once, with one swipe of his hand, my father would send a few plates crashing to the floor and stalk out. She'd sit a minute looking in our faces, one by one, then start twirling her thumbs and talking to herself. What had she done now?

"Eat!" she'd admonish us, and leaving table would go to the mirror over the kitchen sink and ask herself face to face, "What did I do now?" She would examine her face, profile and front, and then sit down to eat. After, she'd gather up the dishes, dump them in the sink, and running the water over them, would study herself in the mirror. "He'll be better," she'd tell herself, smiling. "He'll be soft as butter when he comes home. You'll see," she'd promise her image in the mirror.

Later in life, mellowed by the years perhaps (or just plain defeated—there was no changing her), he became more tolerant of her ways and was kinder to her. When it became difficult for her to get around because of her poor feet, he did her marketing. He attended to her feet, bought her the Martha Washingtons, the Romeo Slippers, and on a summer's evening on his way home from work, a brick of ice cream. She was very fond of it.

Three years ago he began promoting a plan, a plan to give Ma some pleasure. (This was during Exhibition time.) "You know," he said to me, "it would be very nice if Ma could see the fireworks at the Exhibition. She's never seen anything like that in her life. Why don't you take her?"

The idea of Ma going to the Ex for the fireworks was so preposterous, it made me laugh. She never went anywhere.

"Don't laugh," he said. "It wouldn't hurt you to give her a little pleasure once in a while."

He was quite keen that she should go, and the following year he canvassed the idea again. He put money on the table for taxi and grandstand seats. "Take her," he said.

"Why don't you take her?" I said. "She'll enjoy it more going with you."

"Me? What will I do at the Exhibition?"

As children, we were terrified of Pa's temper. Once in a while he'd belt us around, and we were scared that he might take the strap to Ma too. But before long we came to know that she was the only one of us not scared of Pa when he got mad. Not even from the beginning when he used to let fly at her was she intimidated by him, not in the least, and in later years was even capable of getting her own back by taking a little dig at him now and then about the "aristocracy"—as she called my father's Romanian connections.

Aside from his buddies in the back room of the ice-cream parlor on Augusta Avenue, my father also kept in touch with his Romanian compatriots (all of whom had prospered), and would once in a while go to them for an evening. We were never invited, nor did they come to us. This may have been my father's doing, I don't know. I expect he was ashamed of his circumstances, possibly of Ma, and certainly of how we lived.

Once in a blue moon, during Rosh Hashana or Yom Kippur after *shul,* they would unexpectedly drop in on us. One time a group of four came to the house, and I remember Pa darting around like a gadfly, collecting glasses, wiping them, and pouring a glass of wine he'd made himself. Ma shook hands all around, then went to the kitchen to cut some slices of her honey cake, scraping off the burnt part. I was summoned to take the plate in to "Pa's gentle folk." Pretending to be busy, she rattled around the kitchen a few seconds, then seated herself in the partially open door, inspecting them. Not till they were leaving did she come out again, to wish them a good year.

The minute they were gone, my father turned on her. "Russian peasant! Tartar savage, you! Sitting there with your eyes popping out. Do you think they couldn't see you?"

"What's the matter? Even a cat may look at a king?" she said blandly.

"Why didn't you come out instead of sitting there like a caged animal?"

"Because I didn't want to shame you," she said, twirling her thumbs and swaying back and forth in the chair Yankev had given her as a wedding present.

My father busied himself clearing table, and after a while he softened. But she wasn't through yet. "Which one was Falik's wife?" she asked in seeming innocence. "The one with the beard?"

This drew his fire again. "No!" he shouted.

"Oh, the other one. The pale one with the hump on her back," she said wickedly.

So . . . notwithstanding the good dream Ma had of Pa coming home with a basket of apples, she never saw him again. He died six days after the operation.

It was a harrowing six days, dreadful. As Pa got weaker, the more disputatious we became—my brother, my sister, and I—arguing and snapping at each other outside his door, the point of contention being, should Ma be told or not.

Nurse Brown, the special we'd put on duty, came out once to hush us. "You're not helping him by arguing like this. He can hear you."

"Is he conscious, nurse?"

"Of course he's conscious."

"Is there any hope?"

"There's always hope," she said. "I've been on cases like this before, and I've seen them rally."

We went our separate ways, clinging to the thread of hope she'd given us. The fifth day after the operation I had a call from Nurse Brown: "Your father wants to see you."

Nurse Brown left the room when I arrived, and my father motioned me to undo the zipper of his oxygen tent. "Ma's a good woman," he said, his voice so weak I had to lean close to hear him. "You'll look after her? Don't put her aside. Don't forget about her——"

"What are you talking about!" I said shrilly, then lowered my voice to a whisper. "The doctor told me you're getting better. Honest to God, Pa, I wouldn't lie to you," I whispered.

He went on as if I hadn't spoken. "Even a servant, if you had her for thirty years, you wouldn't put aside because you don't need her anymore——"

"Wait a minute," I said, and went to the corridor to fetch Nurse Brown. "Nurse Brown, will you tell my father what you told me yesterday. You remember? About being on cases like

this before, and you've seen them rally. Will you tell that to my father, please. He talks as if he's——"

I ran from the room and stood outside the door, bawling. Nurse Brown opened the door a crack. "Ssh! You'd better go now; I'll call you if there's any change."

At five the next morning, my brother telephoned from hospital. Ma was sound asleep and didn't hear. "You'd better get down here," he said. "I think the old man's checking out. I've already phoned Gertie."

My sister and I arrived at the hospital within seconds of each other. My brother was just emerging from Pa's room. In the gesture of a baseball umpire he jerked a thumb over his shoulder, signifying "out."

"Is he dead?" we asked our brother.

"Just this minute," he replied.

Like three dummies we paced the dimly lit corridor, not speaking to each other. In the end we were obliged to speak; we had to come to a decision about how to proceed next.

We taxied to the synagogue of which Pa was a member, and roused the shamus. "As soon as it's light I'll get the rabbi," he said. "He'll attend to everything. Meantime go home."

In silence we walked slowly home. Dawn was just breaking, and Ma, a habitually early riser, was bound to be up now and in the kitchen. Quietly we let ourselves in and passed through the hall leading to the kitchen. We were granted an unexpected respite; Ma was not yet up. We waited ten minutes for her, fifteen—an agonizing wait. We decided one of us had better go and wake her; what was the sense in prolonging it? The next minute we changed our minds. To awaken her with such tidings would be inhuman, a brutal thing to do.

"Let's stop whispering," my sister whispered. "Let's talk in normal tones, do something, make a noise: she'll hear us and come out."

In an access of activity we busied ourselves. My sister put the kettle on with a clatter; I took teaspoons from the drawer, clacking them like castanets. She was bound to hear, their bedroom was on the same floor at the front of the house—but five minutes elapsed and not a sound from the room.

"Go and see," my sister said, and I went and opened the door to that untidy bedroom Pa used to rail against.

Ma, her black eyes circled and her hair in disarray, was sitting up in bed. At sight of me she flopped back and pulled the feather tick over her head. I approached the bed and took the covers from her face. "Ma——"

She sat up. "You are guests in my house now?"

For the moment I didn't understand. I didn't know the meaning of her words. But the next minute the meaning of them was clear—with Pa dead, the link was broken. The bond, the tie that held us together. We were no longer her children. We were now guests in her house.

"When did Pa die?" she asked.

"How did you know?"

"My heart told me."

Barefooted, she followed me to the kitchen. My sister gave her a glass of tea, and we stood like mutes, watching her sipping it through a cube of sugar.

"You were all there when Pa died?"

"Just me, Ma," my brother said.

She nodded. "His kaddish. Good."

I took a chair beside her, and for once without constraint or self-consciousness, put my arm around her and kissed her on the cheek.

"Ma, the last words Pa spoke were about you. He said you were a good woman. 'Ma's a good woman,' that's what he said to me."

She put her tea down and looked me in the face. "Pa said that? He said I was a good woman?" She clasped her hands. "May the light shine on him in paradise," she said, and wept silently, putting her head down to hide her tears.

Eight o'clock the rabbi telephoned. Pa was now at the funeral parlor on College near Augusta, and the funeral was to be at eleven o'clock. Ma went to ready herself, and in a few minutes called me to come and zip up her black crepe, the dress Pa had bought her six years ago for the Applebaum wedding.

The Applebaums, neighbors, had invited Ma and Pa to the wedding of their daughter, Lily. Right away Pa had declared he wouldn't go. Ma kept coaxing. How would it look? It would be construed as unfriendly, unneighborly. A few days before the wedding he gave in, and Ma began scratching through her ward-

robe for something suitable to wear. Nothing she exhibited pleased him. He went downtown and came back with the black crepe and an outsize corset.

I dressed her for the wedding, combed her hair, and put some powder on her face. Pa became impatient; he had already called a cab. What was I doing? Getting her ready for a beauty contest? The taxi came, and as Pa held her coat he said to me in English, "You know, Ma's not a bad-looking woman?"

For weeks she talked about the good time she'd had at the Applebaum wedding, but chiefly about how Pa had attended her. Not for a minute had he left her side. Two hundred people at the wedding and not one woman among them had the attention from her husband that she had had from Pa. "Pa's a gentleman," she said to me, proud as proud.

Word of Pa's death got around quickly, and by nine in the morning people began trickling in. First arrivals were Yankev and Danyeh. Yankev, now in his seventies and white-haired, was still straight and handsome. The same Yankev except for the white hair and an asthmatic condition causing him to wheeze and gasp for breath. Danyeh was wizened and bent over, her hands hanging almost to her knees. They approached Ma, Danyeh trailing Yankev. Yankev held out a hand and with the other one thumped his chest, signifying he was too congested to speak. Danyeh gave her bony hand to Ma and muttered a condolence.

From then on there was a steady influx of people. Here was Chaim the schnorrer! We hadn't seen him in years. Chaim the schnorrer, stinking of fish, and in leg wrappings as always, instead of socks. Rich as Croesus he was said to be, a fish-peddling miser who lived on soda crackers and milk and kept his money in his leg wrappings. Yankev, a minute ago too congested for speech, found words for Chaim. "How much money have you got in those *gutkess?* The truth, Chaim!"

Ma shook hands with all, acknowledged their sympathy, and to some she spoke a few words. I observed the Widow Spector, a gossip and troublemaker, sidling through the crowd and easing her way toward Ma. "The Post" she was called by people on the street. No one had the time of day for her; even Ma used to hide from her.

I groaned at the sight of her. As if Ma didn't have enough to contend with. But no! here was Ma welcoming the Widow Spector, holding a hand out to her. "Give me your hand, Mrs. Spector. Shake hands, we're partners now. Now I know the taste, I'm a widow, too." Ma patted the chair beside her. "Sit down, partner. Sit down."

At a quarter to eleven the house was clear of people. "Is it time?" Ma asked, and we answered, "Yes, it was time to go." We were afraid this would be the breaking point for her, but she went calmly to the bedroom and took her coat from the peg on the door and came to the kitchen with it, requesting that it be brushed off.

The small funeral parlor was jammed to the doors, every seat taken but for four up front, left vacant for us. On a trestle table directly in front of our seating was the coffin. A pine box draped in a black cloth, and in its center a white Star of David.

Ma left her place, approached the coffin, and as she stood before it with clasped hands, I noticed the uneven hemline of her coat, hiked up in back by that mound of flesh on her shoulders. I observed that her lisle stockings were twisted at the ankles, and was embarrassed for her.

She stood silently a moment, then began to speak. She called him her dove, her comrade, her friend.

"Life is a dream," she said. "You were my treasure. You were the light of my eyes. I thought to live my days out with you—and look what it has come to." (She swayed slightly, the black shawl slipping from her head—and I observed that could have done with a brushing too.) "If ever I offended you, or caused you even a twinge of discomfort, forgive me for it. As your wife I lived like a queen. Look at me now. I'm nothing. You were my jewel, my crown. With you at its head my house was a palace. I return now to a hovel. Forgive me for everything, my dove. Forgive me."

("Russian peasant," Pa used to say to her in anger, "Tartar savage." If he could see her now as she stood before his bier mourning him. Mourning him like Hecuba mourning Priam and the fall of Troy. And I a minute ago was ashamed of her hiked-up coat, her twisted stockings, and dusty shawl.)

People were weeping; Ma resumed her place dry-eyed, and the rabbi began the service.

It is now a year since Pa died, and as he had enjoined me to do, I am looking after Ma. I have not put her aside. I get cross and holler at her as I always have done, but she allows for my testiness and does not hold it against me. I'm a spinster, an old maid now approaching my thirty-seventh year, and she pities me for it. I get bored telling her again and again that Pa's last words were "Ma's a good woman," and sometimes wish I'd never mentioned it. She cries a lot, and I get impatient with her tears. But I'm good to her.

This afternoon I called Moodey's, booked two seats for the grandstand, and tonight I'm taking her to the Ex and she'll see the fireworks.

FOR DISCUSSION

1. People gain their sense of identity from two general sources. One is the groups or categories which society assigns them to. The other source is the individual's unique traits, habits, and abilities. What are the groups or categories which Ma takes her identity from? How important are her unique characteristics in determining the way she sees herself and the way others see her?
2. What positive things do you see happening in Ma's life because she fits roles that we usually think of as stereotypes?
3. Do you think that stereotypes can play a positive role in people's lives? What, if any, limits would you want to place on your own adoption of such stereotypes?

INTRODUCTION

An especially appealing stereotype of women is that of "Mother." The Mother role defines a woman by her ability to give birth to and rear children. Because women know that their creative and nurturing functions are important, indeed vital, to humanity's survival, they may find the Mother role very attractive. Thus, there is a danger that they may try to define their whole being in terms only of this role, submerging other aspects of themselves in the process.

In the following poem the woman is a symbol of the Mother role. Through the use of garden imagery, the poet further suggests that the woman is an "Earth Mother," a role that carries the Mother stereotype to an extreme. The Earth Mother exists solely and exclusively to give birth and to bring up children. In this poem, her fertility is compared to that of a garden. Her love is compared to the power of creativity, "the strength of shoots breaking ground."

Eyes of the Garden

For Alice Chester

Laura Chester

We have come home here
to be revived by the balm of greenwood and grasses
and the gathering hours in the garden
where feet sink into black earth
and tomatoes are picked sun warmed and in the mouth 5
still warm where zucchini hair prickles when snapped
from the vine and the swelling bust of summer squash
are arranged in a basket with zinnias.

We come back to this wicker basket to be born again
from the warm potted smell of the green house 10

into the pace of farmers.
Our days spread out like fields to be grazed
slowly in this August heat.
And yet we are still waiting.
Expectation is a thin honey on our skin. 15
It's something like the storm's approach
a tense green violet
over the stillness of the water's teal.

We have come home to be cleansed from distance
from speed and the people we passed like mere items 20
in too many approaches and quick departures.
Relief lies like a wound at the bottom of the lake
where we cry beneath dark waves for the ache
of coming and the ache of going.

Still nourished by communion of summer 25
the long arms of cousins the flush on a sister's face
the hair of a brother holding onto them for survival.
Back to the oldest woman
who has kept us together like memory.
And now to sit with her and hold her hand 30
while she diminishes gazing
like a bouquet of pink and yellow gazing.

Her skin is of the delicate pansy her odor of fading roses
but her eyes are delphinium blue without reserve
so sure of their love so clear against
 the slur of days. 35
And when she attaches them to us we see the ache
 for living
in them that her love is the strength of shoots
 breaking ground
again and again.
And now we have come to watch the flower drop
so slowly from her hand 40
catching that jasmine star to continue.
And though she is quiet now
I know that her eyes are speaking
speaking with the voice of the whole garden.

FOR DISCUSSION

1. What is the importance of the garden in the poem? How is the woman like the garden? Is this a fair view of her? Is it an attractive one? Whose view is it? Would you be happy with your life if you could think of yourself as the woman in the poem? Why or why not?

2. Look up the word "archetype" in the dictionary. Ask your teacher to discuss the meaning of this term with you. Can the woman in the poem be considered an archetype? Is the Mother role an archetype?

3. Do you think that supporters of women's liberation are against marriage and the family? Why or why not? Do you know any women who are wives and mothers yet still have a separate, personal identity? Write about them.

ACTIVITY

Write a biography of a woman you know. Develop a list of questions for interviewing. The following could be a start:

a) What are the most significant aspects of your life? Family? Friends? Activities? Beliefs?

b) What are the events, people, education, circumstances, and concepts that have allowed you to develop into yourself?

c) When you were young, what did you think your life would be like? How were your expectations answered? What accounts for the differences between outcomes and expectations in your life?

d) How do you handle failures and mistakes in your life?

e) Do you think of yourself as more dependent or independent?

f) How has the fact that you are a woman directed and affected your life? Have you changed your view of women as you've grown? What advantages and disadvantages do you see in being a woman?

g) What do you do in your spare time?

INTRODUCTION

The "lady" in Judy Collins's poem "Albatross" is trapped
in the loneliness of a prison created by stereotypes. And, as the
myths and mystery about her continue to increase, she grows
even more isolated. She waits for a rescuer, a "prince
charming," who will never come.

Albatross

Judy Collins

The lady comes to the gate
Dressed in lavender and leather
Looking North to the sea
She finds the weather fine
She hears the steeple bells 5
Ringing through the orchard all the way from town
She watches seagulls fly
Silver on the ocean
Stitching through the waves the edges of the sky.

Many people wander up the hills from all around you 10
Making up your memories and thinking they have
 found you
They cover you with veils of wonder
As if you were a bride
Young men holding violets are curious to know
If you have cried 15
And tell you why and ask you why
Any way you answer.

Lace around the collars
Of the blouses of the ladies
Flowers from a Spanish friend 20
Of the family

The embroidery of your life
Holds you in and keeps you out
But you survive
Imprisoned in your bones 25
Behind the isinglass windows of your eyes.
And in the night the iron wheels
 rolling through the rain
Down the hills through the long grass
 to the sea, 30
And in the dark the hard bells
 ringing with pain
Come away alone.

Even now by the gate
With your long hair blowing, 35
And the colors of the day
That lie along your arms,
You must barter your life
To make sure you are living,
And the crowd that has come, 40
You give them the colors,
And the bells and the wind and the dreams.

Will there never be a prince who rides
Who rides along the sea and the mountains,
Scattering the sand and foam 45
Into amethyst fountains,
Riding up the hills from the beach
In the long summer grass,
Holding the sun in his hands
And shattering the isinglass? 50

Day and night and day again,
And people come and go away forever,
While the shining summer sea
Dances in the glass of your mirror,
While you search the waves for love 55
And your visions for a sign,
The knot of tears around your throat
Is crystalizing into your design.

And in the night the iron wheels
 rolling through the rain 60
Down the hills through the long grass
 to the sea,
And in the dark the hard bells
 ringing with pain,
Come away alone 65
Come away alone . . . with me.

FOR DISCUSSION

1. What are the "veils of wonder" the poet refers to?
2. Why will the prince the woman waits for never come?
3. How is the problem of the woman in the poem a problem of stereotypes?
4. Do you know why the poem is titled "Albatross"? What is the woman's "albatross"? (If you cannot answer this question, see Activity 2 below.)
5. Have you ever found that something you first thought a delight and a privilege became too heavy a burden to bear? What do you think this has to do with being a "lady"?

ACTIVITIES

1. Find Judy Collins's record album *Wildflowers* and listen to this song.
2. The word "albatross" has acquired a figurative meaning from Samuel Taylor Coleridge's poem *The Rime of the Ancient Mariner*, a meaning which you probably will not find in the dictionary. If you are not familiar with this poem, look it up and ask your teacher to discuss what the albatross is a symbol of.

2 3 4 5 6 7 8 9 10 BPBP 85 84 83 82 81 80 79 78 77